Miles G. Batt '02

MILES G. BATT

the complete guide to

Creative

WATERCOLOR

CREATIVE ART PUBLICATIONS/FORT LAUDERDALE FLORIDA

LIBRARY OF CONGRESS
CATALOG CARD
NUMBER 87-071439
ISBN 0-9619386-5-X

MILES G. BATT is nationally known as an artist, teacher, and juror. Since 1968, Batt has received 105 major painting awards. Respected as a teacher of design, color and creative thinking, assignments have taken him to universities, museums, art groups nationwide and workshops worldwide. Listed in "Who's Who In American Art," Batt has participated in more than 250 group and one man exhibitions and is represented in over 450 public and private collections.

"Art is the unlimited search for fresh approaches to express today and tomorrow. The process may begin with the synthesizing of opposing elements, the life giving tensions necessary to a work of art. The wide choice of opposites available to the artist are intellectual or emotional in source, tempered by subjectivity. The creative process is an illusive experience resulting in what may be called an idea... this idea **when coupled with suitable presentation, transforms the strange and curious into the realities of art. Making visible, rather than reproducing vision, is expansive to the life process."**

CONTENTS

from Irene

**WISHES WERE HORSES
ALL BEGGARS WOULD RIDE
AND.....**

...... you are willing to work with
every fibre of your being
as often as you can,
... you are eager to read every art
book you can, especially
the ones without pictures,
........... you love the medium of
watercolor,
......... you want to forever learn
and stretch your mind,
......... you are sure one lifetime
will fall short of exploring
all the possibilities...

:YOU DON'T NEED THIS, OR ANY OTHER BOOK, ALL YOU HAVE TO DO IS

PAINT

INTRODUCTION

TEACHING AND TAP DANCING

The word "TEACH," and the title "TEACHER" has always made me uneasy, especially as it applies to watercolor painting. It is difficult to imagine a course of action more filled with obstacles than one person attempting to teach another person or persons how to paint. Filling the role of "Teacher of Watercolor Painting" clearly reveals two different paths.

Instructing empirically involves a follow the leader approach....."It works for me and it will work for you, It's easy just do what I do." The drawback to monkey see, monkey do activity is that the student is perpetually tied to the smock strings of the teacher. Satisfying results on a beginning level may be immediate, but the aspects of setting and solving a problem creatively, fall terribly short. The concept of painting a certain way because someone else paints that way is creatively doomed at the outset. Creative results are dependent upon expanding, adding to, or rejecting the past outright. It is fundamentally insincere to paint "like" anyone else.

Teaching a student to do it "your way" carries with it the guilt, at a later date, of hindering growth. The sincere student is going to find creatively fertile soil different from the teacher's and appraise much of the teaching time as lost time. In many instances we must **unlearn** to find more of ourselves.

Instructing encyclopedically also has its drawbacks ...presenting the many alternatives available to the watercolorist tends to befuddle the beginner and presents for the intermediate painter the perplexing problems of having to creatively choose. Having utilized both the empirical and encyclopedic instructional methods at length, I prefer the encyclopedic approach. The teacher provides an environment ripe with learning potential, never intending to **just** answer questions for the student. The goal is to have the student arrive at a personal conclusion as an outcome of presenting many alternatives. **Freedom is choosing!** When you must choose from many ways to put a painting together, **the relationship of the painting to you must be considered,** also **the relationship of the painting to you and the rest of the world must be considered.** Because you must select from many possibilities, what you produce will depend upon your **mind and spirit** just as much as the painting materials and subject matter. You surrender the possibility of creative understanding when you accept someone else's answers.

Avoiding the transfer of the teacher's limitations to the student involves standing out of the way, giving the student a chance to expand. It's a lot like tap dancing...keep it moving, keep it interesting.....don't stay in one place too long.

Students tend to think of teachers as persons not governed by the same circumstances as students. Teachers, however, must walk the same tightrope of self acceptance and self rejection as the student. In a creative sense, it never becomes easier.

Students who discover the strengths inherent in their own work, may find it necessary to reject all remnants of instruction from a traceable teaching source. Anything that forces you to look within yourself for an answer is correct.

IT'S HERE. IN THIS BOOK!

Words have more meaning when the reader doesn't have to stop and use the dictionary. With this in mind, I've chosen words and phrases that will require careful, concentrated reading, but little or no need to refer to a dictionary.

We are all motivated differently...............
Because I do something differently doesn't make me right and you wrong or vise versa.....it just makes me motivated differently.

A good watercolor book doesn't show you how to paint. A good watercolor book makes you **want** to paint! Unfortunately, most publishers are primarily interested in making money.....not necessarily educating.

Most books look good but offer little foundation for the thinking process.....just things to "copy." You don't have to see everything demonstrated with step one, step two, and three photos.....you'll do more creative paintings if you interpret the words in your own way.

Beware of books that show you "How To Do **IT**." If you are eventually able to do **IT**, what is **IT** worth? If you can do **IT**, and the author can do **IT**, lots of other people can do **IT**. Each person doing **IT** drains **IT** of creative potential. **IT** is the last thing you should attempt to learn how to do.

Whatever is different about you is what is uniquely you! I've designed this book to encourage you to discover and utilize what is different about you. Bridging the gap between intermediate and advanced painting concepts to the creative level is my intention. How do you remember everything in this book when you're painting? You don't! This book is meant as a guide for study.....a guide for filling the subconscious. When you paint you should relax and allow the subconscious mind to indicate procedures. Certain sections of the book offer exercises to reinforce the ideas in the text.

I wrote this book to constantly remind myself. I'm sure it will open new doors for you also.

ANSWERS FOR THE THINKING WATERCOLORIST

THE MAGIC BRUSH ★ LEARNING BY CREATING ★ GETTING YOUR STROKES WITH WATERCOLOR ★ WHY DO YOU PAINT? ★ HANG' IN OUT WITH WATERCOLOR

ANSWERS FOR
THE THINKING WATERCOLORIST

Where can you expect answers to come from? Definitely from working, if you don't paint, for whatever reasons, you'll be isolating yourself from the first relationship - you and the painting. Thinking - actively searching for answers - working from the subconscious where answers are stored, just letting answers flow, unconscious intuition, provides answers.

The old axiom, intuition is a product of tuition, may be an obsure bit of truth, but most successful teachers and painters don't follow it. To fulfill the role of teacher/instructor, one must claim faith in reasoningwhat else could become a topic for discussion? What else could organized instruction offer? Amazingly, creative painters and teachers never follow any instructions or rules. Every rule you can think of today has so many exceptions, confusions, contradictions and qualifications, so as to make rules worthless.

The answer is.....be totally absorbed in what you're doing, then the artist and the painting work together in harmony. The continuing interaction of paint and thought. Everything the painter is, everything the painter feels, everything the painter thinks, is activated simultaneously with the painting materials, resulting in a progression of changes to the painting until the painter's mind is at rest with the "rightness" of the painting.

Tuition plays a part in the scheme of it all - however, rarely is it a substitute for the intuitive responses produced by the concentrated interaction of paint and painter. Even with absolute beginners, the creative approach is to instruct only in the areas of identifying the irreducible elements and the structural alternatives.

Where you are, and where you are going never makes much sense - however, looking back at where you have been a pattern begins to unfold. Working from that unfolding pattern into the future you will begin to expand. To paraphrase T. S. Eliot , . . . "After all is said and done we find ourselves, again at the beginning, knowing the place for the first time."

THE MAGIC BRUSH

The "Magic Brush Syndrome" is an idea which prevails among beginning, and some intermediate level students of watercolor painting. Loosely defined, it involves buying another book, a new and different palette, easel, color, paper, or attending a workshop with this or that instructor, because surely the experience will solve all the problems you think you have regarding watercolor painting. The illusive "Magic Brush" will become yours! - in any event you might purchase it!

Desire for, and belief in the existence of instant education that will produce instant gratification, seems to have reached a high point, approaching the sanctity of religion. Discovering reasons and placing blame is all too easy - amounting to eighth grade excuses for not completing homework. The truth of the matter is that the process of learning requires discipline, sheer drudgery and, occasionally, even anguish.

Culturally, we've accepted the concept that any activity for which we are not specifically paid must be fast, easy and, most importantly, fun. If we apply this idea to the hard work of learning, the contradiction is enormous.

The best kind of learning happens when we make mistakes or become confused - rather than being able to move upward and extend our reach, we must remain on a plateau moving from side to side until we understand something that allows us to expand at the base of our knowledge, which is where growth occurs.

Learning can be exciting, stimulating, and challenging, however, it often demands the hardest kind of work. If watercolor painting has to be fast, easy and fun - what happens to learning?

LEARNING BY CREATING

Learning implies confronting new information and dealing with it. Learning necessarily begins with the sorting of confusion. If you're not occasionally confused, you're not learning very much. Some creative artists actively pursue confusion, just to impose organization upon it.

The highway to creative painting is not as difficult to travel as we might suspect.

Central to all creative activity is the function of the brain. It perceives, arrests and stores information, while responding to the information. Experiments with stroke victims have proven conclusively that the right and left lobes of the brain analyze and separate information. *Figure 1.* graphically illustrates how the system might work from sensory base to creative painting. From the five senses, information is gathered and stored in the sensory base. This information neatly falls into two distinctly different categories - here comes right and left brain function - public school educational methods secure the best possible development of the left hemisphere of the brain, where the association of sounds to words to speech occurs. Logic and pure intellect are left brain functions. Time doesn't really exist, man invented it and the left brain responds fully to its imposition upon our consciousness. The left brain is firmly intellectual.

Right hemisphere of the brain activity involves images - most public school educators pre-suppose adequate development of the right brain through human existence. If not, such courses of study would not be the first to be eliminated in any economic crisis. Visual illiteracy is so rampant in our culture as to border on the criminal. Almost all the information we receive as humans is visual, yet few of us "know" what we are seeing.

Aside from thinking in images - seeing mental pictures - the right brain thinks abstractly, i.e., it dreams. Einstein developed his theory of relativity by imagining himself riding a moonbeam. The right hemisphere thinks from part to whole, i.e., how does this small segment of anything belong to the ONENESS of the whole thing? The right brain disregards time, time doesn't exist! Right hemisphere activity has everything to do with the emotions - FEELINGS.

Successful learning techniques rely heavily upon self acceptance. If your attention is diverted by self rejection, it will be difficult to fully concentrate. Accept what you produce as being the best you are able to produce. Every level of accomplishment can be a creative one - I've seen creative beginners and I've seen very ordinary, uninspired beginners.

Fortunately, you are automatically unique - you have a different grouping of life experiences than anyone else on earth - don't hide these differences ----- paint creatively at the outset. Avoid the commonplace, the wedded bliss of right and left brain activity will lead you to ideas, the conceptual base and ultimately creative paintings.

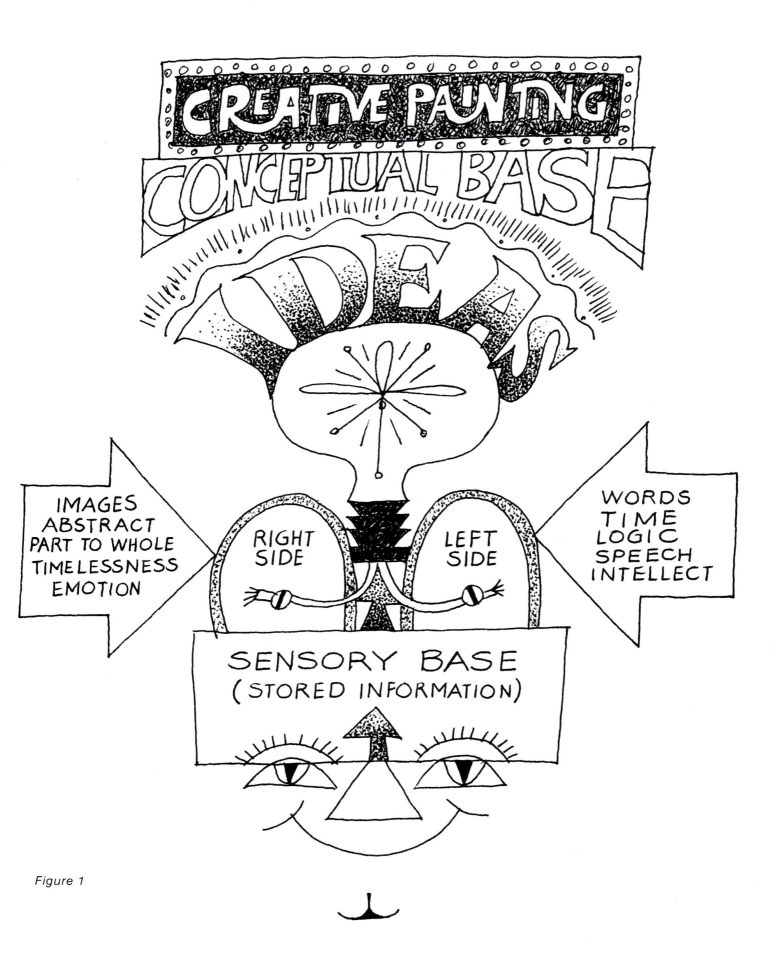

Figure 1

GETTING YOUR STROKES
WITH WATERCOLORS

Those of us who search for acceptance in this world through painting pictures are different from individuals who seek acceptance by other methods. Acceptance and the opportunity to make a contribution to life's experiences through sharing, is basic to all artistic production. Artists who are not compensated either financially or through encouragement, far outnumber those who are. Few professions can boast such speculative risk.

On the other side of this seemingly woeful situation is that striving for achievement delivers necessary meaning to life. In many sectors of contemporary life, caring about what you are doing is considered either unimportant or taken for granted. Don't hurry your development as a watercolorist. When you hurry something it means you no longer care about it and desire to move on to other things. Progress at a pace that suits your personality, but progress carefully and thoughtfully. Don't miss a trick.

Unreasonable expectations more often than not end in frustration, however, if you are able to put frustration to work it may prove a motivational force beyond your most unreasonable expectations.

It is not unusual during a workshop to hear someone exclaim "Gee, Isn't it nice to get back to watercolor,"try it sometime twenty-four hours a day, three-hundred and sixty five per year.....I guarantee you'll have a clearer idea of worth.

WHY DO YOU PAINT?

Question,.......Why do you paint? The larger question might be, why did you select art for achieving your goals? Three possibilities exist; you were attracted to art by a force as mysterious as the sex urge, "Love of Art"; you may have passively chosen art because of innate skills or education; or you may have made art your choice through calculation and drive.

Risking oversimplification, a few generalized categories and some parallels may answer the question, why do you paint?

Most artists begin by wanting to **duplicate or imitate nature.** Certain deep rooted relationships with nature stimulate us to the point of worship. The impossibility of it all results in the understanding that artists have only the possibility of painting a two dimensional interpretation of the relationship with nature, not nature itself. "It's not the world of nature that's important, rather the nature of the world," stated Kandinsky. Imitating nature's appearances is one thing and understanding nature is another. Imitating appearances may simply encourage hand-to-eye coordination. Displaying the world just as we are accustomed to seeing it, does not help us to understand. Studying nature's structures and evolution of form, promises greater understanding of the world we live in.

The urge **to decorate** is a strong motivation for some artists, to adorn with ornamentation, to embellish, parallels wanting to make improvements. Decoration as a goal is practiced, but not admitted to, by many painters. Decorative paintings suffer the indictment of merely diverting attention, becoming a form of entertainment.

Self expression as reason to paint encompasses a host of similar motives such as self discovery, release of tension, and meeting personal needs. "Every good painter paints what he is," a statement by Jackson Pollock, implies that each work of art is an extension of the artist's ego. Expressive art forms draw upon the artist's emotions or thoughts for subject matter. With self expression, the artist surpasses entertainment and is seeking to satisfy the emotions.

Searching for new form is **to create.** Fresh ways to put things together are as much the result of a purposeful search as they are a product of resolving accidental circumstances to a creative conclusion. Creativity is not the result of the status quo — it evolves from the need to be different, the desire to make "things," to discover, and the rejection of the commonplace.

Despite the turning of attention from forming to informing by some contemporary artists, the need to form, to create new formats, procedures and concepts is the life blood of all art form. Culturally, creative form may earn a spot on the endangered species list from time, to time, only to bounce back more vigorously than ever.

Psychologists claim there are basic reasons why people paint pictures:
Escape From Tension
Self-expression
Calming of Nervous Tension
Self Discovery, Who Am I?
Curiosity
Desire to Make Relevant Contributions
To Arrest Time

Our general categories; to duplicate nature, to decorate, to express oneself, and to create new form, explore enough possiblities from which to make choices. Clearly, most painters at any level of accomplishment have experiences that fall within all four categories. Ironically, all four motivations may exist in one painting. Overlapping does occur, nevertheless, you will be one step closer to understanding yourself if you are able to identify with one of the four categories. Your ability to emphasize and direct attention will be stronger.

HANGIN' OUT WITH WATERCOLOR

Decide what you want to do with watercolor and what you expect watercolor to do for you - don't mislead yourself into believing you can become a creatively contributing watercolorist painting only on a "once in a while" basis - it won't happen. Moderate success, in a creative way, often becomes a lifestyle where waking hours are spent in search of another rewarding experience with the medium, or some relevant step to further understanding. It's difficult for me to remember a time when I didn't face a blank piece of something or other, every day, that required painted marks on it. The blank piece of paper is still intimidating at the beginning. It's all in how you see it!

A military aircraft was forced to make a landing three hundred miles from nowhere. Radio gone, water and rations scarce, the walk out seemed an insurmountable task. After having successfully made the trek against all odds, when asked how they walked three hundred miles, the captain stated, "We didn't walk three hundred miles - we walked fifty miles, six times!" How you see it can make the job easier or drain your resources. Take your choice!

Watercolor painting presents a similar situation. You must treat it as a "love affair," a give and take situation. Enjoy taking it one step at a time.

ART IS.....

TO BE LOOKED AT ★ TO BE EXP-
RESSIVE ★ WE'VE GOT A PROB-
LEM QUALITY ★ PAINTINGS A-
RE VISUAL MESSAGES ★
SOMETHING TO SHOW ★ A
WAY TO SHOW IT

ART IS.....

ART - The quality, production of expression, according to aesthetic principles, of what is beautiful, appealing or of more than ordinary significance. (even the dictionary implies the ordinary is negative)

Significantly different man-made objects have by custom been referred to as works of art. What makes these man-made objects different? Objects made for an appreciation of the meanings or values that are inherent in their visual appearance may be designated as art. The sensual dimensions of almost any object may be aesthetic experiences for humans, but a work of art is produced specifically to **focus** upon the aesthetic experience. We may look at and appreciate a claw hammer or a milk carton, however, these objects were not intended for concentrated focus, rather for the functions of hammering nails and transporting milk. Works of art are structured in a rewarding manner. Ideas and emotions are organized with careful attention to the compositional means.

Our culture is so diverse that many different definitions may apply to the word art. The objects we call art have changed through the years. The concept of what is art is constantly subject to expansion through new art forms. Perhaps there is no perfect or true definition of art. Most importantly art may be an ever expanding process --- a search for meaningful ways to express today and the future. It's easy to charm the eye, but creative art must satisfy the mind.

TO BE LOOKED AT

Art becomes art, fundamentally directed towards the two different goals of perfection - aesthetic, and expression - emotional.

Aesthetics is the science of the beautiful, the philosophy of taste, attempting perfection. The more mobile world of expression is the release for human emotions. *Figure 2.*

Some art is created to fulfill the requirements of fineness of beauty expressed in terms of form. Elegant and beautiful are words we use to describe an image or object when its component parts and its structural concepts are in a harmonious, balanced relationship. Unity in the form is clearly indicated.*Figure 4.* "Green Sea Triangle," is an image specifically designed to appeal to the intellect. It has symmetry, logical regularity, rhythm, and is structured by a system of harmonious relationships among the elements utilized. Symmetry and regularity may be obvious to the viewer, but its proportions are dynamic and the elements are held in a unique kind of tension. The painting is satisfying, clear, refined, and conceptual. There is nothing I want to change.

TO BE EXPRESSIVE

Some art is created because of a need to express emotions - this need erupts directly from deep rooted feelings toward the subject matter and its association to the medium - watercolor. *Figure 3.* "Magic Sunrise, South Jetty," is a painting of ocean and sky that is less harmonious than it is dramatic. Its structure and surface may even be described as crude. To evoke a strong emotional response is its goal ——- not logic, refinement or beauty beyond the fact that anything that satisfies us may be described as beautiful. This painting lacks precision, it is organic and expressive, it grabs you by the hand and says, "Come with me, you must see this," it excites! Feeling and emotion is symbolized!

Between these two extremes of perfected and expressive, there are countless intermediate positions that combine characteristics of both extremes. My examples are not purely of either extreme. The problem of imposing the dominant thinking of either of these two paintings upon the other is obvious. They represent opposing approaches within my thinking as a watercolorist. A dilemma is presented for us, as painters, if we concern ourselves too deeply with the duality of choices - both approaches may be successfully accomplished. You can approach a subject intellectually or emotionally. Accomplishing either goal in an absolute pure way probably represents a genuine problem. Intellectual approaches easily become cold and indifferent, lacking interest. Uncontrolled emotions lack cohesiveness. Employing the best of both horns of this dilemma generally produces the most powerful statement.

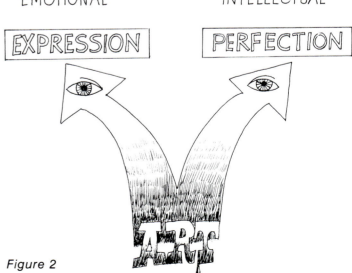

IMPRECISE ORGANIC ROMANTIC IMPROVISATIONAL EMOTIONAL

CLEAR REFINED STRUCTURAL AESTHETIC INTELLECTUAL

EXPRESSION

PERFECTION

Figure 2

All paintings pictured are by the author unless otherwise designated.

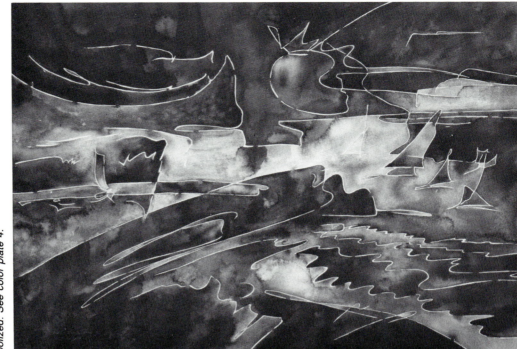

MAGIC SUNRISE, SOUTH JETTY, is a painting of ocean and sky that is less harmonious than it is dramatic. Its structure and surface may even be described as crude. This painting is organic and expressive. Emotions are symbolized. See color plate 4.

Collection MERCEDES VIDAL

Figure 3

Figure 4

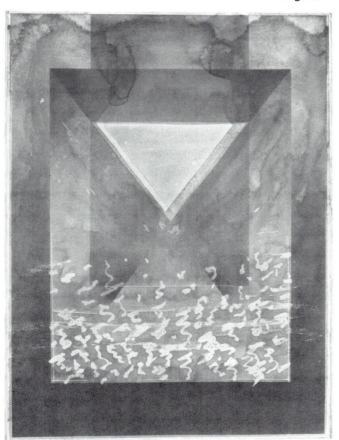

GREEN SEA TRIANGLE, is an image designed to appeal to the intellect. This painting has obvious symmetry and a system of harmonious relationships, but its porportions are dynamic and elements are held in a unique kind of tension. See color plate l9.

WE'VE GOT A PROBLEM

QUALITY

Quality in the arts or any other field of endeavor is almost impossible to define - quality, what is it? You know it when you see it, but can't put it into words successfully.

It would be easy to say quality is subjective — nevertheless there is some criteria for quality we'd all agree upon, so it cannot be totally subjective.

If quality was the objective, every painter would have to work within one definite discipline, where we could successfully judge one painting against another — but that's not going to happen. Yet in one way we are all within a discipline called painting - it's a puzzling situation.

If you paint enough you will define "quality" for yourself over and over again. As a mature painter, you'll be painting it, over and over again - quality is very much like truth - every painting is a truth known only to the painter and necessarily refutes all other paintings to some degree. It says, "This is the truth." Each painter's truth is different - it must be!

For me, quality can only be measured by the time spent in the trenches of not knowing, which encompasses choosing a problem or having it choose you, wrestling with it, and discovering or inventing a solution. Quality is that time spent on the cutting edge of what is important. Other people, even other artists, may not see it - but you will know it!

PAINTINGS ARE VISUAL MESSAGES

Webster's Dictionary defines the noun "painting" as being art or employment of laying on colors; the art of representing objects by colors; a picture; colors laid on.

Paintings result from creatively combining opposites - these opposing factors are many and are as varied in their sources as the mental, physical, and psychological energies that produce them. Paintings are visual messages. Many aspiring watercolorists to whom I say this automatically raise their hands, back away and tune the idea out with, "I don't wanna' make paintings with messages" - as if they're not already doing just that - message, in the broad sense I'm intending is not necessarily involved with socio-political views, hunger and violence in the free world, or the price of soy beans on the open market.

Messages are conveyed in the most subtle ways to those sensitive to the mode. Doesn't a salesman receive subconscious messages from the verbal dialogue with a prospective customer? Doesn't subconscious body language and general demeanor say a lot to someone who is fluent with that language? Doesn't the color of the clothing you choose to wear indicate something relevant to your personality? Certainly. No matter where you are, in terms of development as a painter, your paintings are already sending visual messages. Accepting the idea that the messages can be clarified and focused is a positive step toward creating a more significant painting.

SOMETHING TO SHOW

Content and form are necessary for any painter to explore. Content, something to show - form, a way to show it...sounds like fundamental stuff.....and it is. It's only when we try to define content and form with words that it becomes confusing.

Separating content from form is impossible; they are the two parts interwoven in every painting. However, it is important to understand that each side of this pair influences our concepts or ideas.

Unknowingly, some viewers and some artists believe that content is subject matter, but it's more than that. Content is significant, meaning everything that relates to the emotional, sensory and psychological elements which a viewer *feels* in a work of art, rather than just understanding its descriptive features.

The boundaries of what used to be described as being content vanished near the middle of the twentieth century. Content virtually depends on what the artist is willing to say content is, and what the viewing audience is willing to accept.

A WAY TO SHOW IT

Form is defined as, the shape and structure of anything. Form - a way to show it, all formal aspects of how the painting is structured, how it's put together —- everything from how the paint is applied to utilizing the irreducible elements of line, value texture, color, size, shape and direction; the strategies concerning unity, contrast, dominance, harmony, repetition, balance, alternation, movement and proportion.

As the boundaries of content had expanded, form had also changed. While the subject matter had not yet changed - landscapes, genre scenes, portraits, etc. - the dots, dashes, dabs, strokes, and commas used as elements of form by Cezanne, Seurat and Van Gogh predicted Picasso's new language for traditional subject matter, cubism. By mid-century, form itself became content with the color/field/pattern/shape/object oriented painters. Conceptual art of the seventies almost eliminated form entirely. Nevertheless, form is here to stay as regards painting.

Content and form are the stepping stones between the painter and the viewer. *Figure 5.* Some artists are motivated by what they want to say or show and others are intrigued with how to organize the message and apply paint. No matter what motivates you, you'll find that content - meaning and form - an organization capable of arousing the participation of the viewer - interact with each other until they are successfully unified into one thing.....the painting.

Figure 5

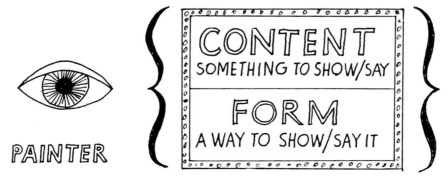

THIRTY-THOUSAND
YEAR OLD TIME CAPSULE

WATERCOLOR & YOU & YOU &
YOU & YOU TOO ★ PAYING YO-
UR DO'S ★ WET PAPER ★ DRY
PAPER ★ FLAT ★ GRADED ★ D-
RYBRUSH ★ GLAZING

THIRTY-THOUSAND YEAR OLD TIME CAPSULE

Watercolor as a medium is a time capsule with a thirty thousand year old cultural continuity. Man, adapting to available methods and cultural attitude, is evident in the earliest known works of art.

At the end of the last ice age, man was painting on cave walls using such simple techniques as flowing lines drawn with finger tips in damp clay. Often the artists hands and other discernable silhouettes were used as stencils. By filling his mouth with a watery mixture of clay or vegetable colorant, these cave artists sytematically blew the mixtures through the hollow leg bone of a deer, a crude spraying tool that allowed manipulations of dark and light value and limited color.

Certain members of primitive tribes became "Shamans," accepting the many roles of priest, doctor, artist, dancer, decorator, singer, and entertainment director. The most accomplished rock paintings are in Southwest France and Northern Spain - 12,000 B.C. Although undoubtedly utilized as models for teaching hunting skills, these "Shamanistic" rock paintings also served as centerpieces for spiritual activities, decoration, and entertainment. Extinct for many thousands of years in Europe, the art form lived on into our own time among the bushmen in South Africa, Australian Aborigines and, until the seventeenth century, in the American West.

Characteristically, cave painting was executed with sparse, linear elements, coupled with an impressionist coloration, echoed in modern painting by Paul Klee and Joan Miro. As the hunter tribes evolved into agricultrual peoples, their art forms changed.

The enormous contribution of the orientals, because of their cultural tradition of writing with calligraphic brush strokes to form pictures, is widely known. Eighth century Hein Period scroll work executed on paper and silk with ink, color, and collaged papers are hallmarks of early Japanese watercolor painting still existing today.

The ancient world produced illuminating examples of tempera on papyrus and tomb painting practiced in Mesopotamia, Egypt and Etruria. Greek and Roman wall decoration also employed paint and plaster. Third centry artists began using water soluble glue-gum as binder for painting on paper and the process, except for pigment chemistry, has changed little since then.

Renaissance artists used water color, bistre, etc., for sketches prior to more elaborate oil paintings. Durer, Tiepolo, Raphael and Rembrandt produced notably different works in water media during the age of Baroque, between the Renaissance and the Modern Age.

William Blake's watercolor illustrations are shockingly imaginative to this day, and equally innovative is the richly expressive work of J.M.W. Turner. Turner was always experimenting. His blotted, mottled, accidental approaches to the medium predicted Expressionism and the contemporary school.

French Impressionism utilized the colors of light, responding to the discoveries of the era. Cezanne's compositional innovations and re-creation of light fortunately spilled over into his watercolor works, becoming a crossroad for the conceptual possibilities of the medium. Before the turn of the century, Winslow Homer's journalistic illustrations and J.S. Sargent's watercolors matured into genuine American contributions.

German Expressionism exploded with the Blue Rider exhibitions in Munich. Kandinsky,Klee, Jawlensky and Marc presented a formidable challenge to traditional naturalism that is still reverberating in contemporary art.

The New York Armory show of 1913 finds Fauves, Cubists, Expressionists, Futurists, Surrealists, and many abstract artists rubbing elbows in an art world promising a variety of new creative possiblities.

The barrage of names significant of this period to the present is staggering; Rodin, Prendergast, Nolde, Rohlfs, Kirchner, Feininger, Schiele, Grosz, Munter, Dix, Kokoschka, Delaunay, Pechstein, Pascin, Nay, Chagall, Miro, Signac, Derain, Segonzac, Munch, Duffy, Rouault, Marin, Dove, Birchfield, Bluemner, Demuth, O'Keeffe, Tobey, Wyeth, Foujita, Hopper, Shahn, Avery, Nash, Moore, Graves, Louis, Davis, Lawrence, Francis and Jenkins.

WATERCOLOR AND YOU, AND YOU,. AND YOU, AND YOU TOO!.

Of all two dimensional art mediums, none is more maligned, more misused, more misunderstood, or more absolutely entrancing, than watercolor. It has so much potential going for it, that many aspiring artists *begin* with watercolor because it appears so deceptively easy when the concept fits the handling.

I don't agree with the idea that a watercolor **must** be fluid, **must** be transparent, **must** be spontaneous —— of course it can be - but all these qualities should be in accord with the painting's content - these qualities are relative under all circumstances. It requires static areas to *"set up"* fluidity, transparent areas cry for opaque areas to bounce off of, and spontaneous areas are more spontaneous if compared to pre-determined areas.

If you like to paint, watercolor offers unique experiences! Logistically, the works are comparatively small. This means you can see the whole painting quickly; relationships are more focused. Water - H_2O - is all that's necessary for cleaning and mixing. You don't have to spend hours building frames, stretching canvas, and applying coats of gesso.....and the paint, WOW!

Incomparable in the ability to appear fluid, watercolor can freeze-frame the essence of movement, among the traces of water interacting with paint and paper. The painter can also saddle and harness the stuff to create wonderfully subtle graduations that only using an air-brush could hope to compare to. Such flexibility!

As an experiment, hold a completed watercolor in front of a strong light..it's transparent! A painter must really go out of the way to make the surface opaque. Transparent and opaque rhythms, alternating the two factors of transparency and opaqueness, is another method for animating the surface of a painting. The paint characteristics to be dealt with fall into three basic categories:

STAIN COLORS-
Any dye-type color will sink into the papers, leaving a stain even after repeated attempts to remove it. All the Thalo colors are staining colors, and transparent.

SURFACE COLORS-
All the cadmiums, earth colors, and ultramarines are colors with pigment particles suspended in the gum vehicle and are easy to remove because they rest on the surface of the paper. They are more opaque.

VARIEGATED COLORS-
Are all other colors like Viridian Green that sometimes is so greasy that it resists mixing and Manganese Blue, which dries in its own way.

Each color is slightly different chemically, consequently, each acts differently. The way to learn the characteristics inherent in each color is to experience it. I keep an on-going file of all available colors and brands. Isn't first-hand experience better than reading a description of what is supposed to happen in a book? Do it!

White paper has always been a concern for painters using watercolor. The paper's whiteness, weight and texture are constant companions to the painter's efforts. White paper **"breathes"**, transparency requires care so as not to suffocate the paper with too much paint, conversely, too much *"air"* might blow it away.

ROUGH PAPER-
Has a deeper surface dimple - texture - and makes wet washes more controllable at the sacrifice of color and surface clarity. Rough paper makes dry brush manipulations easier, it has more *"tooth"*.

MEDIUM PAPER- *(cold pressed)*
Offers less *"tooth"*, it's better for "drawing" with the brush. Because surface textures offer little resistance, more surface is fully exposed so washes are "up front."

SMOOTH PAPER- *(hot pressed)*
Has next to no *"tooth"*, washes have a mind of their own on this paper, producing wonderful liquid accidents.

White paper is the all consuming background a painter floats the color onto. Intensity of coloration depends upon the white paper's regenerating powers. Conversely, some very creative paintings threaten the very existence of white paper - abused, torn, sandpapered, painted over - denying the value of white paper. Try painting with watercolor on a black surface....you'll appreciate white paper more fully.

Accidents will happen....*maybe!* If you're adventuresome, planning some accidents from which to create a painting is the only way to go - are they accidents then? Granted, there are occasions when an accidental drip, drop or run of color cannot be remedied or tolerated, but beautiful, unexpected things happen just by allowing the ingredients of color, water, paper, and opposition to run amuck. Examine particularly interesting areas of an exciting watercolor painting under a magnifying glass..... what wonders!

The inevitable accident is resolved by making it a virtue - integrate it, repeat it, make it an organic part of the painting - or get rid of it, remove it, obliterate it. Accidents may become the final act in a comedy of errors or become the starring players, it's all up to you,.....the Director.

PAYING YOUR DO's

DOING...is the only way to pay your do's. There is only one reason to build a vocabulary with paint...to use it fluently and with subconscious effort. It should be like driving a car, not having to search for the pedals to stop and go. Technique extends the mind and the emotions through the hand. Imperative to extending mind and emotions through eye/hand coordination, is exerting sufficient control over the circumstances that exist between paint, paper and water.

Most crucial to controlling watercolor is **the moisture factor** - water - H_2O. How much is in the brush? How much is in the mixture? **The moisture factor** controls shapes, edges, values, textures, intensity of colors, drying and untold other nefarious situations.

Paint handling technique, no matter how superb, is rarely acceptable content. Technical facility is empty performance with nothing significant to say. Technique should be carried only to the point that adequately supports content. No further! Technique gets in the way - have you every heard a brilliant operatic tenor try to sing "Melancholy Baby"—-very unconvincing!

Control is the ability to induce the paint to do what you want it to do - not beating it into submission. Freedom requires **more** control. Being **"free as a bird"**is a parallel, since birds spend most of their time in search of food. Creative watercolor paintings rarely *"just happen."*

Experience is the only learning procedure - you cannot learn to drive a car by simply recognizing road signs. You must get out and drive!

All paint handling techniques fall into a few basic situations, each controls *the moisture factor.*

WET PAPER - DRY PAPER - FLAT - GRADED - DRYBRUSH

Controlling **the moisture factor** is accomplished through **feel**, sometimes in the literal sense, with the back of the hand. It's very much like the *feel* between car and driver - a sensibility gained from the car and applied to it. A new typewriter *feels* different than the old one. A new pair of shoes *feel* different. New tires on the car *feel* different. Having a *feel* for anything is simply the ability to observe and separate incoming data and arrive at a conclusion. Experience is the key. Instructional methods for the reader to *"copy"* are cheap. Frustration will result if the underlying form necessary in any painting is not understood. Risking repetition of information readily available in the most fundamental technique book, included here is some basic advice. The paper surface you'll be painting on is always either wet to some degree or bone dry. Now, here is where *feel* plays a part....

WET PAPER,
when so wet that it will reflect light - view it an an angle for shine - will not hold the edges of shapes you paint consistently. To affect maximum control during this condition, use a wet brush with the water shaken out, i.e., the water is on the paper so you don't need any more. If the paint on your palette is a dried little ball, it won't work....put some paint out! The trick here is paint, about the consistency of maple syrup, brushed into a soaking wet surface - like drybrush on a wet surface - paint it! Leave it alone, let it do something - do the same thing with some other colors while the paper is still wet - let the paints mingle - that's all there is to it.....that's wet into wet. Once you get the *feel* of it, your creative mind will suggest ways to extend the wet period or to hasten drying. The direct sun will dry it faster, so will alcohol in the water. A drop of glycerin - try dish detergent - in your paint water will make your water *"wetter."* After wet paper, dry paper is a snap.

DRY PAPER,
presents a different problem. Since the edges of shapes are going to hold their own —- you should have enough paint mixed and a good idea of the shape you're going to paint before you touch the paper, or *"wing it"* and watch the shape you're creating.

If planned before applied, shapes, called washes are either flat or graded. **Flat** washes are most easily executed with the paper at an angle slightly higher on the top end than flat. You will need a puddle of color in the proper amount and an adequately sized brush for the planned shape. Any method that will evenly disperse color over the shape area is permitted. While the shape is wet, it is still manipulative. The old **"side to side"** method of floating a bead of color with a brush still works. Some artists rock the board and paper gently in side to side fashion, some blow on the wash to disperse paint evenly. **There is no one "way".**

Graded washes modulate or change from dark to light or from one color to another. Many occult methods will produce a graded wash. No matter how you accomplish it, progressive additions of water will be necessary during application to make washes appear lighter, and/or additions of color different from the one you started with. As long as the shape is wet, you can play around with it until it's the way you want it. After it is dry, you can strengthen by repeating the procedure right on top, if necessary.

Glazing is accomplished by applying washes on top of each other, allowing each wash to become bone-dry before applying the next wash.

Drybrush manipulations require little or no water in the brush. Fill a wet brush with a dry mixture of tube paint and then press the hairs of the brush, where they fit into the metal ferrule of the brush, on a paper towel to drain off water. This will result in a brush full of thick pigment. Pressing the brush into the palm of the free hand and twisting the brush slightly will splay the hairs apart. Now the brush is prepared for dry brush techniques. Dry looking, broken textured shapes will result, especially if the brush is manipulated at angles that *"stroke"* the paper.

FLAT WASHES are untextured, quiet, hard-edged, solid and enduring.

GRADED WASHES are more easily accomplished with watercolor than any other medium, and *feel* good on the paper. Gradation implies movement and vigor, suggesting aspiration, grace and the spiritual.

WET PAPER techniques produce animated, organic areas. Wet into wet will create soft edged shapes, subtle glow and soft underpainting.

DRYBRUSHING will cause a notably different edge quality, may be used to render volumes and weights. Textural, heavy and noisy, drybrush may be utilized for executing rough lines and textures. *Figure 6.*

FLAT **GRADED**

LIGHT

MID

DARK

WET IN WET **WASH SHAPES**

DRYBRUSH **COMBINATIONS**

Figure 6

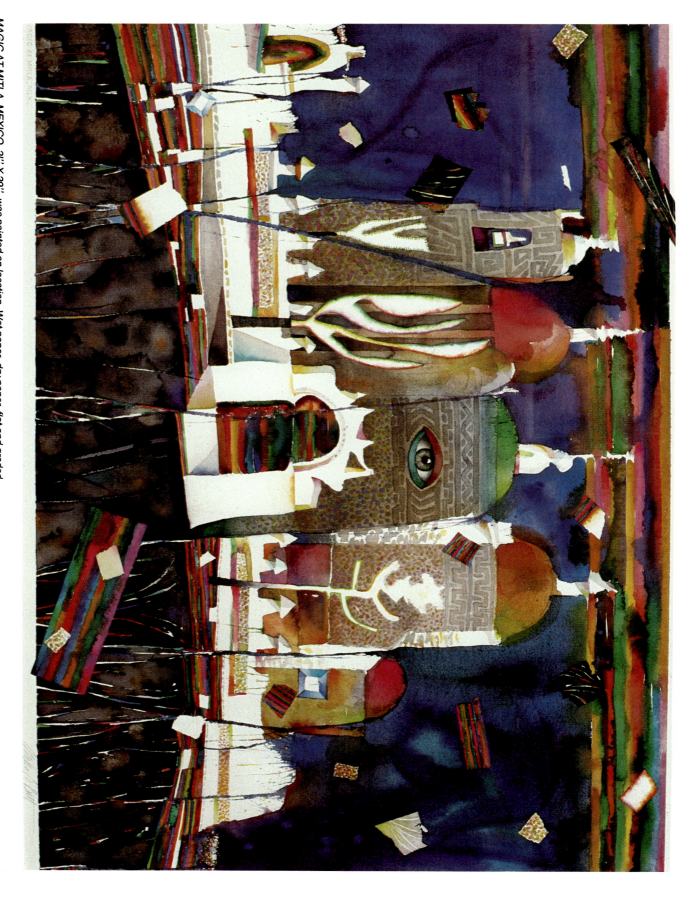

MAGIC AT MITLA, MEXICO, 21" X 29", was painted on location. Wet paper, dry paper, flat and graded washes are displayed on a cold pressed surface. This painting exhibits a balanced handling of fluid wet into wet, flat hard edge washes and dry brush techniques. Conceptually my goal was to "make" a painting not an architectural rendering.

Figure 7

CONTRASTING!
POINTS OF VIEW

TWO SIDES TO EVERY PROBLEM ★ SEE FOR YOURSELF ★ CLEARER THAN MUD ★ THE OTHER STRATEGIES ★ HARMONY ★ BALANCE ★ UNITY ★ DOMINANCE ★ REPETITION ★ ALTERNATION ★ MOVEMENT ★ WHAT TO CONTRAST ★ LINE ★ VALUE ★ TEXTURE ★ COLOR ★ SIZE ★ SHAPE ★ DIRECTION ★ IMAGES WHAT ARE THEY WORTH? ★ SUBJECT MATTER

CONTRASTING!....
POINTS OF VIEW

CONTRAST IS VARIETY, OPPOSITION, DIFFERENCES
All Meaning Exists Within the Idea of Total Opposites

Light is meaningless without dark, sweet without sour, hot without cold, rough without smooth or sound lacking silence. The extremes of each sense category provide a unique experience. Meaning is made clear. Emotionally, happiness is fully realized only by having experienced sadness.

Contrast is unparalled as a vital factor involved with the survival and flourishing of human beings. Human existence on this planet requires constant organization of the information received through seeing, but the information is presented mainly by way of the eye responding to the contrasts of dark and light. Color also helps to process information, however, not as significantly as the tones of dark and light.

Light is an essential factor for human sight, but the contrast of dark to light is of equal importance. Without light, blindness would result. Ironically, if our environment was pre-organized, if everything was a middle toned gray, the consequence would be a paradox of vision without sight. Light and dark create patterns. When these patterns are identified, the information is stored within the brain. **Sight** is the vehicle for over **eighty percent** of the information we receive as humans. Our sense of hearing, touching, tasting and smelling act simultaneously with our sense of sight, increasing our ability to organize information.

Finding an apple on a tree, not having known an apple before, we would press it lightly with fingers to test its softness or hardness, listen to hear if it makes a noise, and if it smelled good, we would perhaps test a small bite for pleasurable taste.

The definitions of contrast - variety, differences - seem to oppose unity, nevertheless, these two strategies are found working together, powerfully, within all natural forms and art forms. Painting with watercolor is no exception.

Contrast keeps us alert. Contrast invites the active participation of the viewer in a search for resolution among varying parts. Contrast intensifies meaning and unity. No problem to solve, no need for a solution - no contrast, no need to unify.

Contrast can get out of control in a watercolor, resulting in a collection of isolated contrasting areas and ideas. Harmony - sameness - the exact opposite of contrast, provides the remedy for too much contrast. Alternately testing areas for too much contrast or too much harmony presents a process for **leveling**- harmony - and **sharpening**- contrast.

In a well organized watercolor painting, the parts interact and become unified without losing their individuality. The parts must be different for maximum effectiveness. Contrast grows into unity.

We see, only because of contrast. Utilize contrast to strengthen, enhance, and enlarge upon. Through the focus of contrast, meaning, balance, description and experience is intensified. See Figure 9.

TWO SIDES
TO EVERY PROBLEM

Understanding the definition of contrast as being opposition may be strengthened through simple physical performances, hand and eye projects, and word meaning puzzles. These sensitizing reinforcement procedures will help you paint more satisfying watercolor paintings.

1. With your entire body as the manipulated material, perform the following contrasts to the count of ten. Alternately use body position, body gestures, and the sounds you believe reflect meaning for these words:

Motion - Stillness
Balance- Instability
Hot - Cold
Rough - Smooth
Sweet - Sour.
Think of five more of your own.

2. Using collage, paste on plain paper one example of:

Thick Line next to Thin Line
Warm Color next to Cool Color
Rough Texture next to Smooth Texture
Large Size next to Small Size
Triangular Shape next to Circular Shape
Vertical Direction next to Horizontal Direction

3. Make a list of twenty-five different descriptive words with their context and opposite such as:

——— CONTEXT ———
HOT - TEMPERATURE - COLD

Accomplish without duplication and without a guide to antonyms. I'm sure you'll sometimes think first of a descriptive word and its opposite, but occasionally the context will occur first. If you had any trouble discovering twenty-five......you're not trying.

*4. Spend ten minutes each day for one week listening to music - your choice - listen intently for contrasts of higher and lower pitch, loud and soft volume, and variations on a theme - a basic theme that is repeated with some **difference**. Spend five minutes, after each of the ten, in silence. Are you beginning to acquire a deeper understanding of contrast?*

5. Go for a walk....amazing as it may seem, if you subconsciously are searching for contrast in your environment, you'll probably be more successful if you forget about it and go for a walk.

6. On your "walk" I'm sure you've found some interesting contrasts. Store them in an old shoe box or coffee can with labels as to context, texture, color, value, etc. Re-examine them a few days later....find someone else to show them to. Talk about them using descriptive words... discover more contrasts that were overlooked.

7. Spend ten silent minutes studying the sky and where sky meets the earth. Discover and record the contrasts that occur. Tape record yourself describing these contrasts, or write it down.

**LIGHT
VS.
DARK**

**LIGHT
VS.
DARK
UP
VS.
DOWN**

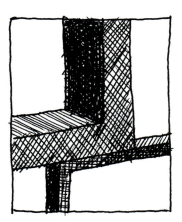

**BROAD
VS.
NARROW
VOLUME
VS.
FLAT**

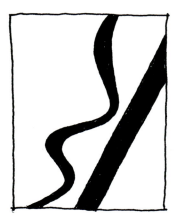

**CURVE
VS.
STRAIGHT
THICK
VS.
THIN**

SEE FOR YOURSELF

Transposing the contrast sensitizing procedures of physical performances, word puzzles and the eyes on/hands on collecting problem to the medium of watercolor is our consideration. Using the skills and knowledge you presently have, design and execute with watercolor simple diagram type examples of some of the contrasts, on your list, completed in the third procedure in the last section.

First, spend some time thinking about the problem - to transpose means to change the order of things by putting each in the other's place. Transposing our contrasts to watercolor requires asking the questions....***How is contrast like watercolor? How is watercolor like contrast?***

Discovering the similarities that exist between what you want to express, at each opposite, and the elements available for creating contrast, the particluar qualities of watercolor paint and its application may play a part in your considerations. What kind of shape would best express each opposite? What color or value would convey the character of the contrast? Would line elements adequately display the contrast? How could the sizes of the shapes or textures be used to focus the contrast? Perhaps utilizing directional symbols? Edge quality of shapes, would they be expressive? Of what?

You have twenty-five contrasts on your list, choose fifteen of them or add some new ones.....think! Create your contrast examples in 3" X 5" formats, label the contrasts on the back side. The viewer should be able to label the contrast by viewing your painted side only. The most desirable results should focus upon the context, i.e., line, value, weight, color, texture, etc. It is not necessary to put all the contrasts you can think of in each diagram. Many results may require just black paint. Use color when it will reinforce or clarify the contrast expressed. Integrate each 3"x5" diagram...make the presentation fit the space. Exhibit polar ends of the contrast.

Figure 8

**WEIGHT VS. WEIGHTLESS
VOLUME VS. FLAT
TRANSPARENT VS. OPAQUE
CIRCLE VS. RECTANGLE
VERTICAL VS. HORIZONTAL**

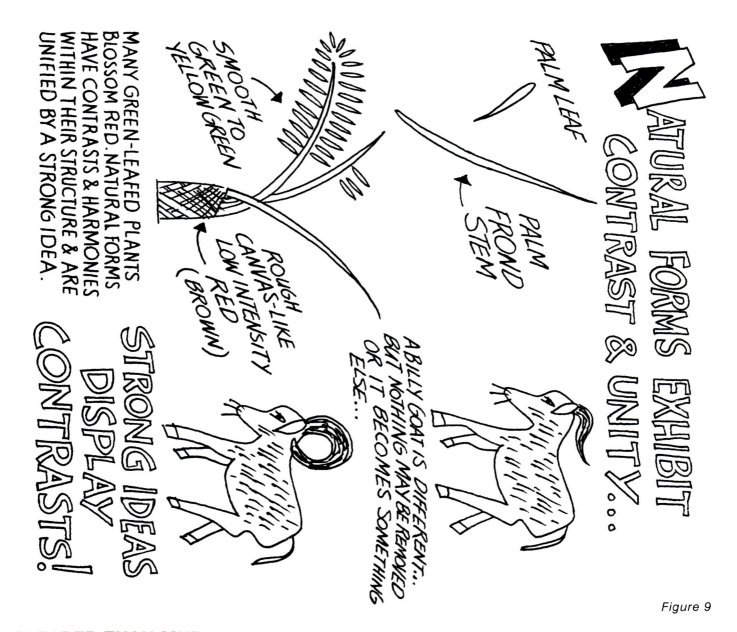

Figure 9

CLEARER THAN MUD

Earlier, painting was characterized as a task of creatively combining opposites, and you were made aware of the principle of contrast. Can you understand the basic contrast in *Figure 10* ?

Because of the contrast of dark against light and vice versa, the viewer reads basic shapes - rectangles, circles, triangles - abstract shapes - positive and negative shapes - and symbolic shapes that represent objects. There are other contrasting elements like thick vs. thin, small vs. large, round vs. square, representation vs. abstract shapes, etc....but the most energetic forces pitted against each other in *Figure 10,* are the forces of **dark and light.**

Understanding this very fundamental way to establish underlying form, you will understand what makes *Figure 10* **"work".** Although some of the picture image is representational and some geometric rectangles and circles, it **"works"** - the images are unified through the

alternation of black and white - the silly little buildings, fences, circles, rectangles, triangles, etc., are not the important experience in *Figure 10.* **Underlying form is important! Contrast is important!**

Expand upon this fundamental approach and think of all the other elements to use contrast with in a similar manner - lines; straight vs. curved, long vs. short - textures; rough vs. smooth -colors; red vs. green, blue vs. orange, yellow vs. violet - sizes; large vs. small - shapes; rectangles vs. circles vs. triangles - and directions; horizontal vs. vertical.

Conditions can be contrasted like; floating vs. stable - hard vs. soft - colorful vs. colorless - warm colors vs. cool colors - fluid vs. halting - falling down vs. spiraling up - real vs. unreal - geometric vs. amorphic - the list is almost endless - each visualized contrast prompts a painted result. **Begin thinking in terms of contrast - it's much clearer than mud!**

Figure 10

DO YOU UNDERSTAND THE BASIC CONTRAST EXHIBITED IN THIS EXAMPLE

OTHER STRATEGIES →

THE OTHER STRATEGIES

Harmony, balance, unity, dominance, repetition, alternation, and movement, the other design strategies, like contrast are formal methods for **organizing** a watercolor. Used primarily as a guide to the combining of elements, the design strategies also become convenient tools for judgement of work in various stages of completion. Watercolorists begin to use these strategies by discovering parallels in life and nature, then transforming these discoveries to visual terms.

The human need to **organize** vision is a result of survival - we must analzye and organize what we see or become a victim of it. We *compose* letters, *plan* a picnic, *form* a committee or *design* a garden. A too ordered life is dull and a life with no order is chaotic. **Organization** harmonizes our lives, providing meaning and pleasure.

Nature supplies a foundation for creative watercolor expression. Rather than imitating nature's appearance, we must investigate nature's various organizational systems. Anything in nature - plants, animals, etc. - that is unable to adapt to new environmental conditions will not survive....**form follows function!** How is your watercolor going to function? What do you want it to do? These are fundamental questions to be answered when employing a design strategy.

Organization is important as a universal visual language, able to communicate across many national, ethnic and social boundaries. All watercolorists consciously or subconsciously utilize design strategies to carry their ideas to the viewer. The fullest effects are accomplished through knowledge and practice. Recognizing the potential for using a design strategy when the need is presented, becomes the problem, and also the solution.

Many creative watercolorists are not satisfied with order created by others and endeavor to *invent* an order sometimes understood only by other creative minds. Designing a watercolor with any or all of these strategies will not guarantee results - these strategies become *vehicles for ideas* - if the idea or message is trite or cliche, no amount of organization will make a watercolor significant.

There is no such thing as a design law or rule with only one method of application. Their meaning and use are subject to individual interpretation. When the design strategies are used with an organic flexibility comparable to the life and nature from which they derive, a watercolor painting also takes on life and becomes meaningful. **Properly utilized, design serves to open new doors and regenerate rather than restrict.**

HARMONY-
THE OTHER SIDE OF CONTRAST

Harmony as a design strategy underscores a **similarity** between components of the elements chosen for use. Harmony is the **adaptation of parts** of a watercolor to one another. For example, if we wanted to harmonize the contrasting shapes of a circle and a triangle we could color one shape red and the other violet. Both shapes would now be similar - more harmonic - red, being half of violet, would be imposed upon each contrasting shape, making them more the same. Many characteristics could be made similar for more harmony, such as sameness of edge quality, sameness of texture, sameness of value, etc.

Harmony of function may be affected by picturing objects related to one another through usage, such as a knife and a potato. Disimilar objects, harmonized because they are *used* together.

Symbolic harmony is another type of harmony that appeals to the reasoning mind, employing symbolic associations like the American Flag, the Minuteman and George Washington as subject matter for one painting.

Harmony, being the opposite of contrast, provides an essential tool for moderating contrast. Harmony becomes a **leveling** agent that controls the **sharpening** action of contrast.

Beginning a painting using the design strategy of harmony may mean restricting the components of similar elements to impose *sameness* before painting. Similarity may be imposed upon any of the components found in line, value, texture, color, size, shape and direction. The possibilities are many.

Caution, the mind and eye require stimulation and surprise. Designing the components or elements with sameness risks monotony.

Harmonize these three shapes with two different components or elements.

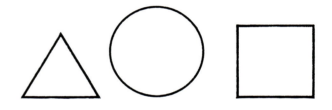

Figure 11

Creatively "sharpen" these three shapes.

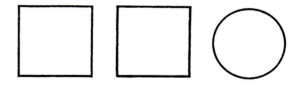

Figure 12

Creatively "level" these three shapes.

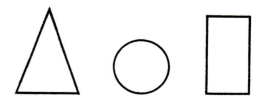

Figure 13

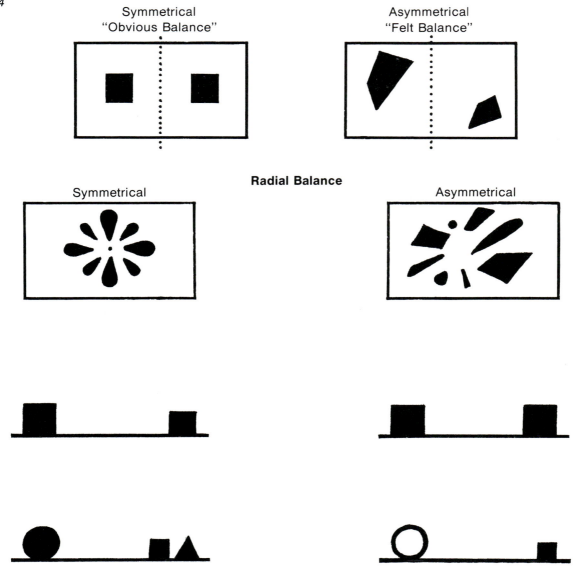

Figure 14

Symmetrical "Obvious Balance"

Asymmetrical "Felt Balance"

Radial Balance

Symmetrical

Asymmetrical

Place the △ triangle point as if the weights were on a balanced see-saw.

BALANCE,
PLAY JUGGLER, PLAY

Balance is *equality of equilibrium* in opposition of any kind. *The sense of balance* functions on a fundamental level within the human experience. Try standing on one leg for any length of time....disorientation occurs. Three types of balance furnish categories for further explanation.

Symmetrical balance is achieved when identical compositional units are placed on each side of a central axis. Symmetrical balance is formal or passive - perfect - one side mirrors the other. Symmetrical balance may be used for its calming effects in a painting that is particularly over active. Sometimes symmetrical balance is resorted to, merely because it is easy, nevertheless, many natural forms are symmetrical, including humans. The effects of symmetrical balance are stability and formality.

Asymmetrical balance occurs when compositional units are not identical but are placed on the sheet to create a "felt" equilibrium. Forms of different visual weight are counterbalanced by placement at unequal distances from a central axis. Asymmetrical balance is energetic, active and informal in appearance. Natural forms like trees, sea shells and rocks are principally asymmetrically balanced.

Watercolor paintings that are balanced in an *asymmetrical* or *"felt"* way, attract and vigorously hold our attention quicker than symmetrical balances.

Radial balance employs a central point instead of a central axis, and the important parts extended from a center, like spokes on a wheel, appearing usually with a sense of circular movement, it may be balanced secondarily in symmetrical or asymmetrical fashion.

The central axis or central point in each of these three kinds of balance need not be emphasized as part of painting unless desired.

Since we must deal with balance all of our lives, we respond naturally to its effects. Symmetrical balances are passive, and asymmetrical balances are energetic.

UNITY,
HAVING GOOD CONNECTIONS

Unity is the quality of **oneness.** Unity exists when the elements that fit into the whole become vital to it. Contrast adds variety, harmony supplements similarity and unity provides the orderly weaving, or **connecting of the parts.** A strong, clear idea or purpose almost guarantees unity. Natural forms like birds and fish have evolved over extraordinary periods of time resulting from strong purpose. Man-made objects such as modern aircraft, space craft and submarines have developed from **powerful ideas.** The directness of children's paintings frequently overcomes fragmentation or lack of subtlety, to become unified through strength of idea or purpose.

Isolating your watercolor from the rest of the world with a mat, produces unifying results by eliminating distractions. **Enclosure devices** within the painting format may produce a place for the viewer to look.

Using **fewer elements** in a watercolor painting may affect unity. If there is less to deal with for both artist and viewer, the ability to concentrate is enhanced.

Repeating elements, or making parts similar, coordinates, ties together, makes the parts *"belong".*

Suggesting that these few hints always result in success is not intended. You will need "something" to surround with any isolating device. Too few elements may result in not enough to hold a viewer's attention, and unthinking repetition becomes more chaos than unity.

No one kind of unity is greater than another, unity is a quality or state of being. Watercolor paintings that are unified are a product of forceful **oneness** that develops out of differences and vital interaction of elements used.

Figure 15

1. Unify or weave these shapes into *"oneness."* (use tracing paper)

2. Unify three more times, using three different reasons, i.e., arrange for idea, for balance felt, balance tension, common line, etc.

3. The opposite of unity is fragmentation. With a piece of tracing paper and a reproduction of a watercolor you like, fragment, or remove and isolate the parts just as if you disassembled a woven straw object.

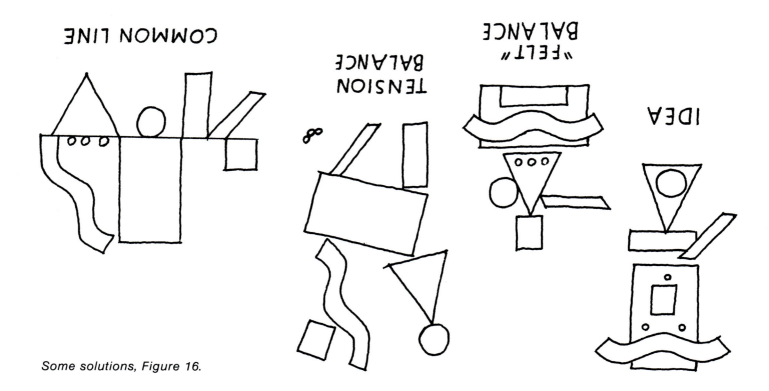

Some solutions, Figure 16.

DOMINANCE, ONE OR THE OTHER

Dominance seen as a design strategy involves choosing lesser and greater parts. **Dominance is emphasis or subordination.** Images or elements of similar size tend to compete for attention. Emphasizing one image or element eliminates competition through subordination. Emphasis is effective action among all the elements of line, value, texture, color, size, shape, and direction. Dominance, or emphasis may be asserted in many ways. Mainly the strategy has to do with amount - size, number of - or position - where it is located on the sheet.

One line will be seen as dominant over another if it is longer or thicker in size, or warmer - more red - in color. A line that is centrally located will attract more attention than one in the outer margin areas of the sheet.

Watercolor paintings that are surprising or unexpectedly different, among other watercolor paintings, may be seen as emphasized. Any component used to underscore an image, or element may become a tool for dominance.

Subordination - creating lesser elements - is the flipside of dominance. Forms that are smaller in size or number, cooler in color - more blue - and positioned nearer the edge of the sheet will force the viewer to concentrate on the more dominant elements. Limiting the number of elements may also render unity by subordination.

Dominance is capable of serving either or both strategies of unity and conflict. Some watercolor paintings are not designed with dominance as a factor. These compositions may demand and retain our attention, with the unity found in the constant tension of equality. *Caution, the risks are that disorientation may result. See Plate 12 for equally compelling images within one watercolor painting, where disorientation is precisely what is desired.*

1. Resolve the conflict present in these groupings through dominance/emphasis.

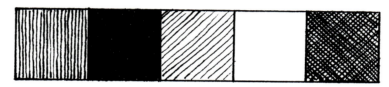

Figure 17

2. Add three figures to each original figure group to result in subordination of the original figure in two different ways.

Figure 18

3. Disorient yourself!

Figure 19

REPETITION,
DO IT ONE MORE TIME

Repetition means to repeat - to paint a given element or image again. **Any line, value, texture, color, size, shape or direction may be repeated, at any place on the sheet.** Comforting rhythmic effects are the result of repetition. Arresting our attention with insistence,, repetition invites pause for examination.

Repetition is basic to the nature of our existence, human heartbeat, sunset and sunrise daily, etc.

Fundamental to the human mind is the desire to group similar elements - not too many of us desire placing round pegs into square holes. We search for repetition and are supported mentally when we discover it.;

Composing watercolor paintings, two types of repetition are at our disposal, **exact repetition**, which is formal or static, and **repetition with variety**, which is informal and dynamic.

Repetition may reinforce unity through creating dominance. Repetition may create movement - owing to the positions of the repeated element. The eye systematically will follow their paths. See also *"Armatures" Page 74.*

Repeated configurations are also fundamental to the time arts of music, dance, and poetry, however, the time element in these other art forms has the opportunity to extend and control with more precision. A watercolor may be viewed sequentially or simultaneously. Music, dance and poetry always **unfold** to the senses. Many painters use the words "echo" or "rhyme" to express the essence of painted repeats. All forms of music, including classical, pop and rock, develops primarily from recurring pattern.

Improperly used repetition will go unnoticed or become irritating. A clock ticking soon falls from the ear into the environment, unheard. Conversely, a dripping faucet may rapidly become an irritation. The effects of repetition depend on what is repeated and how the reappearance is executed.

The following procedures were designed to offer support to your comprehension of repetition as a design strategy:

1. Repeat the following figure at least two additional times to affect exact repetition.

Figure 20

Figure 21

2. Repeat the following figure at least three additional times to affect repetition with variety. (similar rather than exact repeat)

Figure 22

3. Using repetiton with variety, create your own figure and repeat it three times to form "triangulation." A rhythm will occur within the excursion the eye must take, make it an interesting trip - different measures between repeats.

ALTERNATION, THE BEAT, BEAT, BEAT OF THE TOM TOM

Alternation is another strategy of design that is capable of producing *rhythm.* For the watercolorist, alternation may be defined as exchange, for elements to act by turns, or repeated interelated sequence. *A regular exchange of properties within any design element or image will cause alternation.*

Straight, curved, straight, curved, etc.
Dark, light, dark, light, dark, light
Vertical, oblique, etc.
Large, small, etc.
Round, square, etc.
Vertical, horizontal, etc.

With images, it could be doors, open, closed, open, closed, etc.

Episodic paintings are the opposite of alternated paintings..............an episodic watercolor, *Figure 26,* develops no regular exchange, rather expresses a loose connection by strengthening aspects of the parts without loss of meaning to the whole.

Alternation is similar to an abstract checker board, able to create and *control rhythm.*

Figure 23

Alternation Regular Sequence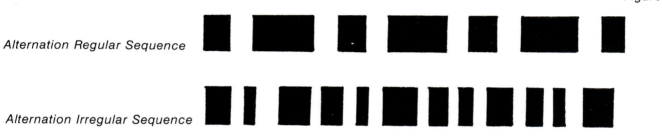

Alternation Irregular Sequence

1. With simple black and white value, produce alternation on these shapes.

Figure 24

2. Create an alternating rhythm with these windows.

Figure 25

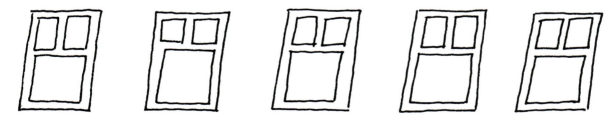

3. From the great outdoors, find three natural forms that display alternation.

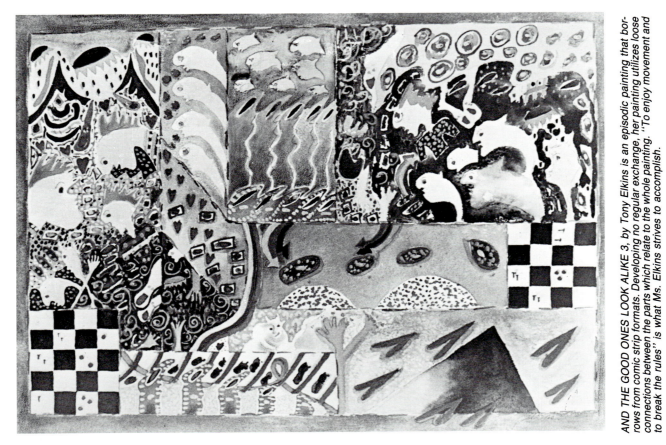

Figure 26

AND THE GOOD ONES LOOK ALIKE 3, by Tony Elkins is an episodic painting that borrows from comic strip formats. Developing no regular exchange, her painting utilizes loose connections between the parts which relate to the whole painting. "To enjoy movement and to break the rules" is what Ms. Elkins strives to accomplish.

MOVEMENT,
GROOVIN' WITH MOVIN'

Movement does not physically occur on a painted watercolor surface. Because its parts do not move, any animation in a watercolor painting must be a product of an *illusion* created by the artist. Implied movement and expressed movement result through placement and configuration of the elements or images. Movement is experienced completely, as a condition of our lives as human beings - almost everything we see moves - **we move.** What watercolorists label as *"movement"* is acquired from this experience and transformed onto the static two dimensional watercolor surface by utilizing elements that *"feel"* like they are moving or *"appear"* to be moving. A simple slanted, - oblique - line *"moves"* more than a simple vertical or horizonal line.

Gradation, the gradual transition possible within any of the compositional elements, quickens the pulse - *"moves."* Gradation may be found readily in natural forms. The taper from thick cylindrical to thin cylindrical in every tree branch is an obvious example. The measured passing of time from wax to wane of the moon, ebb and flow of tides, the seasons, the flowing pattern from birth to death, all illustrate nature's **movement.**

Arrows or arrow-like directional shapes produce readable movement. The eye will obligingly follow **"tracks"** much like a dotted line. **Overlapping shapes** result in movement into space as do **linear perspective** convergences. Warm colors move toward the eye while cool colors recede. Repetition produces its own kind of **movement.**

Our culture reads from left to right, nevertheless, the watercolor painter may use a variety of directional flows or movements that defy the enter left top, exit right bottom reading. Scientists fail to agree on a universal scanning pattern, but do agree on a general preference for the bottom left area of a horizontal rectangle.

The art form of film - motion pictures - trades heavily upon its uniqueness to produce movement. Closer examination proves that the individual pictures are motionless. The illusion occurs in the technique of blending, grading them together by a holdover factor known as *"persistence"* of vision.

Movement in painting may reinforce the idea that all areas of the painted surface should be utilized, having no *"dead spots."* Creatively directing compositional elements toward each other so the viewer is unknowingly carried along self-renewing paths.

Passage, a word used to explain the lost and found edges commonly used by impressionist painters is in fact, clever usage of the device of **movement.** The eye is persuaded to *"move"* from shape to shape by way of lost and found edges.Passage, since it is *"implied movement,"* may be a method of thinking of and applying the illusion to any of the compositional elements. *See also Composing Sub-Structures, Page 73.*

The sense of movement in a watercolor painting is created by the artist, mainly to satisfy the need to connect the various parts in a rhythmic sequence.

GRADATION SEQUENCES (POLAR)

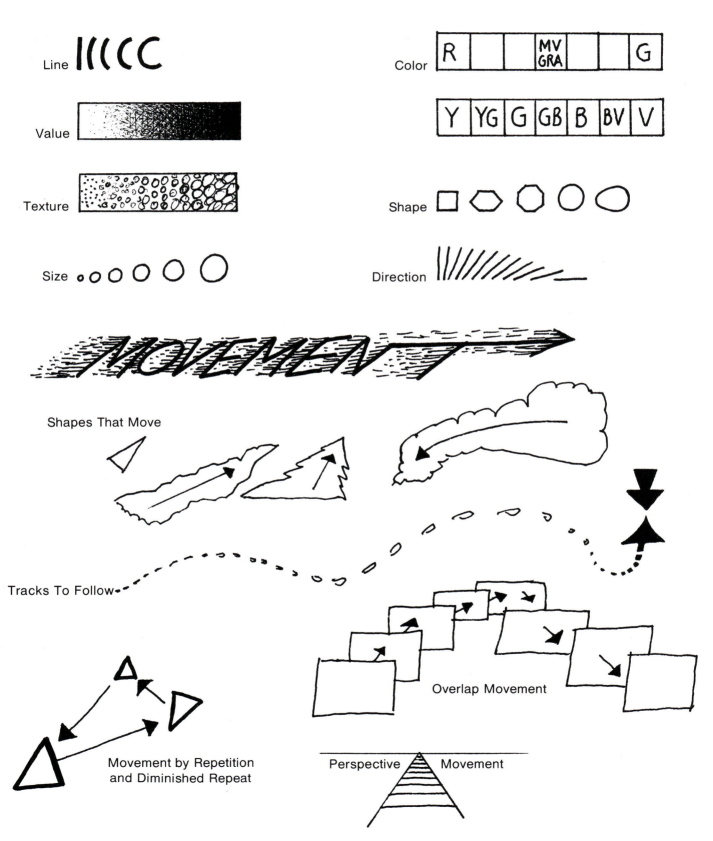

Line

Value

Texture

Size

Color

R			MV GRA			G

Y	YG	G	GB	B	BV	V

Shape

Direction

MOVEMENT

Shapes That Move

Tracks To Follow

Movement by Repetition
and Diminished Repeat

Overlap Movement

Perspective Movement

WHAT TO CONTRAST?
IT'S ELEMENTAL WATSON!

As human beings, how we move, stand and deal with balance; the meanings we attach to light, dark and color; how and why we survive; influenced by individual experience, frame of mind, expectations of our culture and environment, all effectively modify our understanding of visual information. Language is often compared to painting in hopes of discovering usable relationships for understanding. *Correlating the art form of painting to language is futile.*

Languages are man-made systems devised to cipher, store, decipher or communicate ideas, thoughts, and information. Languages are constructed with a logic that is too restrictive for the complexities of the visual sense. As painters we do have guidelines, there are basic elements that can be learned and understood by artists and non-artists alike. Clearer understanding of all visual messages and paintings in particular may rely upon these elements. **Line; value; texture; color; size; shape; direction; these are the component building blocks for painting.**

LINE = MEASURE

Line is an *abstract, graphic tool,* invented by mankind to function as a stand-in, or symbol for representing the volumes presented by nature. The utter simplicity and directness of line makes it a dynamically versatile element that defies complete analysis.

Objectively, line may be **measurement**, by comparing lengths or widths, *Figure 27.* There are only two types of lines, straight- actively continuing in one direction; or curved - actively continuing through gradual changes of direction, *Figure 28.* Straight lines suggest unyielding rigidity, hardness and precision. Crooked, zigzag straight lines create an irregular, jerky rhythm, *Figure 29.* Conversely, slightly curved lines are passive, fluid and sumptuous. More certainly curved lines are active and dynamic by comparison, *Figure 30.* When lines meet or intersect, definite shapes and planes are described, *Figure 31.*

Subjectively, line has the potential to suggest a wide variety of *emotional responses.* Letters of the alphabet are line symbols used by man as basic communication, likewise watercolorists use line, however, with more varied characteristics, *Figure 32.*

Lines create *textures and values* through repetition, *Figure 33.* Formed with ruler and compass, lines have a precise, formal appearance. Written - calligraphic - line is informal, *Figure 34.*

Lines are either straight or curved, long or short, broad or narrow; may convey directional elements, describe, and generally serve to unify or divide the painted surface, all with a large potential for emotional expression.

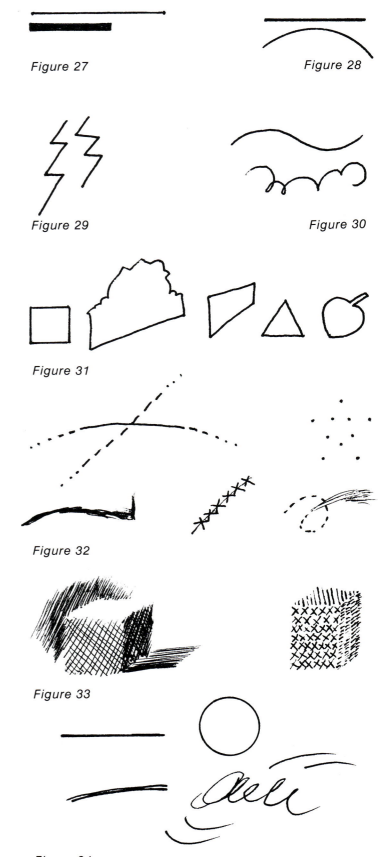

Figure 27

Figure 28

Figure 29

Figure 30

Figure 31

Figure 32

Figure 33

Figure 34

Fill an 11" x 15" quarter sheet of watercolor paper with lines produced with watercolor. Use your imagination to order or present variety (contrast) within a unified concept.

VALUE OR TONE = WEIGHT

Value defines the relation of one section or detail in a painting to another, with respect to *lightness* - white paper or pigment - and *darkness* - the blackest pigment, and all the graduated levels of gray in between. For the watercolorist, the light/dark contrast is not only a fundamental compositional method, but also a most expressive element.,

Human vision occurs because of the relative presence of light. Whether by sun, moon, or artificially, light is not dispersed on the environment in a regular manner. Light is reflected from some surfaces and absorbed by others. Light goes around objects, and falls on objects which are comparatively dark or light. Color reinforces and enhances vision, but variation of light and dark value is the most important factor to human vision. We see a light shape because it's next to a darker shape, and vice versa, *Figure 35.* We immediately accept the black and white images of photographs, T.V., newspapers, films, etc., as representations of our world which, ironically, never appear to us in tones of black, white and gray.

Nature presents to us a world of tonal value range impossible to duplicate with the value limits of paint and paper. *A ten tone scale and knowledgeable placement greatly expands the possibility for value variation.* Simultaneous contrast magically changes middle value gray and the value it is placed on. A fluted effect also appears on the value scale itself, *Figure 36.*

Value may be organized through various methods, primarily dictated by the choice of value patterning.

Chiaroscuro, *Figure 37* creates the illusion of objects existing in depth through careful manipulations of value. Volume is reported in terms of subtle gradations that imitate appearances.

Flat Pattern, *Figure 38,* displays poster-like shapes, where the changes of dark and light seem to happen only on the surface of the paper. Volume is reported in terms of flat shapes that are true to the two dimensional surface.

The events of the mid-nineteenth century brought a subtle departure from illusionistic value patterning. Western artists began to interpret Near Eastern and Far Eastern painting, resulting in flat shapes that interpreted three dimensional objects. With contemporary photo realist painting, a full cycle is being completed. Artists are again using a type of Chiaroscuro, distilled from photography, to describe volumes.

Representational methods derive their descriptive facilities from the different value patterns produced by variations in the direction of light source. See section five, *"It's a Tonal Valued World."*

Expressive use of value is a consequence of the amounts of dark, light, and middle values employed in a painting. Compare the value plans in *Figure 39.* Paintings that rely on a dominantly dark scheme express mystery, drama, and a sense of menace, while examples with light values dominating produce the opposite effect of exuberance and gaiety. Value schemes which exhibit no strong contrast between lightest light and darkest dark, are as subtle as gypsy music.

Value affects the **spatial positions** of shapes - on a black field, a white shape advances - on a white field, a black shape advances - on a middle value field, white and black alternately advance and recede. Equality of value rhythm creates a pulsating surface, *Figure 40.*

Value as an abstract element should be thought of as being **weight** *and dark is heavy.*

Contemporary watercolorists revere value as a dynamic, organic element, able to reinforce two dimensional organizations through emphasis, value patterning, expressive mood and spatial oneness.

The temperament of the artist determines whether value is used purely as a tool for rendering retinal description of light and shade, adopted as a highly sensitive tool of expression, or employed as structural form.

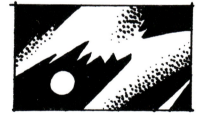

Figure 35

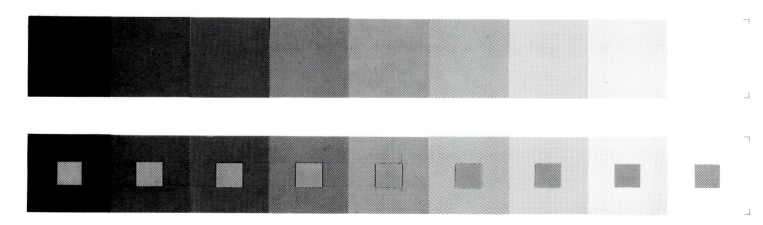

Figure 36

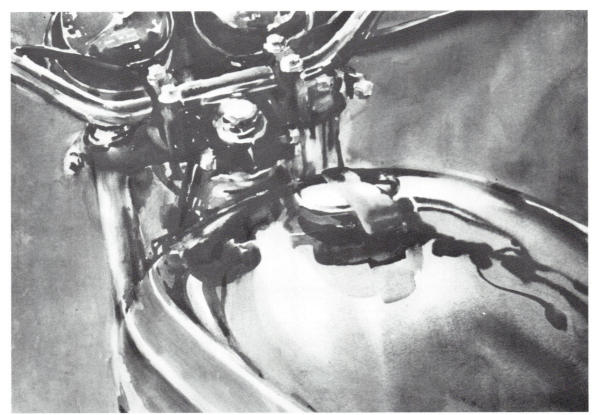

CHIAROSCURO *PHIL'S BIKE, 21"x29" transparent watercolor* *Figure 37*

FLAT PATTERN *Figure 38*

LIGHT MAJOR PLAN **MIDDLE MAJOR PLAN** **DARK MAJOR PLAN**

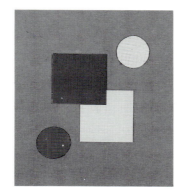
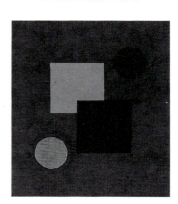

Figure 39

LIGHT MINOR PLAN **MIDDLE MINOR PLAN** **DARK MINOR PLAN**

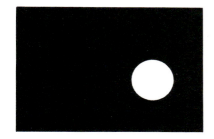

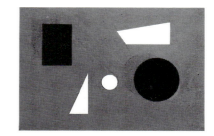

Figure 40

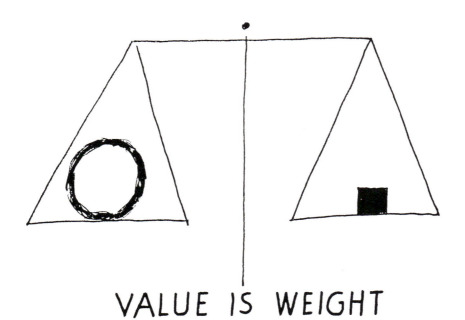

Figure 41

VALUE IS WEIGHT

1. *Create your own value scale by cutting many one inch squares various gray values from magazine or newspaper photos. The object being, to form an orderly eight or ten step graded scale. When you have found an evenly stepped grouping, glue them to a piece of paper with no space between each step.*

2. *Choose a color reproduction of a watercolor you like. Using only the three values of black, white and middle gray, create the general value pattern with watercolor on paper.*

3. *Render one simple object with just black watercolor, as faithfully as you are able. Careful observation of related values and shapes will be necessary.*

4. *On a rectangle 7 ½" x 11" arrange seven smaller rectangles various sizes - with black watercolor choose a background value and paint values on the seven rectangles to create a balanced spatial effect.*

TEXTURE = TOUCHING

Texture as a visual element combines the sensory processes of sight and touch. Humans begin storing information dealing with the experience of touching at birth. Painters utilize this sight and touch association to enrich pictorial areas, to control pattern, to inspire tactile responses, to describe objects, and enhance spatial information.

Employing **actual texture** involves including touchable materials as an integral part of the surface by collage, or with certain mediums, significant build-up of pigment, *Figures 42-43.*

Imitated textures require precise rendering of the dark/light and color patterns produced by surface characteristics *Figures 44-45.*

Invented textures result from the artist's need for suitable surface embellishment. Often having its source in nature, the sense of touch may be interpreted by calligraphic brush strokes, *Figure 50*, or by manipulating the accidental quality of the paint itself. Watercolor, a very flexible medium, offers the peculiarities of wet and dry states, involving the techniques of stamping, scoring, scraping, spraying, blotting, etc., while wet; and stenciling, lifting, sanding, scratching, etc., when dry, *Figures 46-47.*

Examples of textural contrast are rough/smooth, soft/hard, shiny/dull, etc. *Smooth textures* are essentially less demanding. *Rough textures* activate surfaces and tend to subordinate form and color. Informal by comparison, rough textures express stimulating irregularity.

Distinct, detailed or large textures approach the eye, while blurred, indistinct, or small textures retreat, *Figure 48*

Pattern becomes texture whenever similar units are repeated so as to obscure individual units, *Figure 49.*

Serving primarily to enrich or enhance, texture is an element of lesser importance. Choosing to use texture, the final effect in painting is always a consequence of relationships.

Figure 42

Figure 43

ACTUAL TEXTURES

Figure 44

Figure 45

IMITATED TEXTURES

TEXTURES IN WET PAINT

Alcohol

India Ink

Salt

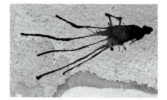

Airbrush Blow-Away

Scratch

Figure 46

Tissue Blot

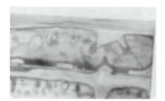

Vinyl Imprint

Candy Box Paper Stamp

TEXTURES ON DRY PAPER

**Crayon Resist
Masking Tapes**

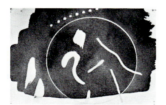

**Masking Agent
with Ruling Pen**

Cardboard Stamp

Sandpaper

Airbrush Trench

Figure 47

**Rewet Lift
Stencil Lift**

**Water Soluble
Pens or Pencils**

Finger Painting

Figure 48

Figure 49

Figure 50

1. Discover and collect examples of actual texture. Emphasizing one of the design strategies, collage your actual textures to a 7 ½" x 11" card.

2. As faithfully as you are able, represent these textures with paint on 7 ½" x 11" support.

3. Interpret these textures on another 7 ½" x 11" sheet with calligraphic brush strokes or any device you wish that will create textures.

4. Fill a 7 ½" x 11" sheet with shapes having little or no obvious texture.

BLACK

Figure 51

Stare at the center triangle of the letter A for I I/2 minutes then cover the entire word with a white piece of paper.

COLOR = SUCCESSIVE, SIMULTANEITY FOR SEVEN

Color is the result of vision responding to light wavelengths reflected from a surface. The color of light behaves differently than the color of pigment. For the painter, colored pigments are capable of separating shapes toward the varied goals of spatial effects, emphasizing components and describing objects. *Color may also act independently of shape to symbolize ideas, create mood, express emotions and aid aesthetic organization.*

We live in a richly colored universe. Color is everywhere! Value or tonal difference provides visual information necessary to survival, but color is also loaded with information.

As an element of composition, color is closely related to human *emotions*. Having universal appreciation, color appeals instantly. We are helpless in responding; blood pressure, pulse, muscles and nervous system are all affected. Associations of memory and symbolism with color uniquely surpass the elements of line, value, texture and shape in the potential for affecting physiological reactions.

Gasoline stored in white tanks evaporates one-third less than storage in red tanks. Race horses "cool down" twice as rapidly in pale green stalls as in red-orange stalls. Likewise, pale green shipping crates seem to weigh less than black crates. In Cuenca, Spain, townspeople paint window borders blue, to discourage insects from entering, and night insects dislike yellow orange light, etc.

Diversity is both the advantage and disadvantage of color. An ultimate method for relating hues to each other does not exist. Intuitiveness is superior to any plan guiding the painter through the irrationalities of color relation. However, objective color construction may become the vehicle to transport the artist to the *threshold* of intuitiveness. *"Feeling" a color is "right"* becomes the intuitive state.

Every color has three dimensions that can be identified and measured. **Hue** identifies the color itself. Yellow, red and blue are the primary colors. Their individual characteristics are unique and unobtainable through color mixing. The secondary hues of orange, green and violet result from mixtures of the primary colors. Color structure is most easily understood using a color sphere. The color wheel, *Figure 52*, indicates the view from above, of an equatorial cross section of the sphere.

Intensity, the second measurable dimension of color, is defined by relative purity. True primary, secondary and tertiary colors are intense colors. Additions to any pure, intense color of its complement, black, white, or water itself will alter its intensity toward neutrality.

Value is the measure of any color in relation to the graduated scale of values between dark and light. *The presence or absence of color does not alter value, value is constant.* Comparing a black and white photo with a color photo of the same subject, or tuning out the color on your TV set will prove that tonal value is unaffected. Color and value do not change each other, they co-exist in every color.

Constant comparison is the prodecure for developing the sensibility necessary for accurately judging these three properties.

The sensory mechanism of the human eye is finely balanced. Equilibrium is so desireable, that the mechanism will produce a synthetic balance. *Afterimage* is the visual phenomenon that results from the human eye having been fixed on an example of any color for a duration of about two minutes. When the color example being stared at is replaced by a blank, neutral or white background, a negative image is seen on the blank field in the complementary color of the original example. Most adults have seen the optical exercise picturing the American flag in its opposite colors; orange field, black stars, and alternating green and black stripes. Focusing on this flag longer than the eye wants to, then immediately viewing a blank piece of paper will produce an afterimage of the flag in its proper coloration. All colors and black and white will produce afterimages in opposing coloration and value. Test *Figure 51*, and see black turn to white.

PAINT THE COLOR WHEEL
FIND THE PUREST TUBE COLORS TO PAINT THE OUTER RING INNER RINGS ARE OBTAINED BY GRADUATED INTERMIXING OF COMPLEMENTARIES—FORMING AN INTENSITY SCALE.

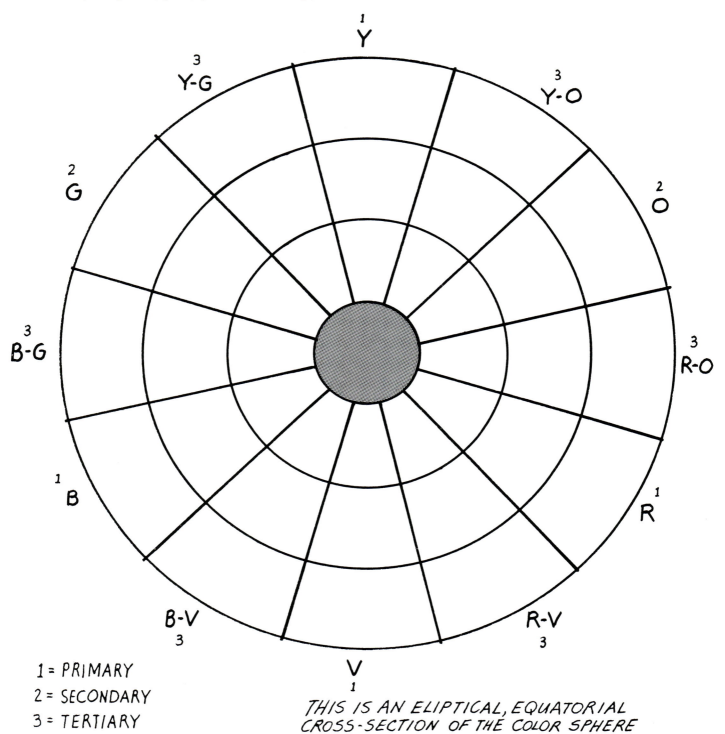

1 = PRIMARY
2 = SECONDARY
3 = TERTIARY

THIS IS AN ELIPTICAL, EQUATORIAL CROSS-SECTION OF THE COLOR SPHERE

Figure 52

THE COLOR WHEEL is an eliptical, equatorial view of the larger idea of the COLOR SPHERE. Figure 54 graphically explains how to ''read'' the COLOR SPHERE.

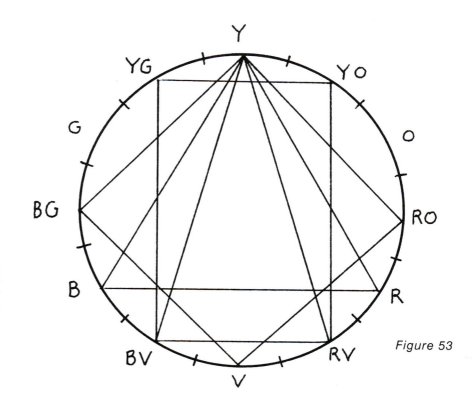

Figure 53

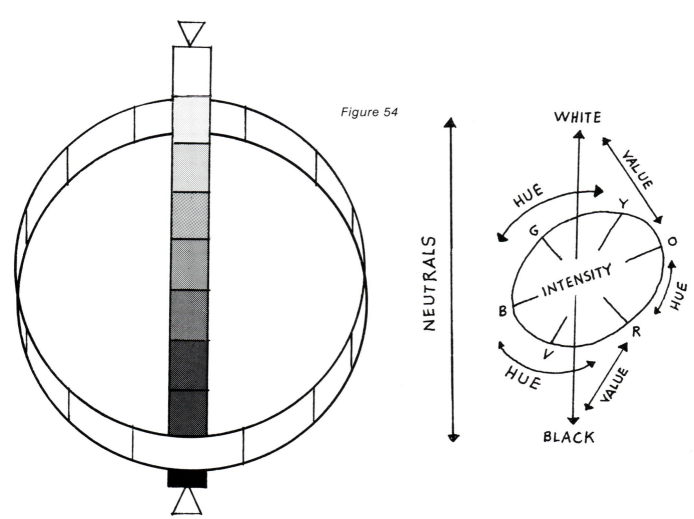

Figure 54

Afterimage, sometimes called successive contrast, is peculiar to human perception and cannot be photographed.

The phenomenon of afterimage dramatically demonstrates the need for, and search, for balance by the human entity. Every force in the human physical and psychological makeup is geared for survival, equilibrium is also the favored circumstance in the visual context.

Color harmony truly exists in the "eye"

Balance equals harmony. Any combination of colors that yield neutral gray when mixed together may be seen as harmonious. Harmony equals balance - visual color organization. Many beginning and intermediate level painters assume that harmony is the only goal for color. Instead, color may be more fully realized when serving to support or enhance what is expressed.

Constructed color schemes produce balance and harmony. Any triad of colors forming an equilateral or isosceles triangle upon the twelve hue color wheel and all tetrads forming squares or rectangles are logically harmonious, *Figure 53.*

All meaning exists within the idea of total opposites

When contrasts or oppositions reach the extreme effect they are considered polar, diametrically opposed, or at points of reversal. Our investigation will reveal these polarities among seven significantly different oppositions within the element of color.

Color is acutely relative - color offers more opportunity for comparison than any other element - consequently, an annoying quality of overlapping occurs when explaining the seven contrasts. Concentrate upon grasping each opposition individually, disregard the incidental overlapping. A foundation for color construction may be formed by understanding these seven oppositions:

Opposition of Hue
Opposition of Light and Dark
Opposition of Intensity
Complimentary Opposition
Simultaneous Opposition
Opposition of Cold and Warm
Opposition of Amounts

YELLOW, RED AND BLUE WILL DO!

Pure yellow, red and blue offer the strongest opposition of **hue.** The effect is always energetic and direct. The dynamics of the opposition of hue are diminished as the hues used are removed from the primary colors. Green, orange and violet, the secondary colors, are slightly weaker in character by comparison. Yellow-orange, red-orange, red-violet, blue-violet, blue-green and yellow-green, the tertiary colors, are much less distinctive.

Placing pure hues in close proximity to either white or black produces noticeable changes. Black intensifies the luminosity or pure hue and makes the pure hue appear lighter in value. White, to the contrary, weakens luminosity and darkens the value of pure hues, *Figure 55.*

Using opposition of hue in the broadest sense, the color assigned to a shape is a fundamental method of rendering that shape visible.

Yellow embodies light and warmth, red is a provoking, active color, blue is passive. Yellow and red expand, blue contracts. The opposition of hue involves the inter-relationship of primitive forces. Intense primary and secondary colors are endowed with universal magnificence and concrete existence. Black, white and gray become powerful elements when composing with contrast of hue.

Folk art, embroidery, costumes, pottery and stained glass utilize the contrast of hue. The formal paintings of Mondrian, and various painters of the Blue Rider Group offer excellent examples of color construction based upon opposition of hue. *See Plate 25.*

DARK AND LIGHT AND ALL POINTS BETWEEN

Opposition of Light and Dark - Black vs. White -

Every color has a tonal equivalent on the graduated gray scale, *Figure 36.* The value of the color assigned to a shape is another basic method for making a shape visible. Conversely, to join or bracket shapes of different colors, use value sameness. *The sensibility necessary to extinguish light and dark tonal differences between colors is invaluable.* Altering the value of a color to a lower value requires an admixture of complementary color or black.

Raising the value of any color requires admixtures of white with opaque pigments, or simply more water if working transparently.

Pure colors reveal a value range easily used for comparison; yellow is a light, high value; orange is medium high, red and green are middle values; blue is middle low, and violet is a dark, low value.

Compositions constructed in oppositions of dark and light are commonly arranged in two, three or four value groupings, i.e., having two, three or four planes. Each plane may have unimportant tonal differences within itself, however, not enough to destroy the idea of the designated value of the plane. Connecting color to a value sketch, which is a plan for value placement is a widely used method for achieving illustrative pictorial effects. With a black and white sketch, literally any color will function, provided its value matches the sketch. Designing light and dark into generalized planes or groups and the ability to produce hues that match these groupings is imperative to the illustrative pictorial effect, *Figure 57.* The works of Homer and Sargent are examples of this concept.

Value planes or value groupings function well when designing more abstract paintings, *Figure 58.* Constructing color by organizing values is more objective and intellectual, appealing less to the emotions.

The eye responds to dark and light contrast first and foremost. Value grouping depends upon this factor, however, most of the next contrasts will depend upon *similarity* of value to function. *When we offer no value contrasts the eye must compare colors. See Plate 25.*

 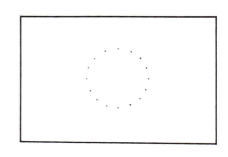

PAINT EACH CIRCLE PURE YELLOW

USE PURE RED

 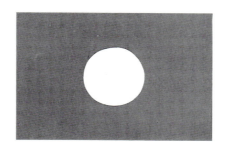 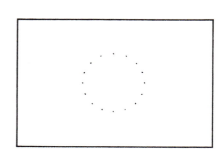

USE PURE BLUE

YELLOW - 3 PARTS

MIDDLE VALUE **NEUTRAL GRAY**

BLUE - 8 PARTS **5 PARTS - RED**

Figure 55

Figure 56

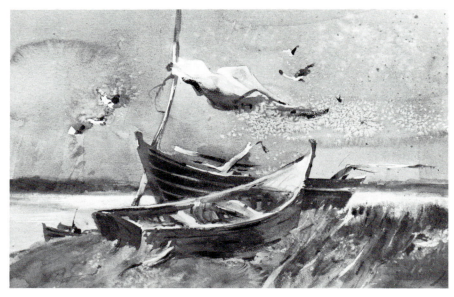

Figure 57

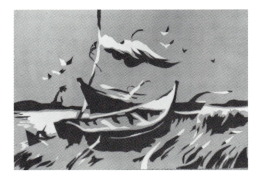

Value Grouping/Planes

Illustrative - Pictorial 14 X 21 Three Boats

Abstract - Night On The Beach, 22 X 30, Eleanor Clarke

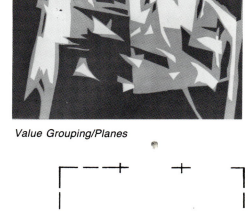

Value Grouping/Planes

YEL RED BLU

RED YEL BLU

BLU RED YEL

**IN EACH LEFT-HAND STRIPE, PAINT AN INTENSE EXAMPLE OF THE DESIG-
NATED PRIMARY COLOR. IN EACH SET MATCH THE TWO REMAINING
PRIMARIES TO THE VALUE OF THE LEFT-HAND STRIPE - THE RESULT
SHOULD DISPLAY ALL PRIMARIES MATCHED TO THREE DIFFERENT VALUE
LEVELS**

Figure 59

Florida Watercolor Society

"My students always ask me how I get my ideas for paintings," Anne Abgott says. "Here's how this painting came about: One day standing at my sink I saw the little dish that I keep my scrubbers in and Mexican peppers came to mind." Taking the peppers, some varied containers and cloths, Abgott headed to her studio. "I set up several still lifes using different compositions and angles while waiting for the sun to change the shadows and make them interesting," she explains. Abgott shot several photos and eventually used them for a series of paintings which includes *Mexican Splash* (at right).

Abgott doesn't spend a great deal of time thinking about the interpretations or hidden meanings in her paintings; her approach to her work is direct and uncomplicated: "I paint what I see and try to present it with good craftsmanship and technique."

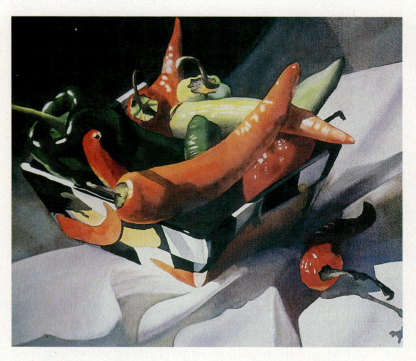

Florida Watercolor Society: Mexican Splash *(watercolor on paper, 30 x 30)* by Anne Abgott

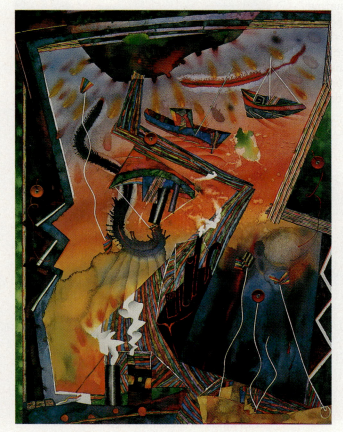

Watercolor Art Society—Houston: Nite Trawler *(watercolor on paper, 30 x 22) by Miles Batt*

Watercolor Art Society—Houston

Miles Batt's *Nite Trawler* (at left) began as a workshop demonstration 12 years ago. "I started by laying down a series of visually tantalizing washes," he says. "Boats and docks, common to the area of Port Everglades, Florida, provided the subject matter. The time constraints of a demo situation, however, allowed for little more than a casual placement of various size pieces of masking tape to save whites."

Frustrated by the nebulous beginning, Batt, upon returning home, threw the painting in a drawer where it languished for years. Only recently did the artist rediscover the painting and set out to finish it. The process took several days, but not for naught. "When an idea, not necessarily a clear-cut idea, builds slowly to where discovery and invention collide, to where content and form are married, that, for me, is the most exciting and rewarding part of every painting."

Northern Plains Watercolor Society: Silently Alert—Uncharted Territory *(watercolor on board, 13 x 21) by Kathy Sigle*

Northern Plains Watercolor Society

"I grew up on a farm in the western United States raising animals, tending the garden and harvesting crops. There's a desire deep in my soul to keep this lifestyle from dying," says Kathy Sigle. Her painting, *Silently Alert—Uncharted Territory* (at left) is a continuation of her love for western themes. Adventurers like Lewis and Clark, whose voyage inspired this painting, are an important part of the western way of life, she says. "There's a dream and desire in the cowboy, Native American and mountain man, to pass on their values and ways of life to future generations, and I like to think paintings like *Silently Alert—Uncharted Territory* support that effort."

Western Federation of Watercolor Societies

The experience of painting people is one that motivates many artists to keep working and experimenting. This is undoubtedly true for Jay Johansen who feels that people move him in a way that others things cannot. *Matriarch* (at right) began quite simply: Johansen was walking down a San Francisco street and the subject of this painting was walking as well, on her way to the library. "This woman was beautiful," Johansen says. "And her face represented to me the entire history of black America. Beauty in America is defined by perfect symmetry, but as you get older you tend to lose your symmetry, and this can be even more amazing."

Johansen regularly enters watercolor society shows out of a sheer desire to compete. "As artists we must compete in one way or another in order to measure our progress," he says. "I like to see how I compare with the best artists out there. It also gives me affirmation as well as motivation. It tells me that I'm OK. It also tells me that what I'm doing is worthwhile. My work right now is who I am; this is what I am. I spend countless hours doing it—this is why I get up in the morning."

Western Federation of Watercolor Societies: *Matriarch (watercolor on paper, 25 x 21) by Jay Johansen*

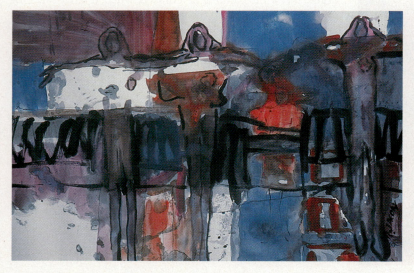

Utah Watercolor Society: Three Sisters *(watercolor and ink on museum board, 31¼ x 23) by Rebecca Jacoby*

Utah Watercolor Society

"*Three Sisters* (at left) strives to say something about unbinding an emotional burden," says Rebecca Jacoby. Each sister figure is an alter ego that holds the power to control, but each is connected, hand-in-hand. After completing the painting, Jacoby noticed a deep red area between two of the figures that was calling out to be defined. "I waited for about a week and finally decided that this color shape defined a fourth figure that was there for a reason." She painted enough detail to form the image of a female guardian who is settled into the background. "This last figure existed all along really, but it was easier to distinguish her when I realized that the painting needed a tie to express how history affects the preservation of society and self."

IMPURE VIRTUES = COLOR TO BLACK/WHITE

The contrast of *intensity* compares the relative *purity* of colors. The effects of opposing intensities are more pronounced when the value between compared colors is similar.

Effects that endow intense colors with heightened intensity occur when colors are restricted to a given color family; i.e., dull red intensifies pure red, gray blue intensifies pure blue, etc.

Colors may be altered to become less pure through admixtures of black. Moving towards black these new colors are called *"shades."* Admixtures of complementary colors will aso produce *"shades."*

Additions of water when using transparent media - white, if working opaquely - will produce new colors called *"tints."* Pink is a **"tint"** of red, while maroon is a **"shade"** of red.

Utilizing the opposition of intensity to structure color in a painting might involve restricting the palette to one or two intense colors and the tints and shades obtainable through admixtures.The effect can be subdued and restful. Another color construction might display shapes of various intense colors compared with shades or tints of the same varied colors, *Plate 4. See Plate 25.*

The Color wheel, *Figure 52,* provides shapes for complementary to mid-value gray to complementary. Fill them in with your estimated color. Even graduations should be your goal.

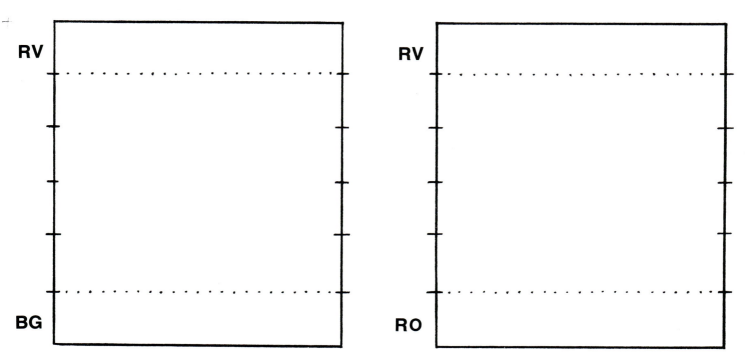

Figure 60

WHEN HELL FREEZES OVER =
BLUE-GREEN VS. RED-ORANGE

Opposition of Cold Warm

Color has *temperature.* Life experiences on planet Earth offer the associations of fire and the color red-orange at one pole and ice as blue-green on the other. Red-orange is always warm and blue-green is always cold. All the other hues on the color circle may appear either warm or cool depending upon their placement with neighboring colors. Vigorous comparisons of warm and cool colors only occur when colors compared are of like value.

Warm and cool as a concept may find similarity in such comparisons as shadow and sun, light and heavy, transparent and opaque, or near and far.

Pictorially, warm equals near and cool equals far. This effect can be used to express a plastic pulsation of depth on the surface as well as a device to create atmospheric illusions of depth.

Transparent pigments tend to be cool stainers, while opaque pigments lean towards warm surface pigments.-

Color structure based upon warm/cool contrasts displays a surface that alternates warm, cool, warm, cool, warm, cool, etc.

Color temperature is closely related to subjective human response. Light green rooms seem cooler than orange rooms. Pronounced effects are produced in the middle value ranges where color is clarified.

Six stripes are marked off in two columns at *Figure 60.* Locate the color red-violet in the top stripe of each column. Place blue in the bottom stripe of one column and orange in the other. Graduate the stripes in between in steps as evenly as you are able. A completed example will illustrate that the red-violet top stripes will appear to have come from two different mixtures. *See Plate 25.*

You can do more with color than any other element!

COMPLEMENTARY OPPOSITIONS = COMPLETELY AT ODDS

Complementary colors are colors **diametrically opposed** to one another on the color wheel. The pairs red-green, yellow-violet, and blue-orange are complementary. When placed next to each other, each activates the other to maximum vividness. However, when mixed together they neutralize each other and can become mid-value neutral gray. *Complementary colors do not vibrate.* Used in proper proportions they become fixed, static and obvious. Complementary pairs exist throughout the color sphere, middle value neutral gray being the fulcrum; i.e., the complementary color of light green is dark red.

One complementary pair can provide, through graduated mixtures, enough opportunity for color structure for an entire painting. Completing the color wheel, *Figure 52,* with four graduated colors for each diametric pair only hints at the many possible mixtures.

Three parts of yellow, five parts of red, and eight parts of blue yield mid-value neutral gray, *Figure 56.* Likewise, each complementary pair becomes a new construction of primary colors; i.e., red vs. green is also red vs. blue and yellow.

The complement of any color may be produced through *afterimage* as previously explained.

Transparent watercolor media provides the possibility for glazing one complement over the other to accomplish graduated mixtures. Using opaque mediums the artist must mix each color independently or place pointillistic dots of pure color for the eye to mix visually.

Complementary colors compl-e-te each other. One or more pairs used for color construction provides a wide variety of subtle grays and the intense diametric contrast of the parent complementaries. Harmony *and* contrast are possible when using complementary colors. *See Plate 25.*

SIMULTANEOUS OPPOSITION = ALMOST A WINNER WINS

When color #1 is placed next to color #2, color #2 is induced to appear more like the complementary color of #1 —or — when two colors are placed next to each other they subtract their appearance from each other - **induction or deduction occurs.**

The human optical sensory mechanism requires balance to such a degree that it will generate complementary colors in their absence. **Neutral gray** areas become particularly receptive to the generated color. Match the value of the center gray with designated colors in *Figure 61.* Isolate each completed example by covering the others with scrap paper and stare at the center to experience simultaneous effects.

We may control simultaneity by predicting the results and altering one color. If the gray center in any of the examples is colored slightly with the induced color - the complement - simultaneous opposition is accelerated. Tinge the gray center with color similar to the color surrounding it and the simultaneous opposition is halted.

Simultaneous effects also occur between colors that are relatively near, but not precisely, complementary. Equilibrium in the optical mechanism is upset and the eye is forced to accept *"near misses."* See also,Tensions, Page 78. Colors are dynamically activated, **they begin to oscillate.** The painter may set simultaneity in motion by placing colors next to each other that are removed from the complementary opposition slightly. Instead of red next to green....red-orange next to green....or red-violet next to green, etc.

The strictness of the effect will depend upon value similarity and amounts of participating colors. *See Plate 25.*

Simultaneous contrast is a multi-purpose phenomenon that works well with all elements, because comparison, as a concept, is at work. A muddy area will not appear as muddy if near it, in it, or around it there exists an even more muddy area. *If you can isolate what is wrong with an element, or area, simultaneous contrast will often remedy the problem.*

"Beauty of color" may often be sacrificed for "expressive" results when subject matter and mood warrant, *Plate 8.*

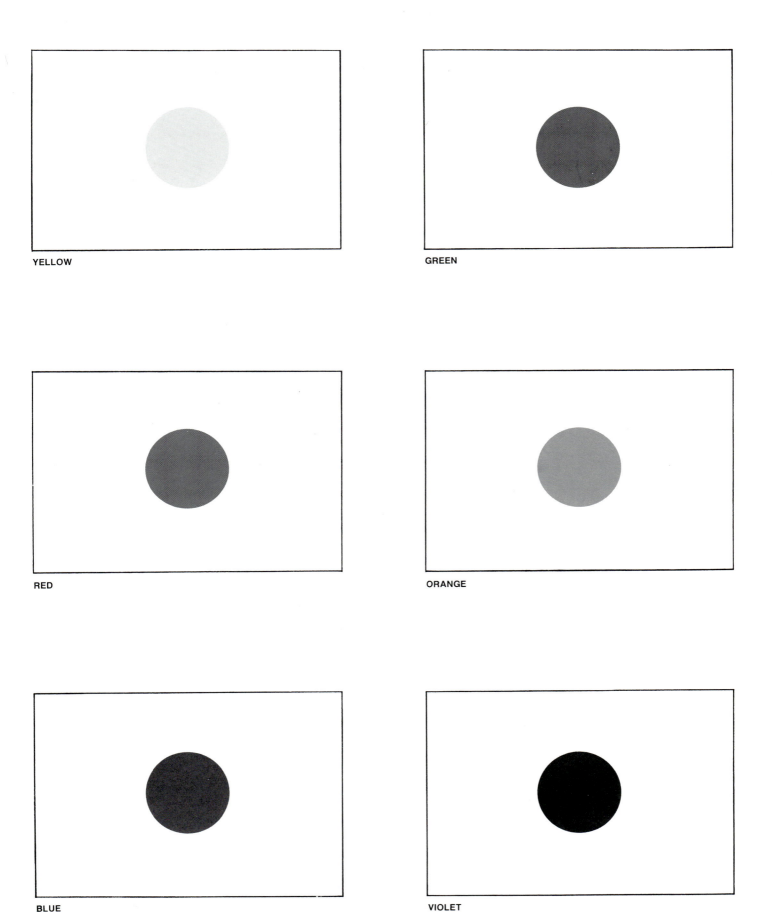

COORDINATE EACH DESIGNATED COLOR TO VALUE OF GRAY CENTER

Figure 61

OPPOSITION OF AMOUNTS = MORE OR LESS

Balances struck between area, sizes of differing colors, involves opposition of amounts. During the painting process, consciously or unconsciously, a painter decides **how much** of a certain color balances **how much** of another color. A computer would be required, along with a very sensitive eye, to completely employ the following mathematical ratios. They are included here to alert you to the need for consideration. These ratios indicate the static fixed harmonic balances based upon the value level of pure complementary hues, *Figure 62*.

One part of yellow = three parts of violet
One part of orange = three parts of blue
One part of red = one part of green

Figure 62

As colors interact on a painted surface, the possibilities for calculation are mind-boggling. A sensiblity for the whole idea is preferable to actual calculation. Static balance is exemplified by these ratios. Opposition of amounts becomes dynamically **"felt"** when the painter begins to alter static balance in favor of expressive choice, which is largely governed by subject matter or subjectivity of the artist.

One of the results of applying the contrast of amounts to the other six color contrasts will be to increase or diminish the effect; i.e., a small, light shape will appear much lighter when surrounded by a large amount of dark; a small area of intense color will appear more intense when surrounded by a large amount of impure hue, etc.

For the true colorist, areas and amounts of color are not arrived at through preconceived drawing or outlines describing objects.....color areas are arrived at through the opposing effects of hue, value and intensity. Example: an area of violet in a dark area that is to make its presence felt must be a different size than the same violet in a middle or high value area. *See Plate 25*.

All color effects depend upon placement. It's the color you put next to or near another color that counts.
No one color is better than another color. Colors are like notes on a piano - it's how you play them - what you put next to what, that matters.

Like letters in the alphabet colors begin to take on meaning and effect when placed next to each other

COLOR CONSTRUCTION/SUBJECTIVE & OBJECTIVE MOTIVATION

Color structure may be accomplished through many occult methods. Each painter has a method. **Theory rarely preceeds practice.**

Leonardo devised a method for teaching color theory employing various color measuring spoons. An apprentice questioned a journeyman as to exactly how Leonardo used the spoons while painting. The veteran informed the apprentice that Leonardo never used the spoons while painting.

Coloration method should always be firmly coupled with content, what is being expressed. Knowledge itself is wasted without inspiration, but habitually choosing colors via impulses which spring from within one's own consciousness may imprison the artist to a greater degree than any theory. Objective knowledge expands the painter's potential, freeing color to concentrate upon expression, aesthetic order, space or description. The happy marriage of the objective and subjective approaches holds the greater promise.

Understanding the basic color contrasts and color schemes will serve as a solid foundation for color planning. The purposes to which you can apply this knowledge vary considerably. Color may function to:

> **Produce spatial movement**
> Warm colors advance, cool colors recede; balancing these movements creates a plastically animated surface.
> **Reinforce value differences or replace them altogether.**
> Extinguishing value differences brackets colors together within planes. If no value differences exist among colors, the viewer **must** see color.
> **Carry emotions or feelings;** symbolizing ideas, moods, or personal expression.
> **Provide aesthetic appeal** through precise color organization, emphasis and relationships.
> **Identify objects** via description of color/surface appearances.

Before the advent of photography, painting was principally an art of illustration or duplicating natural appearances. Photography had the ability to technically reproduce visual reality more dependably - painting had to move on to more fertile ground. Color was no longer captive to the description of an object's local color.

New subjective uses for color were investigated by artists. Color, it was discovered, had unique structural possiblilities as well as unexplored potential for expression.

Except for vague generalities, there is no "yardstick" for measuring the emotional equivalents of color. It is safe to conclude that different values and intensities and hues of colors may relate to or symbolize life's emotional experiences. Most genuinely creative artists acquire a personal style for color usage that springs from inner feelings about the subject rather than from the subject's outward appearance.

Color opens new doors, any shape can be any color, any time. **Only you make the rules you follow.**

SIZE, I MEAN GOLDEN

Size is **comparative measurement or scale.** All visual elements have the capability to change and define each other. Sizes of elements are altered by placement. Large cannot exist without small.

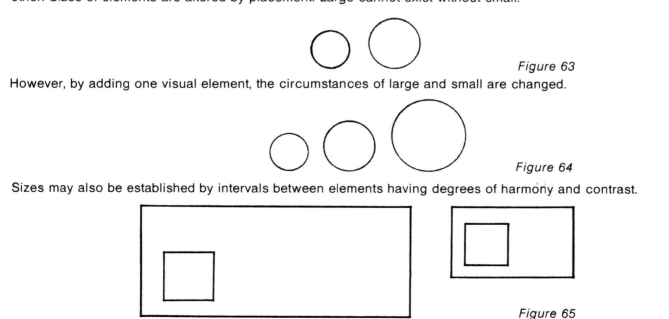

Figure 63

However, by adding one visual element, the circumstances of large and small are changed.

Figure 64

Sizes may also be established by intervals between elements having degrees of harmony and contrast.

Figure 65

The square on the left appears smaller because of a larger field, but the square on the right is the smaller of the two.

Instantly, an element is changed because of measurement and placement. What it is next to or what setting it is in creates *simultaneous contrasts* .

Comparing sizes, often referred to as **proportion,** is fundamental to dividing the two dimensional surface an artist paints upon. The **"Golden Mean"** is unchallenged as the most pleasing and satisfying proportional formula. Classical Greek design utilized this mathematical formula as a plan for most of what they built, from the Amphora to the Parthenon. Constructing a "Golden Mean Rectangle" begins with a square of any size, using the diagonal of one half of that square as radius to achieve the measurement of the long side, *Figure 66.* The diagonal of the completed rectangle provides for horizontal division, *Figure 67.*

Other mathematical ratios exist and what the "Golden Mean" may lack in expressiveness is balanced by satisfying the needs of unity and contrast; i.e., C is to B as B is to A. Structurally, the "Golden Mean" mathematical sequence is the basis for a myriad of natural species, including most plant and animal life. This is demonstrated in the arrangement of cell growth, seed pods, sea shells, rabbit reproduction, etc., etc.

Variations may be seen in the examples for dividing surfaces into contrasting sizes while maintaining unity and flexibility. *Figures 75* and *78.*

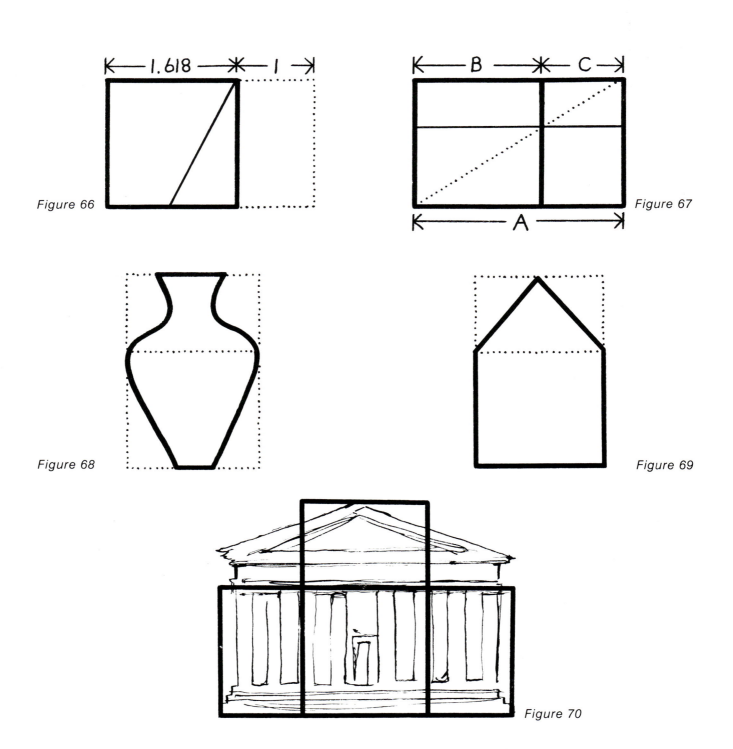

Figure 66

Figure 67

Figure 68

Figure 69

Figure 70

Rabatment is a simplified method for combining the opposing measurements of any rectangle, impose the short measure onto the long measure, locate horizontals on diagonal intersection, *Figure 71.*

Figure 71

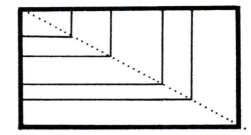

Figure 72

Harmonic rectangles may be formed on the diagonal of any parent rectangle. Placed anywhere on the painted surface, they will produce repetition with variety, *Figure 72.*

Some painters find a defined division of surface restrictive . . . an alternative may be to move the divisions onto a free or open sketch.

There are many methods for dividing a surface. Creative surface division may involve discovering new ways to utilize repeated ratios or rejecting them entirely. Intelligent combinations of methods employed and expressive requirements should provide guidance.

1. With tracing paper and a few reproductions of paintings, discover and record a few examples of space division that utilize repeated ratios - "Golden Mean"/Rabatment, etc. - find some paintings that apparently do not. Examine your results again. Do you want to reconsider?

SHAPE, IN TRIPLICATE

Shape is an area defined by either or all the components of line, value, color and texture. Ideally, an artist selects shapes relative to what is expressed. Theoretically, there are only three distinctly identifiable shapes; the square, the circle, and the equilateral triangle. All other shapes are produced by combination and will exhibit varying degrees of harmony and contrast, *Figure 73.*

The **square** is an invention of man, and reflects solidity, regularity, stability and honesty. A **circle** expresses endlessness, warmth and protection. **Triangles** produce anticipation, action, tension and conflict.

Shapes may be categorized as geometric, precise shapes conforming to mathematical laws - or biomorphic - freely developed shapes found in living organisms. The familiar ink blot test suggests the emotional responses humans connect with organic shapes. We often describe shapes as being dynamic, awkward, aggressive, weak, etc. Our response to shape is largely associated with human experience. *Balancing organic shapes against geometric shapes is an alternative to the exclusive use of either.*

Variety at the edges of shapes will vary from painter to painter, having much to do with what the painting expresses, or the particular passions of the painter. Four general edge types are; **Blended Edges** - soft, fluid, impressionistic; **Hard Edges** - definite, regular, formal; **Broken or Drybrushed Edges** - rough, dry, textural, *Figure 74,* **Vibrating Edges** - simultaneously contrasting colors meeting at edges, nervous, jumpy, lively.

Dynamic in its ability to disclose, shape becomes the primary vehicle for objective and non-objective paintings. After selecting the shape of the support (paper or canvas) the artist chooses shapes to affect the various goals of description, aesthetic considerations, directing attention, and for emotional impact.

1. In a 5" square, create a painting or collage of objects, elements or actions that relate to the square as a shape; circle as a shape; and triangle as a shape.

2. On a 7 ½"x11" format, compose a painted surface using only black, white, gray and rectangular shapes; curvalinear shapes, triangular shapes.

Figure 73

Figure 74

RATIO IS THE IMPORTANT ELEMENT/DOTTED LINE = FLEXIBLE

SEE PAINTINGS....... PLATES 1,3,5,6,9,10,12,18,19,20,22

THE NUMBER ONE, IS THE SOURCE OF THE SEQUENCE THAT LEADS TO THE GOLDEN MEAN.

1-2-3-5-8-13-21-34-55-89 AD INFINITUM
Y·R·B $\frac{1}{1.618}$

Figure 75

DIRECTION, N.S.E.W. AND ALL POINTS BETWEEN

Each of the basic shapes displays a meaningful, visual direction. The square expresses the horizontal - vertical relationship, the fundamental reference utilized by humans in terms of well-being and movement; the curvalinear directional force expressed by a circle is relative to enclosure, warmth, and continuity; the triangle expresses diagonal or oblique directions which oppose any type of stability; the diagonal is constantly provoking imbalance, *Figure 76*.

Horizontal directionals have meanings associated with the human body at **rest**, when gravity's pull is distributed over a large body area. Horizontal formats are comparatively passive and calm.

Vertical directional forces relate to **growth** processes on this planet. Paintings employing a vertical format present feelings of aspiration and strength.

Diagonal directions engender a response of anticipation and **movement**. Since diagonals are never in harmony with the outside edges of the painting surface, a shifting instability results.

Artists imply meaning with choice of horizontal or vertical format. All subsequent selections of directional force are important to final compositional effects, *Figure 77*.

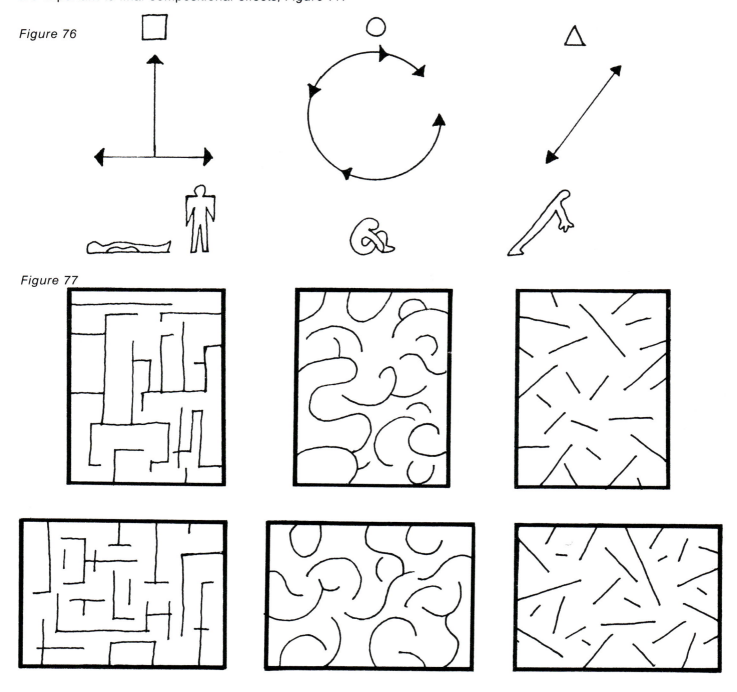

Figure 76

Figure 77

1. *Discover visual examples of the six dominant compositional directional motifs, using magazine and newspaper photos or advertisements.*

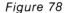

Figure 78

DIVISION TO 3 HARMONIOUS PARTS

RATIO = EACH SUCCESSIVE NUMBER IS 1.84 TIMES THE LAST NUMBER

FOR MORE VARIATIONS SEE FIGURE 75.

20

37

68

20 37

6 HARMONIOUS PARTS

IMAGES, WHAT ARE THEY WORTH

Images - - - - the physical likeness or representation of a person place or thing - - - - may be understood on one level as being subject matter. On a different level, it's not only the **visible,** but also the **invisible** - felt - counterpart of idea, form or symbol. *Figures 79 & 80.*

Objects pictured that easily relate to the real world are the images that we call subject matter. Choosing significant subject matter presents a problem with solutions that are revealed under the umbrella of time - some subjects such as landscapes, still lifes, portraits, etc., are categorically timeless and seen historically as reappearing. Creatively, however these categories never reappear presented in exactly the same way - twentieth century landscapes are different in presentation and handling than nineteenth century landscapes. When a painting's subject matter or the way it is presented does not reflect the time in which it was painted, it is an anachronism - out of sync, and unknowingly insincere. Watercolor paintings that reflect nostalgia for a bygone day are everywhere. Zillions of "how to watercolor books," hobbyists, Sunday painters and many watercolor societies regrettably accept and revere cliches that would serve better as greeting card illustrations. *The question is, why shouldn't they?*

Think about it . . . painting in a manner that more aptly reflects an earlier time not only refutes contemporary thinking but also arrogantly denies that anything of importance has happened to change the way we think and see. Lack of flexibility results in stunted growth . . . many technically proficient watercolor painters are prey to having formulated their ideas of what a watercolor painting is, many years ago. Unfortunately, finding an audience for the product was not a difficult task, and in doing so, the artist was left to thoughtless repetition of an idea that has outlived it's creative usefulness.

The error is compounded by artist/teachers who pass on to students the idea that what you paint pictures of is of no other value than as a vehicle for some obscure "design law." **NEVER!** Images are at the very least fifty per cent of what is meaningful - - - -you can organize, design or theorize into eternity, but if your subject matter or the way you've presented it is a cliche, or belongs more fully to another time - your painting is insignificant.

Images have a relationship to the real world - unless you've been somewhere else. Some painters are comforted by duplicating what they see, . . . *it's easier.* Painting what you see avoids the search for creative answers, and also the fear of rejection from peers. *Creative artists consider imitating the world we see as being ridiculously limited compared to the more penetrating, fluid inner world of vision and feeling.*

Imitative, or creative . . .? *Creative* - because it's a mental destination we arrive at only when we capture the imagination.

Images are the result of giving visual sensations "meaning."

IMAGES AND SUBJECT MATTER

Choosing subject matter that is likely to contribute something of worth to the whole field of painting is a sticky problem. Some subjects do wear out. Subjects like hoop skirts, stovepipe hats, pump handles, old oaken buckets, horse wagons, rural decay and the like may be revered for whatever reasons by some watercolor societies. Nevertheless, they relate very little to contemporary existence. They may be wonderful as nostalgia, however are completely **unthinking as candidates for art status!** Contemporary objects like highway entrance and exit ramps, junkyards, consumer products, modern architecture, machines, computer technology, street signals, etc., may not excite artistic fervor, but they are contemporary and relevant.

Subject matter . . . matters!

There are subjects that will never wear out because of their extraordinary potential for releasing human expression through the conduit of that subject's imagery. Broadly based categories such as landscape, seascape, still life, nude, portrait, etc, will be around as long as paint is. Creative success with these timeless subjects relies heavily upon **concept** and **presentation.** A fresh way to display familiar subject matter invloves orchestration and design. We are all different, liberating that difference, is a problem that requires translating intense feelings about the subject matter into painted evidence of those feelings, rather than academic description.

Updating, adding to, or imposing something of a contemporary nature on timeless subject matter, requires a keen sense of what to add or impose and what category shows promise for successful rejuvenation.

Simplification is a useful approach. It's contemporary. The emphasis in modern living is on simplicity and functionality. Symbolism communicates. Most of us can remember when the Bell Telephone symbol was an imitative rendering of a bell, in a circle formed by

lettering. Today it appears in its simplified form, no lettering, just a simple circular ribbon around a similarly ribbon outlined bell shape.

Making the universal particular, or the particular universal, plays games with readability. Utilizing very common subject matter with exotic presentation, and conversely, very exotic subject matter employing a straight forward handling.

Often subject matter we identify through representational imagery is not the subject at all, but rather the vehicle for less obvious subjects like color, movement, balance, and a host of other strategies. This fact also reveals the essence of non-objective painting. It isn't necessary to exhibit representational imagery to have subject matter. When using representational images, reconciling them with the *genuine motivation* should always be considered.

Adopting an "everything has been done" attitude leads to utter frustration, yet it is necessary to be in this predicament from time to time. Knowing frustration for what it is, and then investing that energy in a positive manner, is one way frustration can become a creative force. Creative solutions often evolve out of frustration.

If we had the opportunity to compare a gallery of contemporary watercolors to a gallery of nineteenth century naturalistic watercolors we would discover that what once seemed fresh and expressive now appears stale and insignificant. No one writes in Shakespearean prose today, it would be laughable. Ruskin would be out of place today and very likely, so would Cezanne. The boundless individualism of our time is a product of freedom from the restrictions of academic naturalism.

Perhaps we don't choose subject matter as much as it chooses us. Creative paintings result from the dialogue between artist, paint, time and subject matter.

Between artist and viewer, subject matter becomes acceptable or pleasurable by virtue of *shared experience.* Subject matter drawn from the world of retinal vision will always find a larger audience, albeit less educated, than the more obscure worlds of geometry, the subconscious, and personal emotions.

Choose your subject matter from inside. Finding a sincere interest for what it's a picture of and how you are going to present it is a winning combination. *See also Imaging, Page-106.*

17th ST. CAUSEWAY, is a very predictable painting. The visible subject matter only demands from the viewer as much as the average postcard.

BEACH SEEN, is an invented paint symbol that might be undesipherable without its title. The viewer must bring a certain frame of mind, and some sensibilities to appreciate it. This painting demands more from the viewer. Can you feel the ocean tide, the sandy beach, the sun and its reflection, the presence of a sea shell? See also color plate 23, page 173.

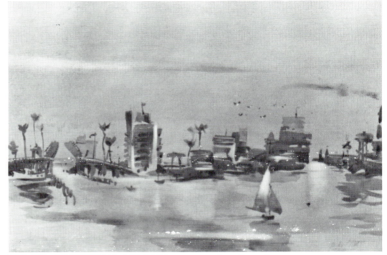

17th ST. CAUSEWAY, 14"x21" transparent watercolor *Figure 79*

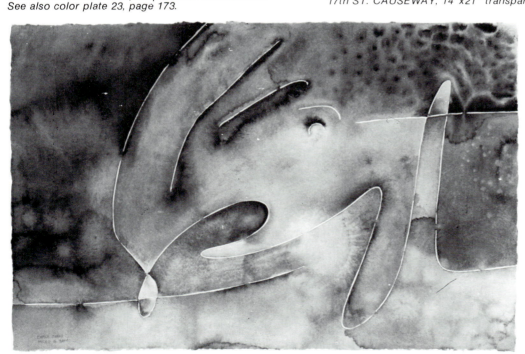

Figure 80

BEACH SEEN, 14"x21" transparent watercolor

Paintings like MONHEGAN LIGHT, 21"x14", despite thoughtful compositional factors, appeal as "nostalgia." This subject matter and concept belong firmly to the nineteenth century. See how to do "it," pages 79-82.

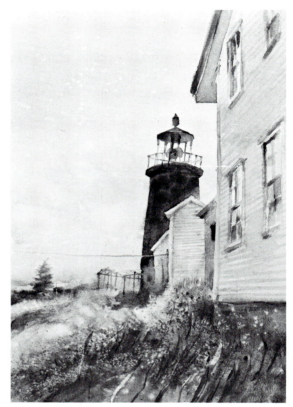

Figure 81

ARRIVAL, 30"x22", is a watercolor painting that belongs completely to the twentieth century. Color, shape, texture, movement and concept/subject matter avoid trading on sentimental reverence for a by-gone era. Refer to the color section for other paintings that avoid becoming anachronisms.

Figure 82

STYLE

PRIMITIVE ★ CLASSICAL
★ EXPRESSIVE ★ BARO-
QUE ★ FUNCTIONAL

STYLE with the medium of watercolor, as with all the visual arts, is the combining of all the elements and strategies, techniques, inspiration, expression, content and form that produces a particular kind or type. The sum total of many decisions, such as, what influence the medium of watercolor might have on what you want to show and how you want to show it; what purpose the work will serve, entertainment, communication, self-expression, etc.; choice of elements and compositional structure to affect the desired response; choosing suitable techniques for manipulating the elements. The resulting watercolor painting will be an individual expression, influenced greatly by what is happening around the artist culturally, and the artist's own physical and mental attitude.

Advising the beginning and occasional intermediate level painter, "not to worry about style," is well intentioned. Average beginners are fully occupied learning neessary craft and basic theory. Unfortunately, style will not magically drop from the sky. Style, with all its options, should be introduced as a necessary area for study at the earliest sign of interest. *Many painters cling to the security blanket of whatever style they begin with - usually the academic naturalism of the instructor -* and suffer from stunted artistic growth in the process.

In a culture that continues to overshadow the individual by transforming his identity into numerical regularity, two choices of style become obvious; **conformity,** which entails trusting someone else's formula for what painting with watercolor should be, and blindly following, or **nonconformity,** trusting that the only geniune treasure you have to contribute to any larger entity, like painting, is your own vision, your own life experiences, hopes, desires, and energies. Submission to conformity requires creating within a discipline of rigid rules, related more accurately to vegetation, rather than creation. If vegetation is your goal, my advice is to do it somewhere else.....painting with watercolor is a vibrant, vigorous activity.

The word image may be confused with and often carry meanings more fully understood as style. In this sense, the word image means an appearance, a "look" that epitomizes the artist. A calling card of uniqueness, this could be anything repeatable as an artistic trademark. Such idiosyncrasies, planned or otherwise, will never adequately conceal a lack of style, but they do call attention to - make sure there is something to call attention to!....genuine style.

Style basically refers to a way of doing things related to form, appearance or character, that allows separation into particular groups.

Byzantine, Renaissance, Baroque, Norwich, Victorian, French Impressionism, German Expressionism, Dada, Bauhaus, Surrealism, Abstract Expressionism, Functionalism, Minimalism, etc., are names of epochs or schools of thought that immediately earmark the work of many painters and the period and place in which they worked. Each group while searching for new forms, produces its own traditions. When preferences for certain structural form, paint manipulation, subject matter, compositional orchestration, and other characteristics are shared by painters, they are grouped together. *Notable style is a product of cultural environment.*

Today we live in a pluralistic society; widely differing styles are acceptable, consequently, similarities of form, content, method, media, and technique are used to categorize artists according to style, despite their being separated by historic era or geography. Therefore, we may categorize a contemporary painter's style as being primitive, or baroque, etc., even though the painter did not live or work during those historical periods. There are five general categories of style that deserve consideration, since they serve as the foundation for all styles; Primitivism, Expressionism, Classicism, Embellishment and Functionalism.

PRIMITIVE

Primitivism is the outcome of a recurrent belief that the qualities of primitive cultures are superior to those of contemporary civilization. Stylistically, primitivism claims its ancestry in the art of cave dwellers, thirty thousand years removed from the present. Primitivism as a style still being practiced today, must be described as a style that shuns developed techniques for realistically representing natural vision, but rich in meaningful symbols and naive simplicity.

What shorthand is to language and the written word, symbols are to painting. The potential for conveying energy from painter to viewer is enormous. Simplicity is the basic technique of the primitive style. Primary colors, childlike elimination of detail in favor of revealing flat silhoutte shapes and linear elements typify the style. Essences are exaggerated in an attempt to be more realistic, but result in an intense directness.

Often criticized as immature and crude, the art of children and primitives should be evaluated on the basis of its *purpose, directness, intensity and purity* of style. Methods employed by the primitive style are:

Simplification
Exaggeration
Primary Color Usage
Activity
Flatness
Discord
Roundness
Improvisation
Distortion
Imperfection

ROCKETSHIP, 24"x18", Will Elmore, age 5, Nova University School, Ft. Lauderdale, Florida

Figure 83

CLASSICAL

The classical style is rooted in the Greek and Roman heritage of the ideal - *the perfected.* The Greeks believed that the ulitmate desires of the human spirit could be expressd through the perfection of universal order. A profound love of nature, and the search for pure truth, led to principles for harmony and proportion. Using logic and mathematics, the Greeks produced expressions of perfect order in all the arts. Extreme naturalism was formalized. Examples of Greek painting do not exist, but copies of Greek paintings and architecture, inspired an energetic rebirth of the style a thousand years later in the Italian Renaissance. Vital steps in the understanding of the human body, the golden mean, the rules of perspective, and modeling in color, etc., are all attributed to the Greeks, Romans, and the Classical style.

Classicism is the opposite of romanticism and expressionism. Visual techniques utilized by the classical style are:
Harmony
Balance
Simplicity
Unity with Variety
Dimension
Perspective
Monochromatic Color
Consistency
Extreme Naturalism
Precision
Symmetry

FALSE ALARM, 52"x36", Airbrush Acrylic, is a contemporary recurrence of the classical style. Photorealism as a concept utilizes a perfected from, perspective, extreme naturalism, precision, order, etc.

Figure 85

Faye Cavanaugh's watercolor painting, TREES CAN SEE, 22"x15", utilizes a childlike simplification of natural forces. Exaggeration, flatness, imperfection and activity are directly conveyed in a contemporary primitive style.

Figure 84

Figure 86

EXPRESSIVE

Expressionism and primitivism are similar in appearance, but vastly different in purpose. Distortion among primitve styles results from the lack of developed skill necessary to accomplish realistic representation. Expressionist methods however, actively pursue the *exaggeration of reality* in an effort to provoke an emotional response from the viewer. Distortion becomes a positive strategy.

Historically, expressionist styles date from the banning of all images in religious art during the Iconoclasm. Eighth century Christianity had difficulty with doctrine concerning image worship, which was resolved with art forms that compromised and became abstractions with distorted remnants of reality. The Byzantines and Gothics typify the expressionist style. Individual artists and whole schools have adopted the expressionist style as the perfect vehicle for surpassing logical order and entering the realm of the mystical.

Expressionism is a manner of painting in which forms derived from nature are distorted or exaggerated, characterized by lines and forms that are sharply defined by contrasting, vivid colors. Theme material is executed with emotionally charged symbolism. Twentieth Century experimental, and most non-academic styles of contemporary art rely principally upon the expressionist style.

Expressionistic techniques include:
Contrast
Verticality
Colorfulness
Distortion
Placement
Activity
Improvisation
Exaggeration
Discord
Roundness
Oblique Movements

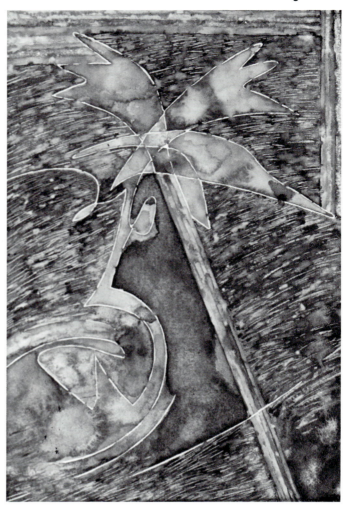

Distortion becomes a positive force to the expressionist style. Vivid colors, rough textures, verticality, and oblique movement support the exaggerated natural forms presented in PALM TREE & ISLAND, 21"×14".

BAROQUE

The Age of Baroque is the most qualified representative era of the *embellished styles*. An outgrowth of the Renaissance, seventeenth and eighteenth century European art was another turn of the wheel. Although the patrons were largely the same - the ruling classes and the church - these artists were among the first in history to consciously choose a style. The reaction was against a too factual approach. Unfortunately, it ran rampantly to a pinnacle that rested on the assumption that, "one more curlicue would do it." Baroque was the art of the rich and powerful, elegant and grandiose, during a time of great economic polarity. Spreading from its origins in Italy to central Europe, Flanders, Germany, France, England and Spain, Catholic Missionaries carried it to Latin America and the Far East. The theme of Baroque was romanticism.....a rebellion against the "rules" of classicism. Serving as a bridge between the Renaissance and the modern world, the Age of Baroque encompasses a vast and varied period of creative expression, during which objectivity and reality were obscured.

The late Roman period, the Victorian period, and Art Noveau may also suffer grouping with this saccharin style. Each having carried ostentatious surface ornamentation to the level of bad taste. On the positive side, even though erroneously manifested, the Baroque style exhibits a *daring inventiveness and sheer energy* difficult to equal. Techniques employed by Baroque styles are:
Intricacy
Curves
Daring
Fragmentation
Exaggeration
Full Color
Decoration
Activity
Detachment
Variation

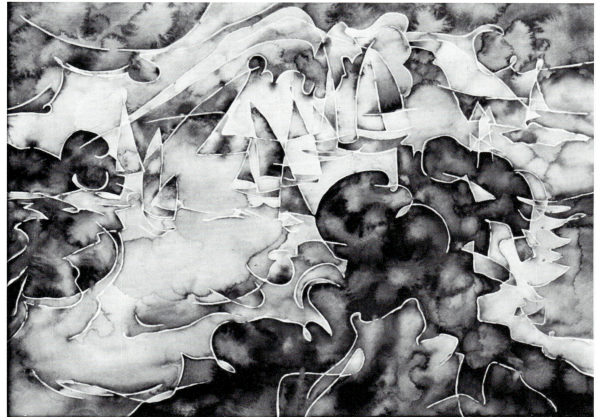

collection M. VOSSLER

Figure 87

FUNCTIONAL

Functionalism finds its origins in the *aesthetic values of workmanship,* which probably dates back to the first hand-crafted vessel to carry water. Functionalism as a style evolved from several nineteenth century movements or schools in Europe.

As early as 1760, the industrial revolution in England predicted industrialization for the arts. Led by William Morris in 1848, the pre-Raphaelites devoted themselves to reviving the spirit and style of the hand crafts practiced by Italian artists before the time of Raphael. They did not succeed in their war against the machine-made. They did draw attention to the implication of craft and workmanship regarding utilitarian products. Gottfried Semper in an 1852 article on science, industry and art, clearly foresaw the significance of industrialization for the arts. Semper fomulated a doctrine that was adopted by the English art and craft movement which was followed in 1907 by the "Deutscher Werkbund." Utilizing the "thingness" of materials, this group of German designers sought to discover inner meaning and quality in their work. After World War One in 1919, at Weimar Germany, Walter Gropius and the distinguished faculty of a new art and craft school known as the "Bauhaus," endeavored to discover new solutions to the problems of reconciling the artist, the machine, and aesthetics. Beauty was re-defined through the fundamentals of design, basic materials, and the practicality of function.

Functionalism advocates the direct fulfillment of the materials used. Purely decorative effects are omitted or extremely subordinated. Aesthetic effects are derived mainly from proportions and finish. Functionalism seeks beauty in the expressive factors existing in the underlying structure of visual work, using the techniques:
Simplicity
Monochromatic Color
Symmetry
Flatness
Precision
Geometric Shape
Economy
Repetition
Unity
Consistency
Sequentiality
Predictability
Hard Edge

The implications of style are wider than five styles and the thinking processes that may create them. Understanding the foregoing five style categories through definition and method will form a foundation for their practical application.

1. Using a 7 ½" x 11 watercolor paper format, paint the same subject matter five times to interpret each style category.

2. Photograph or clip pictures of architecture which illustrate each of the five styles.

3. Do the same for a nature classification; birds, trees, animals, etc.

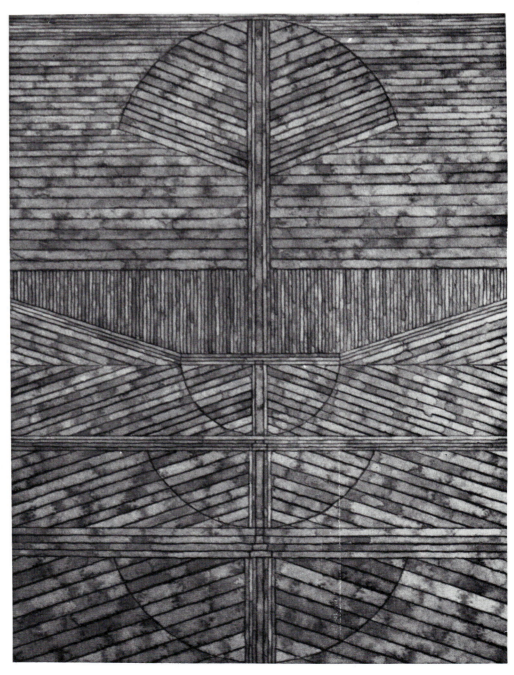

INFLORESCENCE, 23" X 2l", is realized aesthetically by utilizing hard edges, geometric shapes, symmetry, economy, and other attributes of the functional style. Functionalism urges a direct implementation of the materials used. Much like modern architecture, man (the artist), the machine and aesthetics are reconciled.

Figure 88

CHOOSING AN M.O.

SYMBOLS ★ CREATING ARRE-
STING SYMBOLS ★ REDUCT-
ION/SIMPLIFICATION ★ GEST-
ALT ★ READABILTY/CLOSU-
RE ★ COMPOSING A MEANING-
FUL SUB-STRUCTURE ★ SHAPE
ARMATURES & OTHER DEVIC-
ES ★ IMITATING THE RETINAL
IMAGE ★ IT'S A TONAL VALUED
WORLD ★ HOW TO DO "IT" ★ LE-
TS "SEE" HOW WE SEE ★ RETI-
NAL VS. EXPERIENCED IMA-
GES/SPACE ★ GET DISTORTED!

CHOOSING AN M.O.

All the visual information we receive and all the visual information we transmit depends upon three distinctly different methods of operation - modus operandi, or **M.O.** - visual communication is accomplished by:

1. **Imitating visual appearances** - *representational retinal images*
2. **Implications of abstract substructure** - *compositional elements of presentation*
3. **Symbolization** - *stand in images*

Figure 89 illustrates a human eye presented by each of the three different methods of visual communication.

The *first eye* is photographic and closely represents what we see, a retinal image. It informs and describes, requiring no interpreting or decoding on the viewer's behalf. The assets and limitations are obvious.

The *second eye* has been composed purposely to be more intense, more penetrating. The shapes retain some very recognizable aspects of the original form, however the shapes are simplified and geometric - how the message is composed, the choice of abstract substructure, conveys meaning. Some decoding is necessary by the viewer.

The *third example* is a symbol of an eye. It is much more of a surrogate or stand-in for the "as we see it," representational eye in our first method. Symbols identify things or actions, moods, or organizations. Symbols may vary from detailed, - having rich representational value - to those so abstract that they require the viewer to learn how to read or decode them. Contemporary life requires us to decipher symbols constantly - the restroom symbols in international airports, road signs, traffic signals, religious icons, directional signs, etc.

The three methods overlap, intensify and interact with each other. Everything you paint is in some way a **symbol,** every painting must be **composed** somehow, and **representation** plays a part in a lot of what we paint. Separating and understanding the three methods is the important concern.

With content - something to show/say - firmly in mind, the painter's next consideration is choosing an M.O. that will reinforce the intention of content or message. Choosing an M.O. simplifies the entire visual communication process.

A. Knowing the three M.O. gives an artist the choice of remaining consistently within a single M.O. or to effectively combine M.O.

B. The M.O. chosen, simultaneously becomes the method for executing the painting and an integral part of the painting's content.

C. M.O. informs the viewer how to "read" the painting.

Choosing the M.O. does not preclude creative discovery during the painting process. Flexibility is always a desirable state of mind.

Consciously choosing an M.O. before beginning to paint is not a prerequisite. M.O. supports content ----- if content is an unknown factor, to just "wing it," may accomplish successful results. Utilize the methods that are the most rewarding for you ----- there is no best way! No matter which way, successful paintings will easily be grouped under one dominant M.O.

REPRESENTATIONAL
retinal image

COMPOSITIONAL
elements of
presentation

SYMBOLIC
surrogate image

Figure 89

SYMBOLS

The world is an interlaced maze of signals, messages, symbols and signs. Each object, event, plant and animal organism sends out its own identifying signal. Each organism has evolved with an alertness for those messages that are important to its survival. Plant life receives seasonal signals to blossom, foliate, defoliate, and become dormant. Animal life undertakes periods of hibernation and activity. Hunger, thirst, pain, joy, puberty, menopause, etc., are physiological and biological signals that we all deal with as human beings. ***Man is unique, being the only "organism which creates symbols.***

A symbol is something used for or regarded as representing something else. Is one symbol worth a thousand pictures? Probably it is. The twenty-six alphabetical letters are symbols, stand-ins for the sounds that form the words children are already using when they are introduced to the ABC's. We respond to countless other symbols regularly - traffic signals, sound signals, maps, models, visualizations, codified symbols, religious symbols, organizational emblems, abstract symbols, political symbols, hand signals, corporate symbols, ethnic symbols, cartoons, holiday symbols, etc. Each with specific meaning. Some for identity, some for guiding behavior.

Symbols for painters become visual strategies that short circuit information to the viewer, produce a visual game, or focus meaning. The effectiveness of a symbol can be measured in different ways.....some symbols are meant to be recognized and remembered immediately. They must function in a world on the move. Other symbols are meant to hold our interest, enticing us to decode them. Some symbols are not meant to be mysterious, but are, because we don't have a code book to decipher them, like hieroglyphics.

The power of the symbol should never be underestimated.

The watercolor paintings of Raoul Dufy - 1877-1953,- Paul Klee - 1879-1940, - and Wassily Kandinsky - 1866-1944, are similar in that all three used symbols profusely.

Dufy's symbolism is of the good life, summers on the Riveria, horse tracks, casinos, bathers, flowers, gardens, etc. The symbols are fluid, unmistakable and communicate rapidly, at times obvious and lightweight, but rarely uninteresting. Colored brush lines and richly interpreted textures adorn fields of modulated color in Dufy's work.

Klee's symbols are those of an intellectual cleverly disguised, tongue in cheek, as a child. Highly inventive, they run the gamut from nature-landscape interpretation to matters of the human psyche. Form is discovered anew with each painting. Every shape/object breathes a spiritual life through movement and feeling.

Kandinsky's watercolor output, though smaller than works in other media, exhibits a clandestine love affair with symbols of his ethnic heritage and geometric abstraction. Some of the works defy deciphering; a personal language rich with meaning for those with the ability to decode, and an exciting substructure for those who cannot.

Figure 90

CREATING ARRESTING SYMBOLS

Most painter's symbols share the common denominator of **simplicity.** Simplicity takes away the specific meaning of the subject/image, leaving it open to new meaning. The symbolized object takes on a self sufficiency which can then be manipulated by artist and viewer.

Children automatically express themselves with what could be called naive symbolism, easily accomplishing such simplicity because they paint or draw what they see and understand. The perceptions of children are highly generalized, not filled with details. As a child's understanding grows, frustration usually occurs when artistic skills fall short of fulfilling what is seen and understood. The best of children's art is purposeful and sincere. But compared to more sophisticated forms, children's art lacks relationships between its parts. There is no concerted effort at contrast - harmony - unity - etc.

An enormous clue to **simplicity lies in the ability to generalize** - reducing endless detail that cannot adequately be rendered, into graphic relationships which can be rendered. For the uninitiated, it will seem like reversing gears, nevertheless, reverting to seeing like a child is an excellent method for creating symbols. No matter what the subject matter may be, investigate it as if you had never seen it before. Fresh paintings result from fresh experience. *See Imagination, Page 105.*

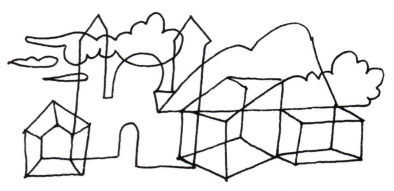

THINKING TRANSPARENCY
EACH SHAPE MAY BECOME A COLOR
ENHANCE VOLUME OR IGNORE IT
PLAY GAMES WITH CLOSURE

REDUCTION/SIMPLIFICATION

Methods for simplifying include:
1. Try to see the subject matter as **one shape,** one silhouette. If it's too large, reduce it to one shape or don't paint it until you can.

2. **Edit** a too detailed first try with tracing paper overlay, eliminating detail until satisfied.

3. Use simple **geometric shapes** for drawing....impose the square, the circle and triangle respectively, upon what you are symbolizing.

4. **Restrict your working time** before you begin....forcing yourself to eliminate detail.
5. You're looking for essences....shape discloses more rapidly than other elements. Think and see in terms of **flat shapes** to paint colors on - don't think about value or lighting or shadow effects, they are elements that belong to the representational M.O.

Plates 2, 9, 13, 15 are paintings in which symbols play a large role. Find the symbols in these paintings. See how simplified these configurations are, notice how color makes them interesting, observe the orchestration of the whole painting. In each example.....The symbols function within a symbolized environment. The whole painting is symbolized. Consistency within the context of symbolization - using stand-ins or surrogates as a dominant M.O. - make symbols an integral part of content and also the legend for the whole painting.

Like language, music, etc., art cannot actually express feelings.....just ideas of those feelings.....symbols, that through relative associations convey emotional ideas. All art is one hundred per cent symbolic.

Plate 1. A single symbol dominates.
Plate 18. Multiple symbols interact.
Plate 5. Space is symbolized.

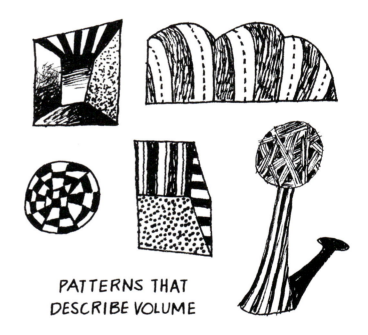

PATTERNS THAT
DESCRIBE VOLUME

CRYSTALINE STRUCTURE
DISCOVER GEOMETRIC EQUIVALENTS
USE THESE SHAPES TO CARRY COLOR
NEXT TO COLOR - VALUE - TEXTURE - ETC.

PATTERNS FOR FLAT SHAPES & AREAS

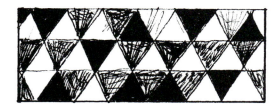

BECOMES

OPEN VOLUMES TO CREATE FLAT SHAPES
SEE AROUND CORNERS

Figure 91

GESTALT

"Gestalt" - Geshtalt - is a German word that is sometimes used instead of the word "form," to describe a **unified whole - a configuration or pattern, or organized field having specific properties that cannot be derived from the sum of its parts, only from the unified whole.** In effect, nothing can be taken away, nothing can be added without loss of "Gestalt."

The easiest way to display this graphically, is to use a value pattern, *Figure 92,* in which a few objects - shapes - are locked together to produce a unified configuration - whole. The "glue" that is holding this configuration or pattern together is alternation of black and white - that's the underlying form. Just as alternation of dark and light produces a unified whole - a configuration - a pattern - a "Gestalt," color has similar potential for "Gestalt" by alternating the contrasts of warm and cool colors, balancing complementaries, simultaneous color balances, in fact at least a possibility for each of the color contrasts. You guessed it, all the *elements, Page 34 and strategies, Page 22*, offer wonderful possibilities for "Gestalt."

Gestalt with images? *See Plates 12 & 16.* Any number of conflicting energies may become a unified whole through the "Gestalt" theory.

"Gestalt," used as a strict method for working, presents drawbacks, by demanding too precise a visualization before wetting the watercolor brush. The creative thinker must make decisions during the painting process, often without benefit of knowing exactly how each decision will relate to the completed painting. This lack of knowing how it is all going to "work out," is at the center of the theory that creative methods reveal new paths for progress at many interim steps. It is impossible to make conscious choices...many creative painters rely on the free powers of unconscious intuition. The process of observing and reacting in situations - without a strict plan - involves more of the imagination. Unconscious scanning becomes superior to conscious visualization.

Gestalt theory directs its methods at a precise goal.....it is more intellectual and objective.

Intuitional theory directs its methods toward discovery and invention.

- Here we are, back at the beginning again -

Figure 92 Here, moon, bird, mountain, boat, water, elephant, banana and attendant shadow shapes - you'll never see this grouping again - unify to become a configuration, not a sum of its parts, but rather a whole thing locked together by alternating black and white - actually, just the manipulation of black.

READABILITY/CLOSURE

The law of simplicity - known as the law of parsimony to scientists - stipulates that the best explanation is the simplest explanation that agrees with the information available.

93 94

It would be difficult to describe the above figures as anything other than a square and a circle, yet they are not a square and a circle. As humans, we visually understand the simplest and best form possible, even to the extent of correcting errors. The need for meaning in all we see is deeply rooted. Survival instincts make it imperative for the human organism to organize all incoming visual information in terms of meaning. We do this millions of times each day.

Vision is stimulated, "something" is there....the "something" is separated from its background...The "something" is observed for color, texture, size, etc....the brain searches for relationships to past experiences and meaning, then identifies, the "something."...resulting in what is known as **closure,** or readability. *"The Eureka Syndrome!"* Figure 95.

Some symbols, especially those involved with human welfare and safety and commerical ventures must be instantly readable, they must have **Instant closure.**

Witholding readability purposefully to involve the viewer's participation in figuring it out....becomes a game. Albeit, an old game - "Don't paint everything you see, let the viewer participate by filling in the details." How many times have I heard that one? Life is so filled with unanswered questions that multi-million dollar industries sustain themselves on the human desire to find answers/meaning - crossword puzzles, games, mystery stories, puzzles, video games, etc. We all love to exclaim,

"Eureka!" Discovering meaning is an exhilarating, rewarding experience.

Once the mind exclaims, "Eureka!," and identifies "something" it usually turns off that "something" and goes on to "something else." An important factor in creating stimulating paintings is to endow them with **renewable closure**....don't paint with subject matter or procedures that are "worn out." Anyone who "knows," will groan, "not that again." A different syndrome entirely. Your Aunt Tillie might love it, but what does she *know* about it? Perhaps she loves, *you,* not necessarily the painting.

There's nothing more boring than the re-run season on T.V. - it's the mysteries in life, the things we don't know, that keep it interesting. Paintings that explain everything are re-runs. Paintings that don't explain everything are a receptacle for the viewer's own experiences. The viewer becomes part of, and contributor to, the creative process.

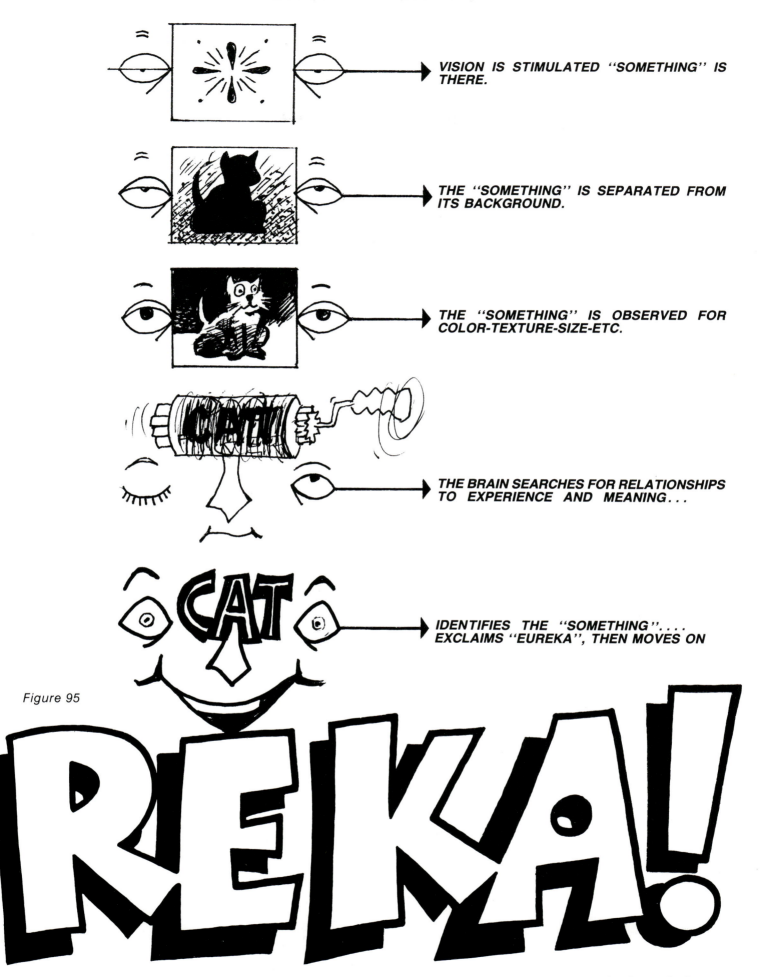

VISION IS STIMULATED "SOMETHING" IS THERE.

THE "SOMETHING" IS SEPARATED FROM ITS BACKGROUND.

THE "SOMETHING" IS OBSERVED FOR COLOR-TEXTURE-SIZE-ETC.

THE BRAIN SEARCHES FOR RELATIONSHIPS TO EXPERIENCE AND MEANING...

IDENTIFIES THE "SOMETHING".... EXCLAIMS "EUREKA", THEN MOVES ON

Figure 95

A.

C.

B.

D.

A. POOR CLOSURE - UNREADABLE
B. OBVIOUS CLOSURE - BORING
C. IDENTIFIES QUICKLY - EXPECTED - CLICHÉ
 CLOSES VERY DEFINITELY
D. NEVER CLOSES TOTALLY - BOAT IS NOT AS EASY TO
 READ - BUT IT IS OTHER THINGS TOO - IT IS RENEWABLE

RENEWABLE CLOSURE!

NEVER JUST ONE THING... IT HAS

EXTENDED LIFE...SOMETHING EXTRA!

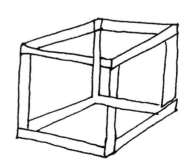

IRRESOLVABLE IMAGES - NO CLOSURE

Figure 96

COMPOSING A MEANINGFUL SUB-STRUCTURE

Any *"thing"* that can be planned or executed with an agenda is obliged to have the quality of movement. If an audience is expected to participate - even if participation means being non-participating - how that *"thing"* is structured - whether the audience is aware of its existing structure or not - conveys meaning.

Simply, the way a painting is put together, holds great potential for transmitting idea and meaning to a viewer, whether the veiwer knows it or not. **The abstract sub-structure of a painting is a silent partner in its success.**

A-B-S-T-R-A-C-T-, many watercolor painters cringe at the mention of the word, indicating a misunderstanding of the word. Anything that is abstract is conceived apart from concrete realities, specific objects or actual instances. In other words, every time an artist paints a representational object, an abstraction is created. The only specific objects are the paper/canvas and paint....everything else is abstract. Paintings, no matter what M.O. is used, are totally abstract. Human beings live in abstractions, go to work in abstractions - even read abstractions. A painter is deeply involved with creating abstractions with the first brush stroke. *"Tuning-out" or "turning off" abstractions is to close a door to creativity.*

Reducing what we see in a painting to its fundamental elements is also a method of abstraction. To extract the ordering of a completed painting's lines, values, textures, sizes, shapes and directions creates insight for future application. Used as a tool for visualizing structural problems, it may save time and frustration.

Photographs as well as paintings may have simple abstract substructures involving shape, value, and size. These abstract schemes show that beneath the representational images, generalized square, triangular and round shapes of differing sizes become vehicles for generalized light, middle and dark values, *Figures 97-98.*

Expression and organized structure are mutually beneficial, each supports the other. Expression without structure is rarely convincing - and structure without feeling easily becomes cold and static. There is no guide for raw emotion - not much audience either. Some painters deny ever thinking about using sub-structure - but it's there, even if the artist denies its existence.

Most jazz musicians and seemingly uncontrolled rock groups still follow the framework of measures and beats - at least to begin and end. The search for new and different structure often means denying all structure, however if there is no structure it is incomprehensible.

The style of painting known as "abstract" is more aptly defined as non-objective. Such paintings emphasize *compositional* questions and *content* answers, found in design alone, *Figure 99.*

The purpose of sub-structure is to **sustain meaning or expression** - Square shapes equal Intellectual solidity. Round shapes equal Emotion, continuity. Triangle shapes equal Action, movement. Dark equals Mystery. Light equals Revelation. Etc. - *See Elements, Section Four.* **Provide aesthetic organization** - Balance - Repetition - Alternation - Rhythm - Movement - Dominance all affect the logical goals of unity, contrast or harmony, etc. - *See Strategies, Section Four.*

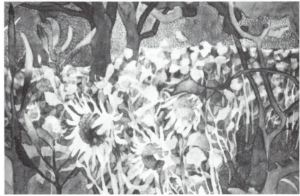

Figure 98

SUNFLOWERS, CUENCA
21"x29"
Transparent watercolor

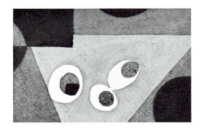

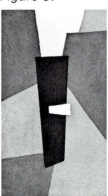

Figure 97

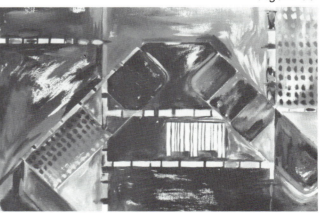

Figure 99

RETROACTIVE, 15"x26"
Transparent watercolor
Miles G. Batt, Jr.

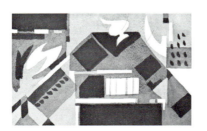

SHAPE ARMATURES AND OTHER COMPOSING DEVICES

Schematic abstractions may explain various compositional ideas involving the other elements of line, texture, color and direction.

Armatures, similar to the skeleton of the human body, or the steel girders in a building, are a concealed framework that function by rhythmically relating parts of the painting to the whole painting. An ideal result utilizes variations of a dominant shape or line characteristic balanced by sub-dominant opposition, *Figures 100-101*. A piece of tracing paper, pencil and a few reproductions of paintings offer an excellent procedure for discovering armatures in other artist's paintings.

One of the most important goals of abstract organizational composition is to generate a *balanced distribution* of the elements used. Just like a central axis point is necessary to the beam of a see saw, an imaginary axis is necessary in a painting. The weights of color, value and texture areas act respectively on either side of that central axis, *Figure 102*.

Repetition becomes a strong organizational tool, taking avantage of the human preference to join like to like and see them jointly. Likeness of color, value, shape, texture, size or accents, form a pattern, a configuration for the viewer, *Figure 112*. Several configurations within differing elements may exist simultaneously. Ideally, each element occupies a separate pattern, *Figure 113*. Repetition produces pattern, movement, balance and distribution.

Abstract sub-structure accomplishes the blending of opposing factors - the interspersing and interacting of opposing elements. *Figures 103, 104 and 105* illustrate some basic abstract color/value pattern plans, utilizing vertical, horizontal, oblique and combined methods.

CARD SOUND, 21"x29"
Rectangular grid over curves

Figure 100

SANTA PRISCA, TAXCO, 29"x21"
Oblique lines over vertical

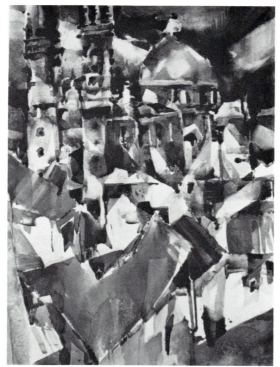

Figure 101

CENTRAL AXIS FULCRUM

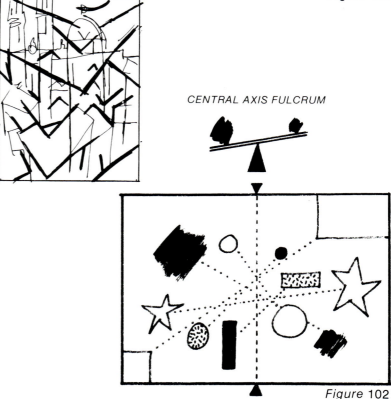

Figure 102

Figure 103

HORIZONTAL **VERTICAL** **OBLIQUE**

These basic value/color band patterns give birth to the...

GRID **CRUCIFORM** **COMBINATIONS**

Figure 104

and other creative compositional structures readily found in nature.

SPIRAL **SKELETAL** **CONSTELLATION** **RADIAL BRANCH**

RANDOM FLOAT **RANDOM LINEAR** **WRINKLE** **ORGANIC OR GEOMETRIC FLOW**

FRAME WITHIN FRAME

THREE SIDED MEXICAN LANDSCAPE, 21"x29", Miles G. Batt, Jr.
This painting blends horizontal, vertical, and oblique, it borrows from other natural sources for compositional structure. Try viewing with different edges as the bottom edge.

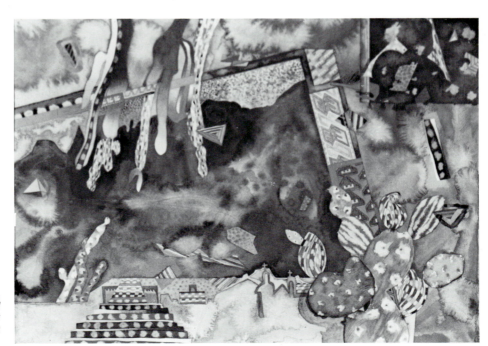

Figure 105

Displacement is a basic idea for combining or synthesizing opposing elements. *Figure 114* schematically illustrates displacing light into dark and vice versa, round into rectangular and vice versa, also rough into smooth and vice versa. The simple idea here is to put some of **this into that** and some of **that into this.**

Permeation is a method for stabilizing a floating shape. *Figure 109* displays an isolated dynamic free-floating shape. *Figure 110* shows that stabilization or attachment may be accomplished by accenting a boundary with a similar shape on top and botton, or right and left or a single boundary. **Parallelism,** accenting a vertical or horizontal within the interior of the floating shape will also stabilize it, by relating it to the direction of the outside edge. Sometimes a mysterious floating shape is desirable. Sometimes instead of isolation, **passage** - another word for permeation - becomes the goal. *See also Movement, Page-32.*

Passage joins opposites together by urging the eye to move freely. Passage may be affected on any element that the eye will move along with - line, value, color, shape, texture, *Figures 106, 107 and 108.*

Tension, that magical "stuff" painters search for is produced whenever a stimulus deviates from the norm. Situations, elements or images that are not visually completed or mentally resolved the way the viewer expected, result in tension. When something is not quite right, added understanding is required to correct it, consequently, a larger release of tension occurs with the understanding of it. One caution, tension exists between the static and the overstated. Opportunities to employ the abstract idea of tension present themselves hundreds of times in each painting. A *life-giving force* that effects our muscles and our minds, tension is similar to opposition or contrast.

Color tensions occur when juxtaposed colors are not quite complementary . *See Color, Simultaneous Contrast, Section Four.*

Tension upsets our equibrium momentarily - tension is that perfect state of irresolution, *Figure 115.*

Abstract sub-structure accompanies all art forms. Much of Gestalt philosophy, overlapping planes, the Golden Mean, positive and negative shapes, etc, explained in other sections of this book could just as well be associated with sub-structure. **There are many sub-structure devices to choose from and combine. The art of it all may be choosing, discovering, or inventing an abstract sub-structure that supports and reinforces expression, or of itself becomes an aesthetic visual experience.**

106

PASSAGE on LINE

107

PASSAGE on SHAPE, VALUE and or COLOR

Figure 108

PASSAGE on SHAPE and TEXTURE

PASSAGE / PERMEATION

Figure 109

ISOLATED

110

STABILIZED

111

PARALLELED

Figure 112 REPETITION CONFIGURATIONS Figure 113

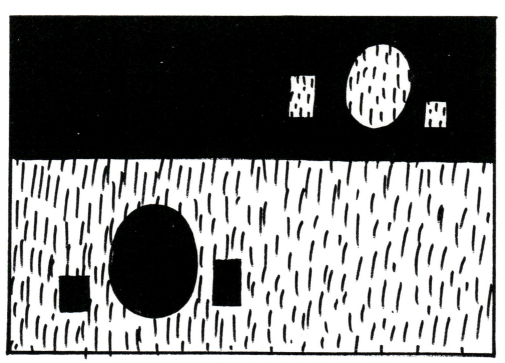

Figure 114 DISPLACEMENT this into that - that into this

DIRECTED TENSION

TOO DISTANT TENSE PAST TENSE

ANTICIPATION

SOMETHING OUT OF ALIGNMENT - INTERRUPTED RHYTHM

ORDERED TENSED OVERKILL

TENSION IS LIKE A MAGNETIC FIELD PUSHING & TUGGING

Figure 115

IMITATING THE RETINAL IMAGE

The representational mode holds the fullest potential for accurately describing and reporting visual details seen in the world around us. The ability to successfully imitate retinal images is considered by the vast majority of human beings as the central task confronting all artists. However this vast majority also responds indifferently to a vertical line compared to a horizontal line - - - - - clearly they have no sensitivities except the one that all sighted persons are blessed with at birth, sight itself. The representational mode will reach a wider audience than any other mode, but it is also the most common carrier - and what it carries mostly is description, ignoring the larger potential for painting to translate emotion through imagination, color, design and structural manipulation. There is a compelling *magic* to all art forms, including the art of imitating retinal images. The Shamans in primitive cultures were considered very mystical simply for having the ability to reproduce images on cave walls.

Almost everyone who decides to paint begins by wanting to duplicate vision. Most do not understand that no one is able to paint what is seen. Representational methods do not replicate objects. That would involve using the same materials as the object itself - you cannot put a tree on a piece of paper. You can produce a structural equivalent using the medium of watercolor. Then shape and value become the operative structural elements.

Under the best conditions outdoors, the natural range of light and dark varies so enormously, that white paper and the darkest paint you can buy, shrink incredibly by comparison. The largest frustration suffered by would-be painters of realism is the realization that representational forms require a disciplined orchestration of shape and value.

Representation as a visual communication method, in the hands of a creative artist, holds great potential. Simple displays of skill which ignore the primary obligations of creativity, result in a representational form that quickly wears thin - *it says nothing - appeals only to those who know nothing, as art, it is nothing.*

Representational modes have been "bum rapped" by artists of other modes and self-serving critics since the camera was popularized - that is not my intention. All painting is locked into natural vision in fundamental ways. Our culture needs representational art forms, they serve many purposes. My intention is to affirm its potential and encourage its creative application.

Artists no longer grind their own colors, make their own paper or brushes - and they don't ride horse buggies for traveling to where those materials are purchased. Reasons for excluding the camera, with all its ramifications, as equipment for creative use by painters, are ridiculous.

The camera obscura and other machines for drawing have been in use since the mid sixteenth century. The names of painters who utilized the camera obscura, and later photography itself, are astounding. Clandestine use of photography is well documented, even among the impressionists - *I thought all those guys painted outdoors.* You didn't think ballet dancers held those poses for Degas while he painted, did you?

Photography and its popular acceptance radically changed the old modes of painting------photography matched the facility of the eye and brain to create illusions of reality.Painters had to break with the imitation of appearances. Today, photography is an art form that is rooted in painting. The structural, two dimensional format similarities are undeniable.

Separating the two art forms and discovering the unique characteristics for creative expresssion embodied in each.....that is the challenge.

IT'S A TONAL VALUED WORLD

It's a tonal valued world, and realistic images are produced by manipulating dark and light values. It is an undeniable truth that humans "see" primarily because of the contrasts of value among shapes in the real world. The representational M.O. is more objective and rational than subjective or emotional. Logic will be our guide.

In Section Four, value was defined as an element to be contrasted. Different value patterns are derived from the direction of the light source and the simplification of its effects, *Figure 116.*

Back Lighting produces strong silhouettes. Gradation and shapes within shapes add animation to this ultra simple patterning. The light source is within the picture hidden behind the veil of value planes and is Oriental in feeling.

Side Lighting creates twice as many shapes. Volume, mass and dramatic shadows result with a light source from the side.

Top Light, a variation of side light, creates a snow laden appearance.

Front Light releases value from its obligation to superficially describe a naturalistic world - color and texture function more completely.

Conceptual value also, is not forced to imitate retinal vision, allowing the watercolorist to maneuver value for results based on ideas. Arbitrarily, value is manipulated by the demand of the two dimensional surface - it obeys no stationary light source - and the desired mood.

HOW TO DO IT!

The three or four value chord system of painting is well known.....and it works. If you want to paint the ordinary genre scene, boats, barns, lighthouses and the like, use it, it's easy! The whole concept is isolated here in this section so the reader can conveniently tear it out, or separate it with book markers for reference.

Teaching watercolor has made me acutely aware that ninety-five per cent of the individuals who ever pick up a watercolor brush begin by wanting to be able to paint this concept. It is also an astonishing revelation to find that ninety-nine per cent cannot even begin to draw what they wish to paint. If you cannot draw it, the hopes of painting it are slim. Learn to draw - you don't need an instructor, just draw! If you need a book, the "Natural Way To Draw," by Kimon Nicholaides is your best buy.

Drawing may become easier by simply drawing the shape that is closest to you, preferably a few interesting shapes that interact with each other, then proceed to draw each shape as it folds in behind, moving back into space, just as it appears to you. Edit it later.... eliminate what you don't want,...then try reversing this process. Start with the shape that is most distant from you and move front, hiding some part of the shape you just finished drawing.

For representational M.O., you'll want to select a view of the subject that provides easy identification and interest - see *Closure,* this section - if you use a camera to sketch, begin thinking about composition when you are looking through the viewfinder.

Not everything you sketch or photograph will succeed as a painting. Testing each sketch or photo for value patterning may save a lot of frustration. Small sketches at first, then through the editing process play around with value/shape placement. Since the eye sees light shapes first, plan to display interesting ones, *Figure 117.* The white shape unifies the boat and house by flowing freely across both. The White shape is balanced by smaller repeats. Purely representational painters use little color - color interferes with objectivity....a simple limited palette consists of any three colors that will serve as yellow, red, and blue. Raw sienna, Venetian red and neutral tint are less intense substitutes painted around the white shapes in various mid-tone values. Salt and some water droplets were scattered into this first big wash. Simple wash shapes that define tree, boat, windows, hill, distant sea and textures complete the painting, *Figure 118.*

Since this is my creation I have the RIGHT to critically appraise its value. It offers not one new insight creatively, it lacks any - except the most obvious - concept. It has instant closure, not much renewable closure. This painting will find a much wider appreciative audience than any other in this book. But it must suffer the worst indictment of all.... *it is ordinary* .

You have the right to paint any way you want, we all do. Judgement becomes a matter of what you hold as important. Historically, however, the painters that make contributions are easily separated from the pack, *they are unique*.

Figure 116

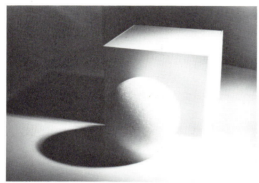

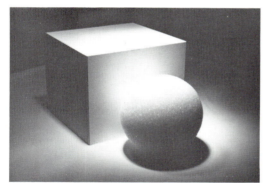

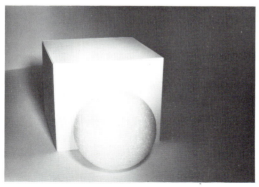

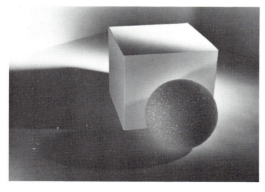

BACK LIGHTING

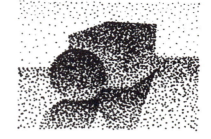

SIDE LIGHTING

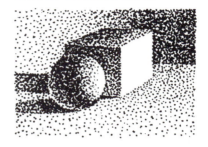

TOP LIGHTING

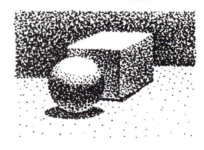

FRONT LIGHTING

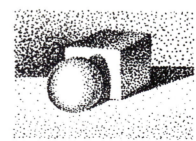

CONCEPTUAL LIGHT

Most watercolor instructors are value painters and rely heavily upon descriptive, representational M.O. This familiar lighting chart, Figure 116, is employed as method for placing values.

The real world however, is not an accumulation of white volumes receiving light, instead, volumes of various colors, producing different values are receiving light.

To overcome this problem color may become severely subdued - limited to neutralized primaries like raw sienna, Venetian red, and Payne's gray.

Conceptual light releases the painter from a light system borrowed from retinal vision, ideas become paramount.

Simultaneous contrasts among values may be creatively utilized to broaden the range potential of value, see figure 36.

Photographers use multiple light sources to illuminate subject matter - painters use ideas, design qualifications and the emotions to suggest alternatives to the representational MO. Value may be categorically descriptive, formative or expressive.

A

B

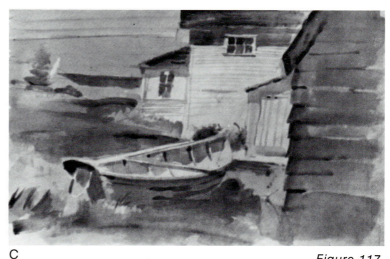

C

Figure 117

A. Photo/sketch of subject uses a vertical format.

B. A horizontal format emerged while searching for a value pattern. Ivory black on newsprint was utilized to locate the white, mid-tone, and dark shapes.

C. Editing extends the left side to include a tree and small white shape for balance.

1. Tracing allows for another edit before transfer to all rag paper.

2. One large mid-value wash isolates the large white shape and smaller scraped light shapes.

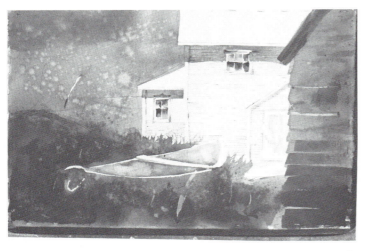

3. Next, the interior of large boat, window shapes and clapboard textures are loosely rendered.

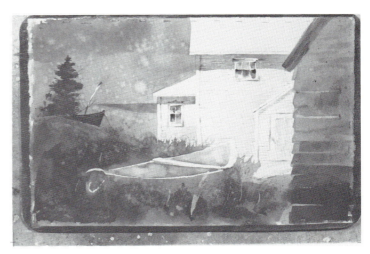

4. The distant sea, dark tree silhouette and small boat are added.

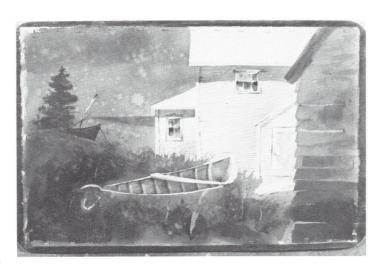

5. Further resolution of large boat interior.

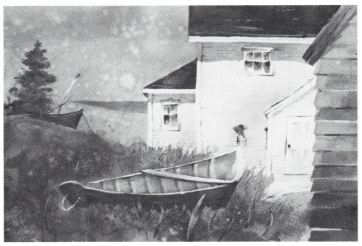

6. Final dark shapes-roofs-boat and finishing detail complete "IT".

Figure 118

LET'S "SEE" HOW WE SEE

Survival for most forms of life depends upon the discovery and gathering of light rays. Most plants and animals on earth have developed light sensitive areas on their skin or surface; worms have light sensitive cells; mollusks have a beaker-eye; some sea life have eyes with a mucus shield; snails an indented retina covered by a transparent tissue; flies have compound eyes able to detect movement in all directions; reptiles can move each eye separately; birds see sideways; vertebrate animals have eyes that are retinal and appear convex - they bulge outward. As human beings, we must analyze and define our sensitivity to light and the environment constantly. Sight is irreplaceable, we have our eyes checked and routinely corrected with opthalmic devices, because even the subtlest flaw in vision hinders the humblest of daily activity. Blindness is perhaps the single most critical handicap a person can endure.

The sun emits radiation in amounts roughly at 250 billions of KG of weight per minute, in every direction. The journey of 250,000,000 miles takes about 8 minutes. On earth we receive only a very small amount of this "electromagnetic radiation."

Wavelengths of electromagnetic radiation are everywhere around us. However, the human eye is unable to see wavelengths like gamma rays, x-rays, ultraviolet rays - all shorter wavelenghts -and infra red, microwaves, radar waves, radio waves, U.H.F., V.H.F., broadcast, band, etc. Of the sixty known octaves of electromagnetic radiation, the human eye perceives only one octave, the visible light bank of indigo, blue, cyan, green, yellow, orange, and red. Just as there are sounds we cannot hear, there are certain things we cannot see, evolution did not equip us to perceive all existing things.

Human vision of external objects begins with the sun's radiation, made of photons, light, striking an object which selectively absorbs part of the light and reflects the balance to the eye. The human eyeball is about an inch in diameter. The frontal surface is exposed, the remainder fits in a rigid socket beneath the canopy of the forehead which, along with the eyebrows, provides minimum protection from the sun and rain. The exposed portions of the eye, the sclera - white of the eye - and the cornea are protected by the filtering action of the eyelashes, and washed and lubricated by the secretion of the salty tears. This mild saline disinfectant is stimulated by smoke, wind, dust, blinking and intense emotion. The tough, transparent, protective layer called the cornea, gathers light rays in a small area and bends them inward through the iris, the colored part of the eye that expands and contracts to control the amount of light entering the eyeball. The crystalline lens lies directly behind an opening in the iris called the pupil. The lens is able to flatten or bulge slightly to accomodate focusing - less able with age - but its chief function is to bend the light rays directed from the cornea through a clear jelly substance known as vitreous humor which fills the main chamber of the eyeball. The bent rays converge on the retina, a ten layer transparent network, as thick as a postage stamp, which culminates in a mosaic pattern of

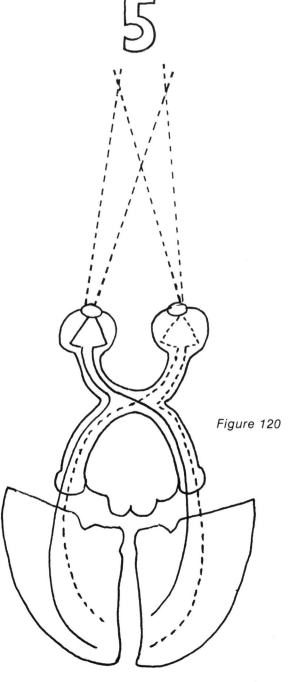

Figure 120

Figure 119

over two hundred million acutely light sensitive cells.

Two varieties of cells exist. Cones are more dense in the center - fovea - where vision is the sharpest for form. Cones register color and are stimulated by bright light. Rods are more numerous but less dense in the fovea, they are stimulated by low light, shades of gray, and peripheral visual movement. Each cell is triggered by light to activity. What is activated is not an image like a movie screen - that never happens - but the receptor cells do receive the light/image in both horizontally and vertically inverted form, *Figure 119.*. A photochemical reaction takes place, setting off nerve impulses that are carried through the optic nerves to the cerebral cortex of the brain, in a manner that has the impluse data from the right retina halves of the right and left eye leading to the right brain; the impulse data from the left halves leading to the left brain,*Figure 120* .

From the cornea to the visual area of the brain, the system is like a complex computer. Exactly what occurs from here is still a mystery, however, the brain registers the electrical stimuli, decodes the pattern to meaningful image through experience only. A comparatively "silent" area of the temporal lobe is where visual and auditory sensory experience is stored. We rarely question the procedure of seeing, being far too busy with the endless procession of our three dimensional world.

Just as everything we see enters via the opening of the pupil, the early camera obscura - dark chamber - utilized a small hole in one side of a portable darkened room, which naturally projects an inverted image of what is outside the room, on the opposite inside wall, *Figure 121*. Artists desiring a more retinal image employed this and other drawing machines to trace from since 1540. Today's artists often use projected images from slides, photos, etc., as expedient drawing tools for aquiring a retinal image. Lest you think projected images will solve all your problems - it's just a drawing - the real work of juxtaposing values and colors lies ahead. If you're going to work from photographs the selectivity occurs with **which** photograph. Working from a poor photograph is the same as working from a poor sketch. Most hard-nosed watercolor instructors make their point about the inadequacies of photography by exhibiting as proof some of the worst photographs the world has ever seen. I wonder what they would say if some of the worst paintings in the world were used as evidence of paintings' inadequacies?

Understanding the limitation and potential of both is important to choosing a method that supports content. The camera is very useful for close-up, short depth of field, and subjects that insist upon moving, *painting cannot compete.* However, when dealing with panorama, deep space, confusing overlapping shapes and countless emotional possibilities, manipulated painted imagery can be more coherent and more expressive.

Departing, even in the most subtle ways, from duplicating retinal images, the artist crosses the threshold to a new realm where perception, experience, and best of all, the imagination participate.

RETINAL VS. EXPERIENCED IMAGES/SPACE

Every animal species, including man, has a comfortable space requirement. Nations go to war over space. Most games of sport define team and player space limitations. We all live in a space bubble and react as soon as our space is violated by either backing away or challenging the intruder. Architecture is designed for human movement and aesthetic pleasure. Gothic cathedrals were designed so that space would be an emotional, spiritual experience.

Space as it affects the aesthetics of painting either moves **into** depth via illusions or functions **on** the surface in a two dimensional manner, *Figure 122*. Painting is a two dimensional art form, offering only the down to up and side to side element of shape for artists to work with. Whenever depth appears in a painting, it is entirely an illusion. The most effective spatial illusions bow to the flatness of the surface through moderation of volume. Thrusts into space are balanced by thrusts that systematically return from deep space. Deep spatial *"holes"* in the surface violate painting's fundamental two dimensional existence. Most *"holes"* or *"dead spots"* result from painting what you see. Antidote: modify volume and perspective, avoid shapes that rush to a vanishing point, minimize detail, maximize distant shapes, utilize flatter shapes, make the surface count as surface, *Figure 126*.

Each element used for designing a painting offers potential for spatial control.

Approach the Eye	Recede from the Eye
Thick Lines	Thin Lines
Light Values	Dark Values
Rough Textures	Smooth Textures
Warm Colors	Cool Colors
Large Sizes	Small Sizes
Large Shapes	Small Shapes
Horiz./Vert. Directions	Oblique Directions

See Figure 124

There are three basic methods for controlling retinal space:

Juxtaposition - among similar size shapes, top shapes recede and lower shapes approach.

Relative size - among similar shapes, small shapes recede and large shapes approach.

Overlap or interposition - in the visible world, quite often one shape interupts another. The painter may employ the space describing properties of overlapping shapes, *Figure 123*.

Comparing paintings that imitate retinal vision to paintings that are derived from experience or concept opens

Figure 121

CAMERA OBSCURA

 # SPACE **NO RIGHT/NO WRONG**

INTO SPACE ILLUSION OF DEPTH

SIMILAR TO LOOKING INTO FISH TANK

OR

SURFACE SPACE

POSITIVE & NEGATIVE

NO PICTURE BOX

ONLY REAL SPACE BETWEEN SHAPES

NO ILLUSION - TRULY MEASURABLE

Figure 122

SPACE - 85

the door to creative use of space, and the clear difference between objective and subjective images. *Figure 128,* is an experienced cubic shape. Analyze it....a cube is a square, period! If we turn it around six times there are six square shapes, exactly the same. As an experienced shape, we can touch it, and trace our finger along each straight side, and each right angle. When we use **only** our eyes, moving around the cube - distortion and subtle untruths creep into our perception. In *Figure 127,* the visually perceived cube indicates that only the front square is the same as our experience of the cube. The side we see indicates that the far end is shorter and the angles are not right angles. Railroad tracks never meet on the horizon just as roads do not. Our eyes deceive us....the vision does not match the experience.

Ask a child to draw a picture of his wagon - he will not draw a wagon similar to *Figure 129*....it doesn't match his experience. *Figure 130* with all its creative newness and strangeness, does match his experience. There's a wheel on each of the four corners and the loop on the handle that he pulls it around with....he must show you that!

Traditional painting such as *Figure 118* reinforces the viewer's normal understanding of space by picturing familiar objects in a familiar setting. Sizes of objects and distance between objects are easy to estimate. The viewer sees what he expects to see. Paintings that imitate familiar space relationships will always find a larger audience. *Imitating familiar space relationships becomes an easily attainable result when compared to the difficulty of involving the viewer in creative, subjective space.*

Paintings that represent unfamiliar objects in unfamiliar spatial relationships challenge normal understanding, inducing the viewer to experience creative alternatives. *Figure 132. Plates 2,3,13,18,* express an uncommon spatial relationship. Familiar and unfamiliar objects are interacting. Some of the objects pictured are purposely painted very realistically. These objects become integral elements through repetition. The compositional approaches prevent the viewer from an ordinary experience. Spatial imagination disorients and transports. Compare *Figures 131-132. Plate 12* presents an intriguing compromise....two familiar images are combined to create one image that never completely allows closure. *See Closure, page 70.*

Surrealism, the most pervasive art concept of the twentieth century, demonstrates that the imagination can overcome logic with conceptual images, becoming more relative to our existence than traditional art imagery. **The subjective impulse reveals more than the objective, paint from inside to the outside, rather than from the outside to the inside.**

Conventional realism is reassuring. Because it portrays illusions of the familiar, it supports the acceptable and the status quo. Historically however, the artists of substance have been those who challenged the traditional during their time - their works are significantly **different.**

THE OBJECTIVE	THE SUBJECTIVE
Rational Space	Spatial Irrationality
Imitative Realism	Four-Sided Viewing
Diminished Sizes	Exploded/Simultaneous Views
Linear Perspective	Color Push Pull
Volume	Positive & Negative Shapes
Overlapping Shapes	Surface Embellishment
Familiar Subjects	Invented Subjects
Description	Unfamiliar Settings
Logical	Symbolism
Realistic Lighting	Unearthly Floating
Atmospheric Effects	Emotional

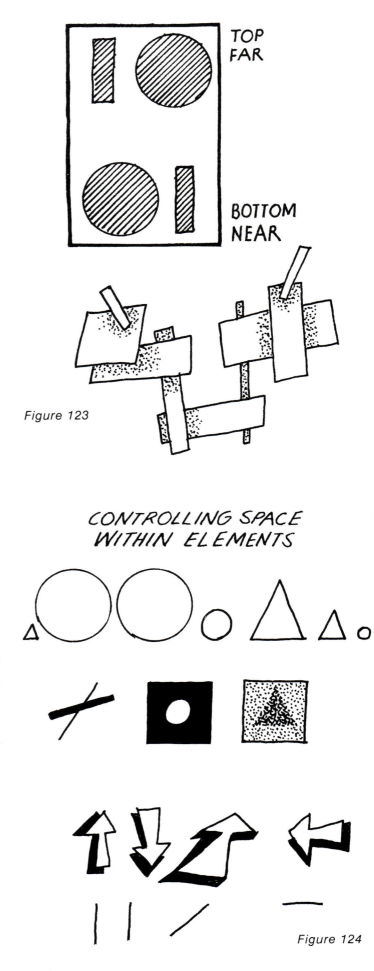

TOP FAR

BOTTOM NEAR

Figure 123

CONTROLLING SPACE WITHIN ELEMENTS

Figure 124

Figure 125

DEAD SPOT

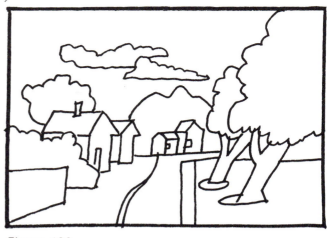

Figure 126

Figure 127

Figure 128

PERCEIVED
RETINAL DISTORTION

EXPERIENCED
FLAT SURFACE

Figure 129

Figure 130

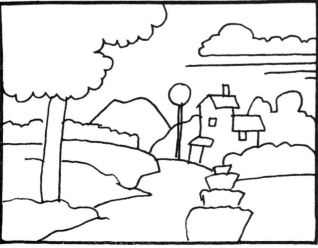

Figure 131

Figure 132

SPATIAL IRRATIONALITY

(CREATIVE SPACE)

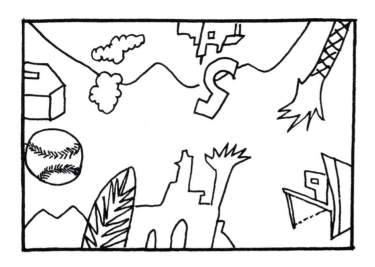

FOUR WAY GRAVITY
ALL FOUR SIDES BECOME BOTTOM EDGE
FOUR SIDES FOR VIEWING

UNFAMILIAR OBJECTS, LIGHTING AND SHADOWS

FLOATING SHAPES

X-RAY VIEWS

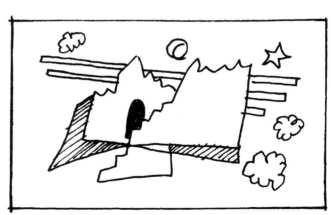

Figure 133

POSITIVE & NEGATIVE SHAPES

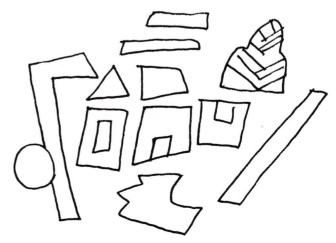

EXPLODED VIEWS

Paintings that conform to retinal vision are so comforting that most viewers resist the distortion of recognizable objects. Nevertheless, modification of forms - **distortion - is required to satisfy expressive and aesthetic goals. Expression begins with distortion**, exaggeration of fact serves to emphasize contrast. Heightened tensions - feelings - result, *see Tension, Pages 76, 78.* Any deviation from normal vision may be considered distortion, just how much distortion is necessary should be determined by the artist's feelings. Distortion still must be comprehensible. Too much or too little may not convey the painter's intentions and may result in an unconvincing painting. **Balance** and **repetition** are strategies for rhythmically relating distortion - exaggeration - to the whole painting. The paintings of El Greco, Van Gogh, Picasso, Blake, Schiele, Marin, Nolde and Grosz, significantly prove the value of distortion for conveying feeling.

Distortion is also an efficient method for preserving the **unity** of the two dimensional surface. *Figure 134* displays the positive shape of an ordinary household scissors. The black shape is commonly known as a negative shape - the shape of no-thing - the background. The viewer has no reason to be aware of the black, negative shape, a "Gestalt" unified whole never occurs. In *Figure 135,* the design has been dynamically modified, distortion functions for the purpose of "Gestalt" **- all areas sustain an exchange of importance.**The negative shape becomes as important as the positive shape...the viewer registers them alternately - positive/negative, positive/negative or white/black, white/black, ad infinitum.

This dynamic modification exercise is an excellent method for analyzing the process of making negative shapes positive. The *"thing"* shape always receives its share of attention by just being a *"thing."* The goal is to create a reality for the *"No-thing,"* negative shape, to produce harmony and an exchange between the shapes.

Select a kitchen item you're familiar with, a tool with some negative shapes or holes in its silhouette. In one example, locate it poorly with no regard for the negative shape as in our Figure 134. Now, for the example with dynamic modification:

A. Observe your selected tool, noting its silhouette/shape. Forget what it does as a tool. Become interested in just its shape.
B. Sketch this silhouette/shape a few times, simplify it, pretend it's elastic. Stretch it here and squeeze it there. Watch the negative shape as you design the positive shape, always mindful that what you do to the positive shape is in turn affecting the negative shape.
C. Confidently change the proportions of the tool, do away with symmetry.
D. Eliminate parallel lines which will create static shapes, and misalign all follow through lines.
E. Try for repetition, contrast pointed shapes with rounded shapes.
F. Avoid touching the perimeter - that will create too many shapes.
G. Corners are dead spots, try to make at least three corners different.
H. Try for a good balance of black and white amounts.
Successful examples will become related through an alternation of equality, positive and negative harmoniously unified.
You'll find many opportunities to use this sensibility to negative shapes. The shape of "no-thing" will become "some-thing" else, positive!

DYNAMIC MODIFICATION

Figure 134

Figure 135

CREATIVE CONCEPT AND WATERCOLOR

WHAT IS CREATIVITY ★ WHAT IS CREATIVE ★ YOU ARE CREATIVE! ★ CREATIVE & OTHER WATERCOLORISTS ★ FACILITY · FLEXIBILITY · ELABORATION ★ CREATIVE NEGATIVES & WATERCOLOR PAINTING ★ TO ERR IS TO BE RIGHT ★ BE SENSIBLE ★ DON'T MAKE WAVES ★ PAINT IT CLEARLY ★ THAT'S NOT MY THING ★ PLAY IS FOR KIDS & FOOLS ★ I'M NOT CREATIVE ★ I JUST WANNA' PAINT ★ UNLOCK YOUR CREATIVE POWER, TODAY ★ POSITIVELY YES! ★ FRUSTRATIONVILLE ★ CHANGE! WELCOME BACK ★ WHO'S AFRAID OF WORK? ★ WHY CREATIVELY ★ THE SAME OLD THING IS ALWAYS CHANGING ★ THINGS GO BETTER WITH FUN

CREATIVE CONCEPT AND WATERCOLOR

Painting is painting!....separating the medium of watercolor from the larger context of painting has stunted a rich potential. There is clear evidence that it is not the medium that is "minor," but rather the thoughtless near-sightedness of the majority of its practitioners.

Severe separation must be acknowledged with the advent of watercolor societies, which began in England in 1804 - the Royal Academy acted indifferently to watercolor artists who did not also paint with oil based paints, denying them membership and poorly displaying their efforts in annual exhibitions. An indignant group of watercolor painters formed what later became known as the "Old Watercolor Society." Because it was an exclusive group, the "New Society of Painters in Miniature and Watercolors" was founded in 1807. Other such groups were formed throughout Europe....by 1855 Belgium had its "Societe D'Aquarellistes" - France by 1879 - it spread to the United States, and in 1886 the "American Watercolor Society" was founded. Today, watercolor societies in the U.S. and Canada number over one hundred.

Well-meaning as these societies may be, they unfortunately are only in recent years beginning to break with the narrow concepts with which they all began in 1807, the imitating of seventeenth century English landscape painting.

Because of the 1807 separation from other art mediums, watercolor was sustained....but it seems to have existed within a vacuum - ignorant of the many changes in contemporary life, artistic and otherwise. The same artists who travel in supersonic jets, travel in automobiles, watch exploration in outer space on TV, utilize modern medicine, and generally avail themselves of contemporary conveniences...insist upon an approach to painting that recognizes nothing beyond the nineteenth century.

Unfortunately, that is the stupidity which has shackled watercolor to its well-deserved status as step-child of the arts. *Watercolor is not a minor painting medium,* the pigments are the same, only the vehicle differs - with similar care they will outlast any other medium.

Joining the mainstream of artistic production, is the key to elevating the branch of painting known as watercolor to full membership status. The fact that watercolor has been separated as a medium is also the reason there is such great potential for *creative concept.* There are so many *ideas* that have not been fulfilled with watercolor.

WHAT IS CREATIVITY? WHAT IS CREATIVE?

Creativity is much like the weather....all artists talk about it, but few artists do anything about it. Many novice and so-called professional painters mistake **recreation** for **creation.** Some are content to read about it; attending classes in so-called "creative activity"; every book publisher tries to work "creativity" into the title, or at least on the dust jacket; the word "creative" stirs the insides with visions just beyond reach. Clearly, the word creative/creativity is sorely abused, even considering its multiple meanings.

The dictionary says creativity is the power to create, to cause to come into being as something **unique** that would **not naturally evolve,** or that is **not made by ordinary processes;** to **evolve from one's own thought or imagination,** as a work of art, **an invention,** etc.

Paintings that are creative avoid the commonplace, the routine, the ordinary. Creative paintings are **different, uncommon,** and **unique,** more unique than the often used rationale that each artists fingerprints are different.

A true state of formlessness doesn't exist for the contemporary artist, which means that creativity involves invention.

Invention: originating, devising or fabricating with the imagination - excercising imaginative powers - rearranging existing elements.
Invention does not preclude discovery, it is dependent upon it.

Discovery: seeing or finding something previously unseen or unknown - to make known - to reveal.

Creativity is a process that begins with the **mind,** without the mind, accident or evolution becomes the formative power. The mental ingredients that play essential roles in discovery and invention are concepts/ideas and emotions/feelings. *Creativity is solving problems with imagination.*

I've experienced discovery and invention many times... *Plate 12* and the other color plates illustrate discovery as seeing something differently than anyone else has seen it. Countless other watercolorists have seen and physically used tie-clasp envelopes. However, none had seen it the way I had when I received one in the morning mail - - - - Picasso saw his old bicycle seat and handlebars as a bull's head, *Figure 141.*

It is poor advice to be told not to **try** to paint creatively - - - - if a painter just paints, praying for an accident or a stroke of good luck, he might just as well pitch pennies to pass the time. To **discover** and **invent** you must test alternatives, *even the craziest ones.* **Shelve your ordinary approaches to watercolor for a while - try creativity, you'll like it!**

YOU ARE CREATIVE!

Creativity is very democratic - it knows no moral, religious or ethnic barriers. Psychologists tell us it is distributed rather equally among humans. Inherited talent or school grades predict very little about adult creativity - creativity depends upon **imagination.** Environment or upbringing have little effect - creativity is a function of the **human ego. You are creative!** Each of us has inborn creative abilities that may be developed and strengthened through **exercise** and **use.**

Who hasn't imagined a catastrophe, or invented a colorful story in their mind? Each night we all dream, what could be more creative than a dream - an **invention** directly from the subconscious? We all have **imagination.**

Who hasn't experienced the self-satisfaction of **discovering** a new way to do something; of changing and improving old things? Your mind demonstrates its great potential for creativity each time you successfully solve the hundreds of commonplace problems faced each day. The smaller problems solved each day, in a creative manner, are extremely important as a **relief from frustration** and are a source of satisfaction.

Creativity is a multi-leveled pursuit - ultimate creativity is responsible for humanity's highest achievements and social progress. Choosing the problems of watercolor painting to tax your personal creativity may never change life....but, *if creativity can serve to free you from the bondage of conditioned responses and ordinary choices, it can do that for the viewer. Creative results are the most exhilarating success you can hope for!*

A creative watercolor painting solves a problem in an imaginative way, **problem solving** and **imagination** are necessary components.

CREATIVE
AND OTHER WATERCOLORISTS

Because ideas/concepts and feelings/emotions are the basic ingredients in painting, *all human beings have a potential for painting.* Artist and non artist share common attributes, the most fundamental being the necessity to create symbols. Lower animal forms rely upon signs or signals, responding to territorial marking by smells, sounds that relate to food, fear, defense, etc. These signs or signals simply direct attention. Man, the highest animal form, not only utilizes signs and signals, but is the only animal that **creates symbols.** Lower animals lead very practical lives, primarily concerned with satisfying simple survival requirements. Man, however, desires a more fulfilling life, and to gain greater control over his existence has developed his ability to think efficiently and communicate with other human beings by *creating* and *using symbols.* Words, pictures, sculptures, music, etc., are the symbols, surrogates, or stand-ins that allow us to relate, refer, or think about something, even if that something is not present. *Literally, all development of human knowledge depends upon the construction of symbols.*

Creating or making a symbol involves transforming experience or information gathered with the senses into significant mental forms like words, images, music, etc. Ideas and emotions become communicable by way of symbolic form. Living, constantly requires participation in the symbol making and symbol reading process. Each person is able to contribute. *See Creating Arresting Symbols, section five .*

The difference between human beings that paint with watercolor and other human beings is the skill necessary for controlling the medium. A watercolor painter simply has a greater degree of proficiency when transforming experience or sensory data into symbols made visible through the medium of watercolor.

More creative painting results may be distinguished from less creative results by comparing paintings and eliminating from creative consideration those paintings that trade on the commonplace, the ordinary, or the cliche. Unfortunately, that would be too easy an answer to be beneficial to the painter desiring to become more creative. The most creative watercolor paintings are produced by painters possessing certain attitudes, characteristics or traits common to highly creative individuals in any field of endeavor.

Creative watercolor painters are:

Willing to work long and hard
More self-sufficient
More introverted
More radical
Less rigid
More tolerant of ambiguous form
More open to experience
More individualistic
More self-confident
More concerned with internal standards for evaluation
Strongly motivated
More impulsive
More observant
Less persuaded by peer pressure
Comfortable with appearing artistically different
Able to visualize mentally

The three categories of *facility, flexibility* and *elaboration* separate the more creative from the less creative watercolor painter.

FACILITY -
FLEXIBILITY - ELABORATION

Facility. Creative results require that the artist not only possess the necessary skills important to manipulating the watercolor medium and a wide variety of knowledge related to art forms in general....but also the ability to utilize this information fluently. The creative artist must be sensitive to what needs to be done, **the problem,** and must be able to know when things are not right....to **evaluate.** A creative painter has a larger mental storehouse of information which enables the recognition of more possibilities, more combinations, more ideas, and more solutions to problems. *Flexibility* is another important element to creativity, the capability to discard old methods of thinking and open the doors to different directions.

Improvisational flexibility is the ability to generate a large variety of ideas as opposed to ideas that are fairly similar, i.e., ten different ways to use a common red brick, such as door stop, pendulum, anchor, missile, hammer, paper weight, measuring tool, abrasive tool , garden edging, to make marks on concrete, step, etc., indicates more flexibility than ideas that are similar, like to build a house, to build a fireplace, to build an outdoor grill.

Adaptive flexibility is aimed at solving a specific problem and involves reinterpreting a familiar material, i.e., utilizing a wire coat hanger to replace a missing radio aerial.

Flexibility promotes unconventional answers and uncommon associations - which most of us define as originality.

Capability for **elaboration** addresses the necessity to redefine, improve, edit, refine, remodel, or fine tune the concepts of a painting with watercolor. The synthesizing of two or more abilities to construct a more complex object. A creative contribution must make an addition to the body of information known as painting. Three general categories under which creative contributions may be manifested are:

Materials:
Creativity with materials involves enlarging the idea of what constitutes a watercolor painting and the techniques of paint application.

Method of Operation:
Adding creatively to the concerns of form and content through representation, compositional sub-structure, or symbolization.

Completed Painting:
Expanding understanding, evaluation criteria, education and appreciation.

Combining the elements of facility, flexibility and elaboration with the characteristic attitudes of the creative watercolorist, *page 93,* provides criteria for creative watercolor activity.

About "novelty" in the arts — the academician claims that anything he doesn't agree with is "novelty" — but today's accepted form was yesterdays "novelty" — nothing remains the same except the deceased!

IMAGE/IDEA

Image/Idea fluency *may be tested by creating at least three simple images from each of the following specific pure shape combinations.*

Your solutions should illustrate fertility of idea and ability to elaborate.

Figure 136

Figure 137

ASSOCIATION/ELABORATION

Create as many symbols related to cooking as possible within ten minutes using the specific pure shape combination of:

Your solutions should illustrate your ability to **associate and elaborate**

Figure 138

CREATIVE NEGATIVES AND WATERCOLOR PAINTINGS

Amazingly, many intermediate and advanced painters side step the issue of creativity....**the obligation to think differently.** It's easy to understand why.....for almost everything we do in our culture we do not need to be creative. Everything in our lives is made easier by routine, or habit. Everyday things like driving on a super highway, regular working hours, scheduled coffee breaks, brushing teeth, shaving, bathing, combing hair, etc. - there is no need to be creative with such activities; in fact, creative thinking in these areas may become life-threatening. Imagine the chaos that would occur if every driver acted creatively at the next stop light.

The attitudes that guide us through everyday problems adopted by a watercolor painter, unfortunately promotes the status quo - it's easier to produce "more of the same kind."

We accomplish much more in our daily lives because of well oiled routine, however, all the arts are hotbeds of imaginative thinking. Creative watercolor painting like-

wise is an activity that **requires new ways** to realize goals - day to day routine attitudes will hinder your creative development.

If you are producing "more of the same" or following someone else's "rules," using "tried and true" formulas, afraid to break the "rules," and generally not satisfied with your results creatively....you're experiencing **creative negatives. A self-imposed process of preventing a creative concept or idea.**

One of the most creative processes you may practice is **changing negatives into positives**. Thomas Edison changed extraneous noise he encountered on a telegraph into the first recorded sound.

The next eight short essays discuss the most common negative obstructions to creative results with the medium of watercolor. **Generating new ideas by breaking through these barriers begins with a keen understanding of each obstruction.**

ICE
CREAM

SHERIFE

IMAGE/IDEA
POSSIBLE SOLUTIONS

A.
B.
C.
D.

Figure 139

CREATIVE CONCEPT - 95

Figure 140

96 - CREATIVE CONCEPT

TO ERR IS TO BE RIGHT.

"Fear...is hazardous to creative painting," this message should, by law, be inscribed on all artist's materials. It is astounding that simple white paper and water soluble pigments can strike such fear into the mental fabric of most watercolor painters.

The fear of making a mistake, easily translates into avoiding the painful but rewarding process of self-discovery. *Fear of rejection* by relatives, friends, and other artists makes a path of less resistance appear temporarily correct. Watercolor painters at all levels may be found compromising their creative desires to gain favorable responses from husband, wife or loved one. This kind of fear can be an imposing obstacle to creative watercolor paintings, resulting in a denial of self-worth and adopting easy answers that exclude the imagination. **Fear,** in its most awesome form, paralyzes the painter into doing nothing - failure looms so large that ridicule or self-rejection are avoided at the cost of not painting at all.

No one wants to fail! Most watercolor painters will go to extraordinary lengths to avoid failure.....or even the sense of failure! However, it is only through failure that we learn. Failure emphasizes what not to do, which is at least as important as information on what to do. Most human accomplishment is a process of trial and error. From each child's first step to exploration in outer space and beyond, *the experience of failure is universal.*

Willingly accepting the risk of failure is fundamental to the creative attitude. If you're succeeding with amazing regularity, you're probably not risking much. Overcoming the genuine fear involved with creative painting is never easy, however there is little that cannot be accomplished with self-reliance and perseverance. Freely admit to yourself that you have fears, and because of these fears or in spite of these fears, go on painting -confidence in your innate creative abiities will grow with each creative success. Did you choose the "different" tree in *Figure 142*.? Choosing any one tree as being different from the other trees may be seen as a correct choice...anyone can see, they are all *"different!"* Our left brain activity - the logical side developed during our formal schooling, teaches us to search for the **right answer.** There very well may be "right answers" to many of the tests confronted by the average scholar from kindergarten through graduate education...but life is *not* that way...and creative painting does *not* present itself that way. Creative painting like life offers many "right answers."..all of which depend entirely upon what you are looking for. If you believe there is only one "right answer," you'll stop looking the moment you find *one.* The number of creative ideas lost through accepting the first "right answer" is mind-boggling!

Did you notice that none of the trees in *Figure 142* is a naturalistic tree? In spite of this, *did you accept them as trees?*

To overcome the *"right answer syndrome"*
Use a plural problem like:
A. How many different ways could this subject be painted?
B. How many different goals can be utilized for this painting?

Answers depend upon the questions asked.....play with the question...it will expand your "right answers."

One idea, if it's your *only* idea, is hazardous. Flexibility is a fundamental key to the creative attitude. Survival necessitates many ideas to compare to each other. This procedure provides more than one narrow, do or die approach.

Figure 141

Keep searching for as many *"right answers"* as you are able to find, you'll know when you've honestly exhausted the possibilities. Then and only then begin the more practical procedure of evaluation and choosing.

BE SENSIBLE

In Section One, *page 8,* we discussed right and left brain thinking. The expression *"be sensible"* is definitely the left brain talking, "everything must be perfectly logical." This kind of thinking is **"closed thinking"**accepting nothing that is vague or exploratory. "Closed thinking" is necessary, however, when thinking creatively, witholding analysis or evaluation encourages the right brain to practice **"open thinking."** Right brain "open thinking" is a process of gathering ideas. In the ultimate situation the right and left brain hemispheres work alternately, but if the "be sensible" left brain restricts the "open thinking" right brain in the early stages, creativity may be sorely limited. Conversely, "open thinking" during the practical stages of carrying out an idea may prevent conclusive results.

"Open" and "closed" thinking each display respective strengths and weaknesses. To be more creative, learn to withold early judgement. Use both "open" and "closed" thinking to utilize their respective strong points.

The various understandable reasons for premature "closed thinking," which stifle creative painting results, revolve around an intolerance for chaos and bowing to "good taste." Picasso claimed that *"good taste" is the primary enemy of the creative artist.* Many truly creative paintings appear quite ugly at first. *If you're worried about anyone else's standards of what is acceptable, your creative quotient will suffer dramatically.*

Chaos is cherished by the creative mind. From confused, "open thinking" ideas are harvested. Creative thinking periods will last as long as a state of mental jumble is sustained. More creative solutions will occur each time you examine the complex of information in your mind. A penchant for an orderly thinking mind may make this stage of creative thinking difficult. But more creative possibilities will present themselves if you are willing to be mentally confused for a time and not become hopelessly attracted to the first few solutions.

Learning to think *is* learning to be creative. Most people automatically associate thinking with logic, but **thinking on the highest level requires both illogical "open thinking" and logical "closed thinking."** To open creatively fertile corridors for your watercolor paintings nothing is more helpful than an extra large application of "open thinking" for *cultivating* ideas, and a proper amount of "closed thinking" for gathering and *evaluating* ideas.

Figure 142

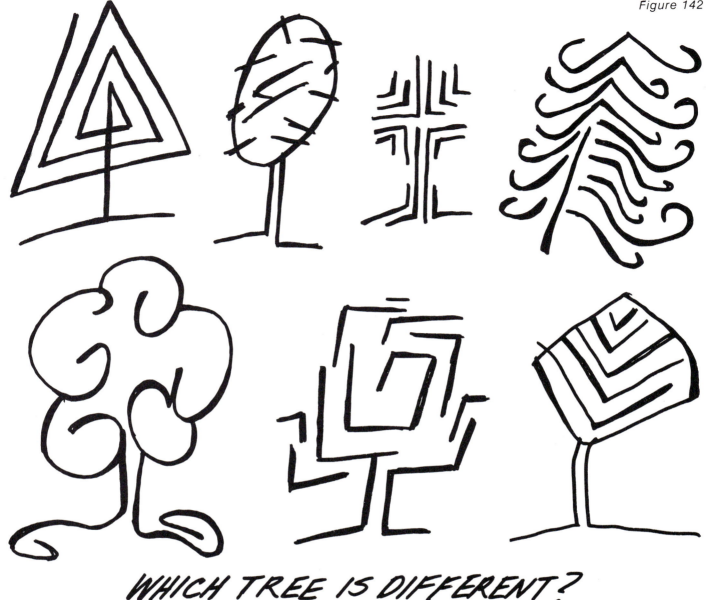

WHICH TREE IS DIFFERENT?

For generating more creative possibilities in the period of **"open thinking"** try "what if" and "why not" questions.

What if there was no color like green?
What if I had three eyes?
What if I had only three tubes of paint?
What if I had only one tablespoon of water?
What if everything could be any color?
What if I could only move my hand one inch at a time?
What if I had to use my opposite hand?
What if I had to paint by candlelight?
What if I had only a toothbrush to paint with?
Why not all straight lines?
Why not very vague?
Why not very explicit?
Why not red?
Why not frightening?
Why not annoying?
Why not what if?

If you have ever acted upon a flash of irrational inspiration, a hunch or feeling....you know the value of *personal intuition.*

DON'T MAKE WAVES

It is *impossible* to be very creative without "making waves" or "breaking the rules." Each of us, painter or not, has a deep-rooted need to conform, *to belong.* To conform often indicates a fear of appearing different. Being creative often *requires* being different. If following rules and formulas are the motives for your painting activities, you may find it difficult to be creative. You do not have to become the stereotypical crazy artist. Adopting an attitude that delights in producing a different kind of painting will go a long way toward more creative results. Try exploring off the super highway that leads to the "same old watercolor painting."

"Every act of creation is first of all an act of destruction," explains Picasso. Paintings that do not cater to mass audiences - more creative paintings - not only *risk* disapproval but *invite* it. **Creative paintings challenge logic, demand that the viewer re-think, change his frame of reference.** Some bit of knowledge or security within the viewer's perception is destroyed - altered forever. Fortunately, this is precisely how every bit of

human progress on this planet has been accomplished.

General audiences "tune out" what they don't immediately understand....intelligent, thinking persons "tune in" what they do not understand....that is the procedure for expanding knowledge. If you "follow the rules" and "don't make waves" it means you're left with only thinking of things the way they are - the status quo.

Creative painters are constantly challenging the rules. Breaking with established patterns is necessary to the discovery of fresh ones. ***With intention, break all the watercolor rules you know.***

*Avoid making your own rules...*if you insist upon painting the same painting again and again, exercising only minor changes, you may be guilty of not only falling into a trap, but setting the trap also. Try paintings that utilize a new vocabulary. Eradicate most of the stale thinking. A brand new start is required every so often.

*Challenging the rules has its drawbacks....*simply playing revolutionary doesn't guarantee creativity. You'll still be required to evaluate results.

Most of life is ambiguous and without logic, much creative painting may appear vague to an uneducated audience. ***If we were required to paint only what is immediately understood by the general viewer, it would be asking much less than we, as painters, are capable of accomplishing.***

Make a list of all the "rules" you've learned from this or that book or teacher and systematically create paintings that openly refute these "rules." The paintings would have to be creative, they're in new territory. ***Rules for painting pictures are silly - don't obey a single one!***

PAINT IT CLEARLY CLEAR

Remember being told to speak clearly and distinctly... exercise good penmanship, clearly express yourself? The everyday, practical requirements of communication insist upon clarity. Creative paintings depend more upon ambiguity! Some of the most intriguing paintings of all time are *unclear* enough to promote many different ways to understand them. The Impressionists are favorites with even the most uneducated viewer - the Impressionists created what must be considered *vague, unclear* pictures - they painted *impressions* of what they saw...not everything they could see. The Cubists also exalted *vagueness* - breaking apart what they saw and reassembling it with paint. *Also see Closure, Page 70.*

Vagueries in art trap the viewer into thinking! The viewer must participate, bring some kind of personal understanding to the painting, or beg off.

Gotcha' questions like: Can you stick out your tongue and touch your nose?, take advantage of thinking that manifests itself in only one direction. The simple answer is to touch your nose with your finger while you stick out your tongue....*Gotcha!* No one said you had to touch your nose with your tongue....you assumed that part of the problem. What is half of ten? The answers could be five, one, zero, or T E *depending upon how you interpret the question.*

A basic theory of humor also takes advantage of a penchant for *one way thinking.* Example: A seventy year old man is having his blood tested in preparation for marrying a twenty year old woman. The doctor feels it is his obligation to warn the man that the marriage could prove fatal,....the seventy year old man replies, "if she dies,....she dies." An old piece of humor which, when analyzed, dramatically displays *one way thinking.* It makes us laugh because our thinking is led in one direction while the punch line reveals the ambiguity of

Figure 143

the scenario and an equally valid though humorous interpretation.

In ***"open thinking"*** sessions it is dangerous to be specific - let your imagination roam. If you fall into a lake you cannot react with much ambiguity....you must swim or drown, likewise when executing ideas, clarity of thought is paramount. Conversely, when looking for a good idea, seeing things in many different ways - practicing ambiguity - may be very valuable. *Look at anything and everything, anywhere, thinking about what else it might be!*

If you concentrate on *finding just one thing* the unexpected will not appear...you'll miss it! Don't look for things in your next painting....*find things!* Pose questions to yourself that are less clear and let your subconscious participate.

To shake myself loose from ***"one way thinking"*** I practice putting my mind into reverse gear - thinking about the *possibilities* of ideas that pursue directions exactly opposite to what seems *"clearly clear."* This kind of thinking is not actually illogical - just a *different* type of logic. Try it!

Figure 144

THAT'S NOT MY THING

Culturally, twentieth century living has led to specialization. competency in almost any endeavor requires focusing upon an area and becoming a past master at it. Maids no longer "do windows," gardeners have become "landscape architects," and plumbers are now "waste water engineers." The more complex our world becomes the more removed we become from each other. *More and more people know less and less about everything.*

Specialization is necessary. Every waking second our sensory mechanisms are assaulted by over 100,000 pieces of information. Our survival requires specialization that supresses unimportant information reaching the nervous system.

On the flip side of this coin, specialization appears as a dramatic hindrance to creative thinking. *"That's not my thing,"* or *"that's not my job,"* easily leads to self-imposed limits that prevent utilizing information gained in one field of endeavor in another field.

A popular TV show was the source of the gotcha' riddle in the last section, *Paint It Clearly Clear.* It was necessary for me to conceive a writing problem it would solve.

Years ago, I watched a contractor mixing stucco prior to applying it to the side of my studio. He poured healthy amounts of dishwashing detergent into the mixture explaining that the detergent made the water *wetter.* Crossing the boundary between stucco contracting and watercolor painting, I've used a drop or two of detergent in painting water, into wet washes, and to keep paint more moist on the palette ever since. Household hint newspaper columns provide useful examples of **cross fertilization ideas** to apply to daily life.

Crossing the boundaries from other activities to the medium of watercolor is easy and fun! Actively search for ideas that show a potential for crossover. Become an **"idea hunter."** *Hundreds of ideas are awaiting discovery.*

Watching a popular TV show discussing Siamese twins cranially attached, suggested the watercolor upside down/downside up, *Figure 145.*

Paragraph headings from news magazines often suggest ideas and titles for rewarding watercolor experiences, *Figures 146, 147, 148,* present interesting titles.

Noticing trends and concepts that prevail currently among other art forms - motion pictures, television, video, theater, literature, become conduits to creative thinkers and what they produce. Movements like abstraction, fantasy, extreme realism, etc., begin as cultural ripples and gain momentum, sometimes becoming roaring waves. *Watch for the ripples.* Proficient "idea hunters" look for analogous situations and similar problems.

Today even though specialization is a necessary factor, role stereotyping by male, female, college graduate or not is unacceptable. Women drive trucks, repair appliances, become law officers, etc. Men cook, housekeep, rear children, etc. Society allows exploration into areas formerly off limits to both male and female. If you are "writing off" your abilities because you think you do not have credentials like a diploma....**think again.** *Degrees and even practical experience have little to do with being creative.*

UPSIDE DOWN, DOWNSIDE UP, 23" X 17", resulted from watching a popular TV talk show that focused on Siamese twins.

Figure 145

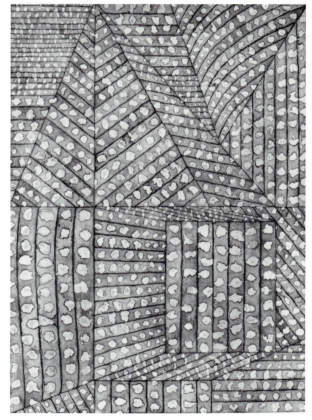

ECUMENICAL COUNSELING, 20" X 14", is an interesting title for a painting. Not descriptive of the painted optical effects. . . the title was suggested by the triangular steeple-like shapes.

Figure 146

PLAY IS FOR KIDS AND FOOLS

Somewhere between childhood and adulthood, **playing** gets a "bad name." Maybe it's parents who keep insisting, "you're not a child any longer, get serious," or "stop playing around, let's get down to business!" Kids can play but adults are expected to "grow up" and put childish things like play in the past. *Unable to play, you're unable to create* - creative watercolor painting is a type of mental play with materials, ideas and reality. **Play is the fertile soil that helps germinate ideas.**

My best ideas occur during periods of relaxing play, periods of letting down and not caring about being right or wrong. Admittedly this tendency toward play and relaxation occurs after wrestling with some problem in a more structurally objective way....sometimes to utter fatigue.

Most of life ultimately places us in right or wrong, win or lose situations, *but play allows us to learn even though we don't succeed....*"after all, it's just a game!" Life usually imposes a penalty for mistakes. **Play imposes no penalty except the time it takes to play...allowing us to learn from our mistakes.**

Drawing and painting materials were an important part of my childhood. Paper, paint brushes and pencils have always been more fun than hard work. Playing allows me to take risks and let down in a way I'd never attempt if it was *"for real."*

Begin by having a fun place to work, surroundings are important. Make it a place where you feel comfortable, a place where you want to be. Plan a practical work area. Have materials within easy reach. Once you've established a problem - *play with it* - refer to Section Four for suggestions. Problem or no problem - play anyway - you'll probably discover some new ideas.

Play is often mistakenly associated with fools - as if fools were the only candidates for such unwise usage of time. There are many watercolor societies that are mostly group-think, therapy groups with tendencies toward incestuous conforming. No one wants to play the fool- - - *no one wants to play* - - - everyone wants to be **"right."** Consequently, everyone is busy seriously trying to outdo everyone else at the same thing. Loss of flexibility walks hand in hand with the inability to play effectively. Become "a fool for a day," play with crazy ideas. *Refer to Free Association Techniques, Watercolor Brainstorming, pages 123, 113.*

Familiarity with all the things around us slowly but surely dulls our ability to enjoy the basic delight of seeing things for the first time. **Play** rejuvenates the spirit

FALSE ECHOES, 17" X 23", is a title and idea advanced from TV radar weather reports.

Figure 147

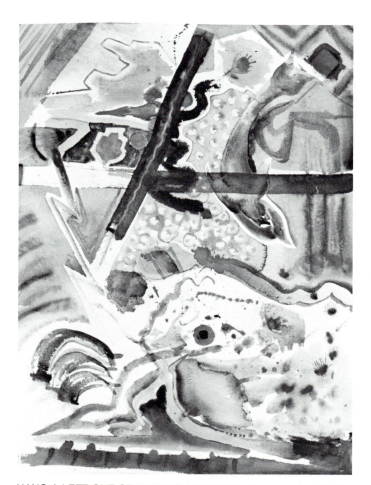

HANG A LEFT OUT OF NUTBUSH, 29" X 21", the engaging title for this good-natured painting was appropiated from a TIME magazine headline.

Figure 148

and joy in the act of painting with watercolor, ourselves, and the world around us, as if for the first time.

I'M NOT CREATIVE

What you think you'll get is what you get in life - and in watercolor too! Barring truly tragic life experiences - and most of them can also be overcome - people become subject to self-fulfilling prophecies. Individually or collectively, human beings believing something to be true, which is not necessarily true, may act on that belief and through that action cause that belief to crystallize.

Experts in the field of creativity have concluded through exhaustive survey that creative people share the distinction of *believing they are creative.* Sounds too easy....but **becoming more creative requires only an unshakeable belief in personal creative power.** Every fibre of your being will subconsciously work toward fulfilling this belief. This basic belief will respond in direct parallel to the intensity of inner desires, a capacity for learning and the act of painting itself.

Discovering more about your creative attitude will result from doing a personal creative profile. List all the good things that make you a creative watercolor painter. List the characteristics that are preventing you from becoming a more creative painter. List what gets your creative juices flowing. When have you painted creatively in the past? What keeps you from painting creatively now? Why?

Reaffirming each morning in a most confident manner that, "I am creative," will automatically make you more creative.

I JUST WANNA' PAINT

Chances are that if you *"just wanna' paint"* - I hear it quite often - this creative section is not for you. Perhaps you'd be happier painting concrete walls or board fences. Some watercolor painters would rather produce mindless paintings than have to think.

While waiting in a supermarket checkout line has anyone asked, "Can I get ahead of you? I'd like to pay for this." If you said yes, someone trapped you in a mindless state. *You responded like a robot.*

Mindlessness is more extensive in behavior than most of us realize. Watercolor painting is erroneously taught as a *formula limited "skill."* Perfecting "skill," passively repeats what we already know. The better we become at what we do, the less we know how we do it. When we paint imperfectly, we are *mindful,* dynamically creating something we are not yet sure of. The moral here is to search for a formula that will produce a more mindful watercolor painting. But change the formula regularly or you'll become *mindless* regularly.

Painting pictures with watercolor is an uncomfortable place to vegetate. Ultimately, comparisons are drawn by those who view your work. Mindless cliches become poor content and even worse form. Novices who "just wanna' paint" and not learn to think creatively, display immaturity born of the frustration with what *must* be learned - what *must* be done. *See Learning, Page 8.*

If you're not intensely interested in what you're doing, *it will show.* Our culture is very intense, much of twentieth century art is judged by its degree of intensity. Manifesting itself in different artists, in different ways, intensity grows from an inner motivation that cannot be taught. Get interested in something *intensely!*

UNLOCK YOUR CREATIVE POWERS, TODAY!

Unlocking your creative powers means exercising the flexibility of mind necessary to a creative attitude. Temporarily, you must forget what you know - - - - forget formulas and ready-made answers that restrict imaginative solutions. Creative solutions to the particular problems of painting with water-based media are discovered off the beaten path. Allowing yourself to think in new directions begins with starting fresh - — - *empty your mind of "how to" routines.*

Forcing yourself to think of or imagine something different may appear a simple remedy for your uncreative watercolor efforts. Fortunately, *it is!* Anything that encourages change may lead directly in a line to the creative answers you're searching for.

If you don't want to be creative, why are you reading this book? Resolve today to unlock your creative powers.

POSITIVELY YES!

Behavior is determined primarily by self-image. If a certain type of painting doesn't fit our artistic self-image, we tend to avoid it. Perhaps less creative watercolorists have very creative watercolor paintings locked away in their subconscious minds. *Lacking the confidence to verbally defend more creative paintings makes a less creative painting acceptable,* and the self-image of easy going, lovable watercolor painter is maintained. Self-image easily translates to *fear of rejection.* Think of rejection as if it were rain. No one escapes the experience of being unexpectedly soaked by rain, relatively harmless, we accept it as a normal occurrence. Likewise, rejection is a universal experience. This knowledge won't remove the *pain* of rejection, but knowing

that it is quite normal should make it easier to deal with. A less than *creative* self-image can prevent an artist from producing more imaginative paintings.

Developing creatively as a watercolor painter requires being prepared to change your self-image to uncover those creative paintings tucked away in the subconscious. We all hold mental pictures of ourselves going through life experiences. *Creative self-confidence is strengthened by winning the conflict between seeing yourself as failing or seeing yourself as succeeding.*

Each time a negative visualization occurs, I stamp it out with a *positive* mental image. As I paint, I *visualize* other people responding favorably...every painting has the potential for success or failure, I prefer to see *mental pictures of success.* Many of my paintings are never submitted to competitive exhibitions, many submitted paintings never are acknowledged with awards, but I hear my name being announced on the audio system as an award winner for *every* painting.

More creative paintings depend heavily upon the *self-image* of being highly creative. *See definition of creative in your dictionary or page 92.*

A positively yes! answer to the question of whether or not you *want* to be creative is the initial commitment.

FRUSTRATIONVILLE

Frustration is wonderful....*it feels so good when it goes away!* When a problem hangs around too long, the result is frustration. The next step is anger and then rage! Sometimes anger and rage produce a creative beginning for a painting, but an enraged mind is rarely rational. When the mind is so occupied with anger, it blocks all possibility of a clear solution.

Knowing when to stem the tide of frustration to *prevent* anger is the problem. *Frustration is an integral part of the creative watercolor process.* I've never met another painter who doesn't regularly experience and control frustration and anger.

Every painter's anger threshold is different. When I notice frustration building, I know I'm either near an answer or ready for a long break. Whenever frustration extends into anger or rage, I must ultimately analyze why I'm angry. More often than not, it is *impatience* that is revealed.

Frustration is an integral part of the creative watercolor process. **Patience is the most potent remedy.**

CHANGE! WELCOME BACK!

Think back to the last time you learned something new about watercolor. *Did you have to change your thinking about something?* The answer is always yes! **Growth requires change!** Why not assume that change will help you grow? It will!

Look for opportunities to change, change style for a while, change hands for a while, change tools for a while, try a new set of colors, a new size of paper, literally *anything that will require you to think in different terms.*The experience is always expanding.

Embracing change perpetuates openness to experience.....mental flexibility.

Change is often thrust upon us from unexpected sources. Most of us can remember how a smack on the behind from Dad could change our way of thinking. Problems we didn't expect to encounter make us think differently. Losing a job makes us re-evaluate. That rejection slip from the last watercolor show you entered - perhaps from the last three shows - might make you *re-think* what you're doing with watercolor. Remain alert and **welcome change,** it probably means you're about to

learn something.

In a time of violent change, it's comforting to know that in earlier times artists were often the agents of innovation and invention. To this day, both art and man have not only continued to evolve, but also to **endure.**

WHO'S AFRAID OF WORK?

Have fun with watercolor.....how often we read the phrase... retrospectively, it is fun...we learn by trial and error which is unavoidably coupled with work. Sometimes the rewards do not seem to counterbalance the effort required. Working creatively requires an extra obligation to work. To discover and invent, the painter **must** reject the obvious cliche results. **Often the most creative results do not find an open armed audience.**

Some artists are comfortable with a regular nine to five work schedule. Others prefer to paint when the inspiration moves them. How much work you expect to produce and for what purposes will determine your working habits. Regularly, I am told by workshop participants...."I have bills to pay and must paint to sell, I have no time to be creative." Painting to sell doesn't preclude creativity, but **the "salesman" and the "creative painter" don't reside in the same body very long.**

I'd rather find other employment than paint with *sales* in mind. Satisfying creative necessities far outweighs producing paintings that may be acceptable to a buyer with money in hand. Setting aside blocks of time to "be creative" is necessary. How you do that is a personal matter.

Mysteriously, rejection and the "work" involved in producing creative paintings disappear as each is realized. **Creative paintings are their own reward.** The world doesn't need another ordinary watercolor painting ...the world always needs the creative effort. **The exchange of money is not the criteria of worth, creative involvement is.**

If creative paintings are your goal, be prepared to dedicate yourself to working more - that doesn't mean you shouldn't have fun - the *fun* is time constructively spent, understanding yourself and the world around you more fully.

WHY CREATIVELY?

Every creative watercolor must embody two mutually related aspects - an opposition to something in the existing artistic situation, and the invention of ideas or new forms. Watercolors that are reduced to continually repeating familiar formats are no longer art, but rather the decay of art....academicism.

Watercolor painters fall distinctly into two groups, those painters who; *are open to new experience;* are impatient with the status quo; are able to visualize mentally; are obligated to discover and invent; are comfortable with appearing artistically different; *and those who are not!*

Being creative means having a capacity for *endless energized* **understanding.** The creative lifestyle intimately involves the painter with the self-rejuvenating life processes inherent in our physical, mental and spiritual existence.

Profound connections between life extension and the creative psyche remain unchallenged.

Visualization techniques inherent in the creative process not only provide meaning and dimension to life, but also play an integral role in the healing process. *In essence, human control and understanding extends from the brain.*

If you do it creatively, you'll do it longer!

THE SAME OLD THING IS ALWAYS CHANGING!

If Mark Twain were writing today, Huck Finn wouldn't be rafting down the Mississippi....he'd be zooming to outer space. **Yesterday's solutions won't solve today's problems.**

Solutions to the problem, "What is a watercolor?," that were adequately inventive twenty years ago, today seem out of step.

Granted, there is not much that is genuinely new in the world of watercolor, still *the obligation to make the familiar intoxicatingly fresh remains.* **The same old thing is always changing.**

Two alternatives are evident....as a watercolor painter you can gather your easel, brushes and palette....and retreat in a flurry of words about how things used to be, convinced through self-pity that you're not appreciated!waiting for the world to call and say, "I'm sorry" won't help! The positive alternative is to go to work....**generate some new ideas.**

Ideas are subject to life cycles - they are born, develop and die!

THINGS GO BETTER WITH FUN

Play produces **fun**....people will do almost anything for **fun.** Mental and physical endeavors are eagerly undertaken with the promise of **"fun."** "Paint with watercolor... it's **fun!"** - most of us picked up our first brushful of paint with exactly that in mind. Only the serious can afford to be *funny.*

Personal characteristics of playfulness and intensity inherit **enthusiasm,** the internal spirit which serves as the origin of **inspiration.** Hope - enthusiasm! That mental ecstasy known to all artists is often experienced as if from divine influence.

Fun/enthusiasm, is contagious - if you have **fun** painting, it will be **fun** to view your paintings. Most of us should remember that our first paintings were painted in a corner of the basement, attic, or on the kitchen table, in search of **fun.** If you eliminate the **fun,** you risk losing the creativity.

"A" type, active, competitive, motivated individuals were once judged as logical candidates for heart attack. Recent evidence strongly supports the conclusion that such activity **sustains** life. Genetics, poor dietary habits, inactivity, non-involvement, repressed anger, and lack of self-expression are now seen as important contributing factors to countless health problems.

Develop your capacity for playing intensely - you'll have more creative ideas - and it'll be great **fun!**

Pursuing **fun** produced *Plates 3, 5, 9, 16, 20.*

IMAGINATION IS SILLY!

IT'S THE THOUGHT THAT COUNTS ★CONCENTRATION★DEVELOPING TWO KINDS OF THINKING/IMAGING★ INTERNAL THINKING/IMAGING★EXTERNAL THINKING/IMAGING★YOUR NEW WATERCOLOR ANCESTORS

IMAGINATION IS SILLY!

Unthinkingly, people regard the imagination as untrustworthy, confusing and troublesome. Acting on the *"open thinking"* of the imagination without necessary evaluation may substantiate that claim. Nonetheless, *Einstein claimed that imagination is more important than knowledge.* Surely he did not have watercolor painting in mind when he said it, but it applies to all creative endeavor. Knowledge is readily available at the next library.... but **imagination** cannot be sought and found anywhere except in your own mind.

A fascinating place....your mind stores, stimulates, manufactures, represses, reconstructs, associates, and overindulges in....*images.*

Producing mental images is exclusively right brain activity. Visual images function differently than the more logical left brain activities like verbalization - thinking from written word to sound and vice versa. Images produced mentally require little or no analysis, and present a *more vivid sensation of active participation.*

As a painter, you must think/imagine with images - where do these images come from? Psychologists have categorized mental images into **five** separate types.

Memory images are common to all humans. Close your eyes and "voila," memory images can place you in different surroundings. Your first grade classroom and any other place you've been may be readily reconstructed, mentally. While talking to a friend on the telephone or writing a letter, it's difficult not to visualize the person you're communicating with. A remembered person, place or thing may produce intense feelings which bypass having to *"see"* a mental picture....instead, *"knowing"* what it looks like. Vivid to some, vague to others, memory images are seldom as accurate as we believe. Revisiting your first grade classroom becomes a paradox of familiar, yet new experiences. Memory images, usually of short duration, may appear to us spontaneously, along with the ability to turn them off at will.

Each of the five senses is able to trigger memory sequences which produce images. Every time I smell leather, I am immediately transported to the basement shoe repair shop our family patronized when I was a child.

Intensely vivid memory images may produce "photographic memory" - *eidetic images.* In its purest form, "photographic memory" is a rare phenomenon that allows a person to read pages chosen at will, from a closed book, word for word. Varying degrees of photolike recall are more common.

Everyone has imagined their car painted a different color, and new drapes in the living room. Using **imagination images,** we test untried waters with uncensored enthusiasm. What would you look like with a different hair style, a face lift, or a new suit of clothes? Images from the imagination have no fixed boundaries between past, present and future. Totally free spirited, *the imagination dares anything.* It's the same creative "stuff" that an architect or writer utilizes when testing possible results. Imagining/seeing completed paintings - or just the next step - beforehand, tests the possibility of a landscape with multiple suns, a landscape with no gravity, a still life totally red, a fantasy in line and color, and anything else you can imagine.

The unattentive mind produces **reverie images.** Daydreaming and fantasizing are a combination of memory and imagination that cross time barriers. Everyone has experienced daydreaming about how a past or future situation might resolve itself. More attached to external reality and sense of personal well-being, *daydreams* become part of the parade of life's possibilities.

Images that preceed and succeed sleep - *hypnagogic and hypnopompic* respectively - occur during the dim, fading state between waking and sleeping, tend to be graphically "real," and seem beyond control.....they just happen.

Sleep experts acrue three to five separate **dreams** to each sleeper each night. Familiar, strange, sweet, bizarre, frightening, pleasurable - persons, places and things hopelessly intertwine in disorder. Dreams are called the perspiration of the mind.....possessing the ability to express subconscious relationships through explicit yet confusing imagery. Memory, desire, fear and imagination combine to produce a *new order* for everyday occurences. Largely uncontrollable, dream sequences often seem to have taken place after awakening, resulting in a confusion of *internal* and *external* worlds.

Rapid beating of the heart, muscular tension, verbal sounds and other physical changes may occur in concert with an alarming nightmare.....likewise going to sleep with a pressing problem may produce an answer. Dream images are in direct contact with the *subconscious.* Have you ever gone to sleep thinking about a painting problem and dreamed an answer? I have!..... *intending to do precisely that!*

Hallucination produces visions or images that are happening in the external world, according to the individual experiencing the hallucination, but not necessarily "seen" or sensed by someone else in close proximity at the very same moment. Hallucinations for most people are regarded as images or sensations erroneously perceived. Severe deprivation of food, sleep and other sensory input - psychosis - mind altering drugs, alcohol, fever, regularly repeated sounds, flashing lights - excessive night driving, prayer or meditation may contribute to the act of hallucinating.

Countless psychological case histories have recorded psychotic artists who refuse treatment fearing loss of their "other world." Some painters claim the need to consume drugs or alcohol in order to function imaginatively - there may be some basis in rare cases - however, the evidence strongly indicates that painted results depend more fully upon having persevered in spite of the mental alteration rather than because of it. An altered mind lacks coherent evaluation.

The general types of internal imagery are not mutually exclusive, tending rather to overlap and become a continuous process. The *external* world of reality and the *internal* world of memory, imagination, reverie, dreams and hallucination share the common denominator of *visual images.* Becoming aware of the differences between image types and sources will enhance your ability to employ your inner processes. *See also, Afterimage Pages 41-44.* Find the imagination at work in *Plates 7, 8, 15, & 21.*

IT'S THE THOUGHT THAT COUNTS!

All creativity is rooted in the wonderful occurrence of an idea. Ideas spring from the subconscious mind..... these ideas are scrutinized for validity. If the ego and the super ego are overly selective, very few ideas will reach the conscious mind level. *When the ego and the super ego - we all have them - are not as selective, a flood of illogical but highly innovative ideas will result.* **Artists create to fulfill themselves as well as to answer the desires of the subconscious mind.**

You will reach further into your creative potential if you give every idea from your subconscious the opportunity to try to sustain itself. *Twenty ideas of which only five or six have true creative possibilities will produce more than no ideas at all.* Record every idea you have in

a small sketch-diary book - 4"x6" - visually, and verbally, with no concern for their ultimate validity. I personally have an ongoing accumulation of ideas, by way of sketchbook, diary, strategy book, that tests handling and theory, plus, a pocket size tape recorder for verbalized recording of ideas. I'll never live long enough to execute all these ideas, even if I only select the potentially creative ones.

To think is to imagine and vice versa. It must be the thought that counts.

CONCENTRATION

Visualizing and painting with watercolor requires concentration, *the fixing of the mind on one thought or image and the ability to hold that fixed single mindedness.*

Sitting quietly and trying to count your breaths will produce involuntary thoughts in the consciousness, causing those with less ability to concentrate to lose count.Thoughts about anything and everything may be expected - basic associations will carry you from one thought to another...how is Aunt Harriet doing?....she bakes great ginger **bread**....**bread** cost a **nickel** more last week....I used to know a girl named Pauline **Nichols**.... people's names are funny...they become popular, then **fall** out of style....how did Aunt Harriet **fall** anyway?, etc. Thoughts will arise but they can be controlled to strengthen the ability to concentrate. Three methods may be practiced to repress unwanted distracting thoughts.

Try *eliminating* the thought entirely as quickly as you can - stop it as if swatting a fly - eliminating the thought allows you to get back to the counting, breaking the train of thought that may arise.

Another method entails concentrating on *each breath* and its effects. Deeply experience each breath - how it feels - its temperature - its duration - its texture - its color - how it affects your body - the muscles it moves - the oxygen you take from it - analyze each breath and then count. Your mind will be discouraged from wandering and you'll appreciate breathing more.

Practice the third method on *objects*. Place any small object where you are able to see it completely. Gaze directly at the object. Notice particularly its shape, size, value, color, texture and the relationship of its parts to the whole - nothing else - only the object. You'll be surprised at how the mind wanders in just a minute or two.

Successfully identifying with only the object gazed at, will produce a state of *less self-involvement* - you'll forget you exist - only the object exists - you become the object! Special properties of alertness, and clarity of thought become yours by such concentrated participation. You'll "see" the object for the first time - with all its potential - free of desire, attachment of labels, cultural expectations or functions. New information, feelings, ideas and images result. Time and space disappear, replaced by a *pure experience of psychic awareness.*

Any method - praying, meditation, repeating a mantra, etc., that strenghtens concentration develops the capacity to focus attention which leads to relaxed alertness.

Have you ever "really looked" at an exciting watercolor!

DEVELOPING TWO KINDS OF THINKING/IMAGING

Through our eyes we are bombarded constantly by images of the outer world of reality. We take the objects we see for granted as being real and separate. We see things that are touchable, some we can taste and smell, some objects also make sounds - all proving their existence.

In silence with eyes closed, the mind presents mental pictures from the past; envisions the future and dreams - thinks - beyond the boundaries of time and space.

Most people will tell you they know very little about their inner world and place even less importance on it, but claim full acquaintance with the outside, "real" world in which they must work out their lives. Involvement with the external world fills some people's existence so completely that they are rarely, if ever, cognizant of their inner world. Many think of the *inner world* as not to be trusted.

Amazingly, people see what they "want to see" when observing an object in the outer world of reality. A supersonc jet may be a sophisticated way to travel to someone who has never traveled in a jet plane. To some, jet flying is merely a conveyance from here to there; aerodynamically, it's a marvel to an engineer, aesthetically satisfying to others; a horribly noisy nuisance if you live in an airport glide path; and absolutely frightening to an avowed non-flyer or aboriginal tribesman. *Depending upon who we are and what we are interested in at any one moment, we will "see" what we want to "see."*

The inner world is as valid as the outer world, and often structures the outer world. The senses are fooled constantly. Whenever a person, object or situation is out of its easily identified place, we may mstake it for something else; a snake in a river often turns out to be a tree branch...and crowds still gather to be fooled by the Lochness Monster.

The outer world is not a single immutable reality.....the mind of the observer cannot be separated from perceived reality. We all "see" things differently.

When you're creating a watercolor painting you are obliged to **balance these two worlds** - many watercolor painters rely too heavily upon imitating the outer world, stifling the only contribution an artist can make....**the gift of self.** Internal joy, sorrow, fear, anxiety, peace, etc., is as real as any mental image attributable to an external source.

Every artist acts and reacts based upon a uniquely different pattern of life experiences. **Creative paintings depend in extraordinary measure upon the equality of the inner and outer "real" worlds.**

INTERNAL THINKING/IMAGING

Memory images, reverie images, dream images, and hallucinations are types of image making involuntarily shared by all humans. Categorically they are **subconscious,** seem to simply happen. We receive these subconscious images rather than summon them. The secret to receiving such images is involved with the ability to relax - to lower brain wave activity to a subconscious level. Various exercises may be practiced, what works and what doesn't may become rather occult.

Procedures employed to produce a receiving state of mind begin with removing all external stimuli - noises, lights etc. - by choosing a quiet place and time. Lay down, eyes closed, arms at the side with legs uncrossedpause momentarily. It is imperative to relax the entire body - deep rhythmic breathing clears the mind, helps eliminate distracting muscular tensions, and provides for the flow of *internal images.*

Progressive, auto suggestion, relaxation techniques require concentrating on a body part like the feet. Mentally talk to them suggesting that they *relax.....*with feet completely relaxed, pause, then move on to the ankles, using the same procedure for lower legs, knees, thighs, pelvis, abdomen, back, chest, fingers, hands, forearms, upper arms, shoulders, neck, jaw, tongue, top of head, forehead and finally, the eyes. Now, calm and relaxed, deepen the state of receiving in preparation for

inner images by riding an imaginary elevator in a wonderful ten floor building. Moving from ten to nine, to eight, etc., with the weight of your body becoming heavier as it descends slowly, more relaxed from floor to floor until totally relaxed in a basement room with a lighted piece of blank watercolor paper on a wall facing you - you are now mentally at a level of relaxed awareness. Here the parade of mental images can be experienced more clearly and vividly. You may now auto suggest lines, colors, shapes, textures, patterns, subjects, etc., as starting points for the subconscious to generate images from.

Often, I've received images of *completed paintings.* Returning to full consciousness merely requires auto suggestion to resume normal activities, refreshed and relaxed, with the mention of a certain word or number. *Recording* received visualizations directly after resuming normal activities is an important part of the procedure. Sketch the visualization, describe it with notes, verbalize it to a tape recorder......anything to facilitate *remembering* it!

Practice perfects - reaching the subconscious may become easier. Practicing creative artists are able to close their eyes and relax briefly to begin receiving images. In recent years, I've become especially receptive during reverie periods and prone to *flash images* during brief periods of diversion.

Imagination images - the singularly voluntary type - when utilized for watercolor painting, necessitates the ability to *consciously* produce mental image situations - problems or solutions - without deliberate organization, freely associated. *See Imagining Answers, Page 123.*

Most people tend to group all visualization under the function of imagination......*but the imagination acts* **uniquely** *as a part of conscious thinking.*

EXTERNAL THINKING/IMAGING

As a watercolor painter, you cannot make something new out of nothing! *You must be exposed to an environment that stimulates you in some way - physically, visually or psychologically.*

Commonplace activities like sketching the external objective world are extremely important. **Shared experience or point of departure** is important for the artist and a key for viewer appreciation of your inner or outer world sources. *Many watercolorists erroneously halt the creative process by accepting the immature results of a sketching trip.* **Ideas need nurturing and development to fully mature.** Sometimes requiring repainting, refining or revamping. The ready market for cliches and ordinary watercolors nips the creative painting at a seedling stage.

Activity with a sketchbook serves two fundamental goals exclusively, collecting **information** or **composing** paintings. When collecting information, the virtues of a camera should not be overlooked - the camera's veracity is unchallenged, albeit cold and limited. Any well known brand of 35mm camera will suffice for recording informative pictures of what "things" look like. Accompanying drawings complete the process of collecting information. Sketching the outer world with the goal of composing may also utilize the camera - choice of format, vertical or horizontal, maybe tested along with imposing geometric space division upon representational subject matter. *See Representational M.O. Page 79. See Meaningful Sub-structure, Page 73.*

When thinking compositionally and sketching the outer world, the inner world has a great opportunity to "shine." This is the time to change things - compose according to inner dictates - make it **your** composition! For **your** painting! *Figures 149, 150, 151* were my compositional sketches for **my** painting on *Plate 2.*

YOUR NEW WATERCOLOR ANCESTORS

Have you ever thought about changing your ancestral tree? Are there a few relatives you'd rather not be related to? Perhaps you've never thought about your watercolor ancestors - yes, we all have watercolor ancestors - those artists upon whose shoulders we nimbly balance. In more esoteric terms we call them *eclectic sources.*

An interesting method for growing as a watercolor painter is to **stop** worshiping at the altar of your favorite painter and *move on.* Amazingly, many watercolor painters, especially during their formative years, surrender the opportunity to grow creatively by hanging on to the smock strings of their favorite instructor or painter until they've lost all hope of self-identity. The penalty always imposed on such unthinking behavior is to be forever labeled as "looking like —— ," - *you fill in the blank.*

There is no need to bear such a burden. Change your eclectic sources.....begin by visiting your local library. Check out the art books with paintings in them that you either *do not like,* or *do not understand* - the ones you do not "see" what anyone "sees" in them.

A good formula for growth is change!

See Change! Welcome Back!, Page 102. Re-learning the same information over and over is unproductive. ***Your creative powers will expand rapidly by diligently exploring those areas you do not understand.*** Admit to yourself that you do not understand - then actively pursue comprehension. Cross the boundaries of medium. Stop reading the books illustrating ordinary watercolor paintings. *Search for the creative product.*

Carefully analyzing other creative paintings and the lives of the painters who produced them may strike respondent chords with your motives. I find comfort in understanding that the creative path with all its vigorous emotional and intellectual activity is never easy, engrossing.....but not easy. Books touch other creative lives with words.

I am not advocating that you "copy" someone else for a while. I am suggesting that through understanding other artist's works, you'll expand your work.

The person who invented the wheel did not close the book on the wheel! Another individual put cups on it and *"zap,"* the waterwheel. Some other person put cogs on the wheel and *"shazam,"* we have a gear, etc. Additions to discovered forms fall under being creative within a discipline.

New combinations of established forms are where many new forms come from.

Knowing what is currently "happening" with other painters is helpful. Don't overlook any possible source for stimulating your next painting. Many years ago, I began keeping a "morgue" - a file of reference material. Pictures, color schemes, value patterns, textural examples, geographic locations, styles, titles, advertising layouts, line drawings, brush drawings, lettering styles, cartoons, catalogs, animals, logos, action/movement, and many other general categories, including other artist's works, are clipped and filed from every magazine I receive. Begin a library of your own books. The first thing I do with any free time in a new city is visit the biggest used book store. The mental stimulation is pure heaven. Ideas utilize basic patterns as foundations. *All you need is a handle on ideas.*

Figure 149

Figure 150

When sketching the outside world the inner world has an opportunity to "shine". With the real objects in front of you - change things - simplify them - discover some essences. Don't try to copy objects - discover shapes. Compose according to inner dictates. Grant yourself the "permission" to feel something about the subject . Make it your composition! Your painting! Figures I49 and I50 are compositional sketches for color plate 2 and the painting composed for the next year's workshop. View it upside down too!

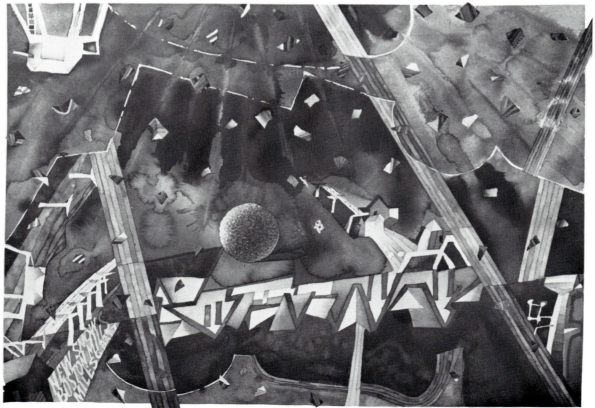

NEW SNOW, BOSTON MILLS, 21" x 29"

Figure 151

A HANDLE ON IDEAS

SIMILARITIES ★ IT LOOKS, TASTES, SOUNDS, SMELLS & FEELS TH'E SAME ★ STRUCTURAL & FUNCTIONAL SAMENESS ★ I AM A ROCK ★ METAPHOR · AS OR LIKE ★ PUNS ★ OPPOSITES ★ IT CAN'T BE · PARADOX ★ LICENSE FOR POETRY ★ NEGATIVE TO POSITIVE, — TO + ★ PARODY ★ CHANGING YOUR FRAME OF REFERENCE ★ FLEXIBILITY

A HANDLE ON IDEAS

Watercolor ideas! If only we could buy them in handy six packs to go. Ideas are thoughts and concepts that have the possibility of being transformed into paint. *Incredibly, many watercolor painters are ignorant of needing an "idea."* Devoting Sunday afternoons to painting in the outdoors and expecting ovations is *naive.* Creativity is a lifestyle and ideas are the product of that lifestyle. **It is impossible to overstate the importance of ideas!**

Rally all the creative watercolor forces at your disposal and systematically bring them to bear upon a painting using one word as your guide and you'll produce a watercolor painting with a central idea. Strong ideas succeed in nature. You're a strong idea, a human being, able to adjust to changing situations.

A central idea is only one of the many kinds of ideas that can be utilized for a watercolor painting. Whenever you receive an idea....two or more of the fifteen billion neurons - small electrical charges running around in your brain - collide, #*!— *click!* The light bulb goes on! An idea occurs.

Ideas are the life's blood of creativity. Receiving new ideas, faith in those ideas and the persistence to build upon them is indispensable to creative watercolor results.

Bauhaus master, Johannes Itten said, "To receive new ideas requires devotion, preparedness, tranquility and self-confidence. To realize creative ideas through the expressive means of art takes sound physical, sensual, spiritual and intellectual powers and qualities."

Three keys open the door to ideas.
Key One: Similarities
Key Two: Opposites
Key Three: Changing your frame of reference

SIMILARITIES

Understanding everything we ever know occurs through understanding the similarity the unfamiliar has with what is familiar to us.

Less is more doesn't work when it concerns ideas. More is always more! *More ideas become more alternatives.* Having only one idea is as dangerous as one basket for all your eggs. All ideas count! The smallest ideas often lead to medium size ideas, which may blossom into your most creative paintings. Play with the smallest ideas, even if you're not sure where they may lead, believing you are capable of making creative things happen.

Developing a watercolor from a **central idea** can produce a painting as organically unified and contrasting as nature - what else could you hope for? A central idea may be a main design theme, a primary contrast, a dominant function, or one emphasized emotion. Following is a list of typical words. Each word has substance enough to base a watercolor upon.

Verticality	Contrast	Complex
Simplicity	Movement	Repetition
Episodicity	Full Color	Punctuation
Activity	Gray	Monochromatic
Detachment	Discord	Soft
Exaggeration	Improvisation	Unity
Fragmentation	Freedom	Alternation
Curves	Restriction	Exuberance
Melancholy	Imbalance	Rough
Balance	Stasis	Tight
Horizontality	Bizarre	Smooth
Variety	Tense	Hard
Angles	Sequence	Harmony
Perfection	Limited Color	Garrish
Unreal	Real	Calm
Probability	Oblique	Loose

Free association sessions, - see *Imagining Answers, Page 123* - no matter how open or free, eventually end in more or less organized associations. Similarities or analogies between things we understand or arrest from internal and external sources - ideas, concepts, systems, and abstractions - tend to repeat or reoccur. No matter how eager we are to "experiment" few of us act without reason for very long. Reason becomes the *permission* we need to go on experimenting.

Free thinkers must promote a state of receptiveness for collecting similarities/analogies. A creative watercolor painting requires the joining together of different, apparently irrelevant elements.

Recognizing similarities - the "common thread" - between different persons, places and things, is vitally important to individual creativity. Understanding expands as exposure to similarities grows.

Similarities are almost always hidden in casual or accidental likenesses/similarities, and are easily overlooked by an individual not prepared to catch them. As a creative watercolor painter, you should **actively collect similarities.** Begin by asking the question; Watercolor is similar to ————— , because —————. You fill in the blank. Asking just this type of question produced *Plates 1, 5, , and 21.*

Watercolor paintings are just like a mailing envelope, *Plate 12,* because....they are both similarly rectangular; both can be mysterious; both can be held in one's hands; both may literally become the carrier of an idea; both can exhibit marks; both are subject to colors, values, textures and sizes; both depend upon glue for substance; both are formed by way of function; both can be used to replace toilet paper if you become lost in the woods, etc. Each similarity you can collect and record has potential. Fill in the blank with anything you like - "see" what similarities you can find - then use the intriguing ideas for watercolor paintings.

Try this procedure with any two objects. A bicycle is like a bird because....both move through an extraneous substance called air; both go from place to place; some birds and bicycles have the same names; some have similar colors; both are interesting to children; both can move on the ground; both have moving parts; outstretched bird wings are similar to handlebars on a bike; both can carry small things from here to there; both have skeletal-like structure; both maneuver easily; both can move in a straight line; both can move in circles; both depend heavily upon balance to function; both may be seriously injured if they crash into something solid; etc. Whether or not you can eventually utilize these ideas as watercolor paintings is totally irrelevant in the gathering stage. One acceptable watercolor idea is worth scores of unproductive ideas. *Plates 4, 10, 19 and Figure 152,* illustrate how watercolor is similar to the ocean.

All ideas are effective stimulation for the imagination, see *Imagination, Page 105.* Simple comparisons of different things that bear small resemblances discovered through direct, personal sensory examination, on a logical or emotional level, are non-symbolic. *Symbolic similarities are involved with internal and external visualization images, may be fantasy or metaphor, and tend to lead to larger ideas.*

TROPICAL SEA / RHOMBIC RHYTHM, 17" X 23" employs pure geometric shapes, and gray rhomboids on tropical colors. The technique of encouraging watercolor to crawl under low tack tape and finely sprayed water produces a fluid surface. This painting is not a portrait of an ocean, rather an invention similar to the ocean. See color plates 4, 10, and 19.

Figure 152

Figure 153

Figure 154

BODY

WINGS

Figure 155

Figure 156

IT LOOKS, TASTES, SOUNDS, SMELLS AND FEELS THE SAME

In search of similarities, **comparing sensory information** aids in discovering and inventing the graphic forms necessary to a creative painting. Test for looks like; tastes like; feels like; smells like; sounds like; analogies. Similarities may be small and on both an *emotional* or *logical* level.

The two compared objects, places, etc., may have similar lines, values, textures, colors, sizes, shapes or directions.

Wonderful, imaginative, creative areas, textures, patterns, and symbols will result through careful scrutiny of anything and then systematically inventing painted equivalents. *See Creating Arresting Symbols, Page 68.* I possess a cigar box full of **magic!** Whenever I need a break, I spend time freely creating samples of invented textures, patterns, and color combinations - like swatches of fabric. Not only does this practice build your watercolor vocabulary, it also gives you a place to reach for magic! Can you paint a watercolor that "sounds" like rock music? "Tastes" like spinach? "Smells" like the mountains? "Feels" like fog, etc.?

The "feel" of the wind is present in many of Charles Birchfield's, 1893-1967, later landscapes.

"Smells" of the sea are undeniably a product of a John Marin, 1870-1953, seascape.

"Sounds" often became the central themes for the paintings of Arthur Dove, 1880-1946.

Alert all your senses for gathering and comparing information. Associating similarities will assist you when you're discovering or inventing a watercolor painting. See Creative, Page 92. "Rock Music and Shrimpers, Shem Creek, SC," *Plate 13,* graphically portrays a variety of *sight and sound similarities* combined with all three M.O. *See also M.O., Page 66.*

STRUCTURAL AND FUNCTIONAL SAMENESS

Similarities are to be discovered between seemingly different elements through close examination of structural and functional sameness.

Structural similarities compare not simply surface appearances, but rather likeness of design logic or engineering schemes. *Figure 153* illustrates the sameness of a palm frond, the skeleton of a fish and a pine tree; *Figure 155*, the likeness of leaf veins and river tributary patterns and tree branches.

Functional similarities compare analogies concerning how things work. Alexander Graham Bell fashioned the telephone using the human ear as a model. Airplanes use the shape of birds, military tanks are conceived similar to turtles, and electrical circuits function similar to the human nervous system, *Figures 154-156.*

I AM A ROCK

Ideas and visulations may be subjectified through **empathetic projection**. Overwhelming personal identification with an animate or inanimate place, person or thing by a painter can project extraordinary emotion and insight into a watercolor painting. *Vicarious experiencing presents a recipe for uncovering similarities.*

Imagine yourself as being cadmium orange paint - or any other color, water, paper, design element, etc., to assist in solving the problem; **How would this feel next to that?**

To solve problems of technique; can you become a hair dryer? Salt? A wet bloom? A drybrush stroke? Using behavior associations, solutions that evade us, crystallize.

Can you paint the feelings of a tree? What a rock feels like? Or rain? **As painters, we subconsciously mirror ourselves in paint; why not pursue a more profound experience?**

Empathetically "riding a moonbeam" uncovered the theory of relativity for Einstein!

Everything on your paper has a concealed inner life - every wash, every line, value, texture, color, size, shape and direction. You can discover this secret kinetic activity by **becoming** *the element you're dealing with -* **empathetic projection.**

METAPHOR/AS OR LIKE

What do the following words or phrases have in common?

> Float a wash
> Proven track record
> Splash in some trees
> Number one artist
> Strike in a line
> His paintings are knock-outs
> Scrub out an area
> A leap of imagination
> Plow through a wet area
> Lightweight subject matter
> Shoulder of the road
> Head of the nail
> Foot of the bed

At first, you might think that watercolor painting is the "common thread" . . . but simply . . . **they are all metaphors.**

In language, a metaphor applies a word or phrase to an object or concept which it does not literally signify or mean, in order to suggest comparison with another object or concept. We use language very metaphorically.

Metaphors for the creative watercolorist are a form of symbolic analogy - painted symbols that are, as or like. Metaphors are schematics that are similar to the real thing. The painter decides how much he allows the viewer to participate - metaphors do not explain or analyze the idea conveyed - personal metaphors can be obscure, even contradictory. Their function is to formulate new concepts for the imagination. Metaphors make difficult ideas easy . . .

In daily life emotional similarities encourage us to see people we don't like as, skunks, rats, jackasses, etc . . . children as lambs, cupcakes, sugar candy, etc . . . loved ones as honey, sugar, gum drop, sweetheart, etc . . . aggressive as a bull, quiet as a cat, looks like a dog, etc.

Visual metaphors embody all M.O. - super real, trompe L'oeil images and highly abstract images and surrogate images - connecting two different spheres of meaning. *Figure 174,* "Island Living," utilizes **metaphor.**

PUNS

Finding a basis in word puns which utilize words that sound alike or nearly alike, but have different meanings, **visual puns,** employ similar images to emphasize different meanings. Sometimes humorous, odd, or just bizarre, visual puns can become very entertaining as **riddles** requiring resourcefulness to solve.

Often paradoxical - seemingly contradictory but having some foundation in truth - **similarity is the keystone.** *Plate 7,* "Blue Collar Rip-Off," combines two odd objects, a

denim shirt and a red tie string from an envelope, while reminding the viewer of blue collar crime. Imaginative results can be provoked by inventing puns and riddles that *don't work.* Amazingly, while trying to invent the non-workable, the workable may occur.

Isaac Newton is said to have discovered the law of gravity by imagining that the moon behaved **like** *an apple. Understanding similarities is fundamental to new and established relationships.*

OPPOSITES

Opposites teach us as much as similarities! The ability to discern the differences between what information we arrest from internal and external sources - ideas, concepts, systems and abstractions - is vital. Contrast, variety, opposites . . . if it sounds all too familiar, re-read section four, *"Contrasting", page 22.*

Opposition/contrast is the simplest, most dynamic tool of seeing and painting. Within these contrasts it is important to discover **similarities.** If this is reminiscent of the "chicken and the egg" for you, . . . **wonderful!** You've been paying attention.

IT CAN'T BE - PARADOX

A paradox is a seemingly self-contradicting statement that has some possible truth embodied within it.

This book is paradoxical, it's purpose is to make things clearer for you, the reader. But, you are apt to close this book after reading it only to discover you now have more questions than when you began. That's what makes it paradoxical.

No apology from me is necessary, all learning opens new challenges . . . the more information you have at your disposal, the more you'll undertake. **Paradox** is the very heart of creativity. It's those seeming contradictions that become the fertile soil in which ideas grow. Crucial to the process is *discovering* the paradox - the capacity to juggle two contradictory ideas at once. "Grand Larceny," *Plate 12,* is a visual paradox.

Guillaume Appolinaire coined the word "surreal" in 1917. Freud's psychic discoveries added spice to the mixture and the world of the subconscious mind flourished. "Surrealism" expresses itself through *fantasy, dreams,* and *visual irrationalities,* that are beyond nature. The surrealists transformed the fundamental human desire for veracity or truth of image, applied our second key *"opposites"* and actively pictured objects that did not belong together, in places where the objects were unlikely to be found. A unique art form, *plates 7, 15, 24,* use surrealism as a vehicle for paradox.

Word games, puzzles and most recently, video games, are big business. There are so few answers in life that many people actively create games that supply predictable answers if one "follows the rules." Likewise, there are people who find *comfort and meaning* in life, pursuing the answers to these games.

When it comes to art, especially watercolor paintings, the *average viewer* has little patience with uncertainty and may choose not to particiate. If a watercolor goes in a different direction- posing more questions instead of supplying answers - the *average viewer* feels threatened and rejects anything that must be "figured out."

The challenge for the watercolor painter who finds his audience becoming **smaller** *as he becomes* **more creative,** *may be to paint things familiar enough to be non-threatening, but different enough to trap the viewer into reaching beyond the obvious - to* **think and feel.**

Watercolor paintings that offer paradoxes, oxymorons, optical illusions, etc., categorically commit visual heresy - and that's not negative.

LICENSE FOR POETRY

Carl Sandburg said, "Poetry is the achievement of the synthesis of hyacinths and biscuits."

The fundamental problem to a unique watercolor is the creative combining of opposites.

As an artist, you have a license to be a poet - and you don't have to pay a fee to a governmental agency. With poetic license, the watercolorist can accomplish the impossible. Ordinary, everyday objects may become exotic, strange, amusing, and surreal. *A poet is a person who possesses the gift of imagination and creation together with expressive means.*

Brainstorming, a group activity, uses group interaction for the purpose of *collecting ideas.* Ideas are allowed to "bounce off" several minds, each adding to or combining ideas. "Watercolor brainstorming" can be practiced as a solitary exercise if you can imagine being five differently motivated persons; prepare five pieces of paper with the description of one of the five different persons atop each paper - use age, sex and personality type descriptions. Alternately allow each person to contribute ideas for a painting, or how to **"see"** a certain subject matter. Set definite rules for your **"solitary group think:"**

> Criticism is outlawed
> Free wheeling is encouraged
> Every idea welcome
> Crazier is better
> Quantity of ideas is paramount
> Perfection is rejected

Strategically, this should produce many ideas - many may not immediately show promise, **but some will.**

Approaching a problem from *five* different motivations will sharpen your "idea" skills, help you focus on unique solutions and expand your appreciation in the process. Painting five different paintings of the same subject, using a different artist as your guide to each painting, is a variation on the brainstorming idea.

Seven manipulative verbs used as a strategy list can also act as a springboard to new ideas.

Adapt = look for alternate ways to use an image/idea, look for other meanings.

Extract = discover essences, use only a small part of an image/idea.

Simplify = reduce to basic terms, fewer elements, less is more.

Complexify = expand upon, utilize detail, more is more.

Recompose = rearrange parts, rethink and repaint, practice makes perfect.

Reverse = do exactly the opposite, reverse gears, turn the problem inside out.

Combine = ideas "piggy back," two ideas may become one.

Exercises:

Use an adjustable viewfinder, two right angles of mat board,for scanning photos, objects, paintings, etc., for the purpose of isolating interesting parts.

Play "let's pretend," answering the question; "wouldn't it be a unique watercolor if . . .?" **See plates 1, 11, 18.**

Paint images provoked by the smells in your spice cabinet.

Cut out five separate images - things - from a magazine to create a collage - glue them in place - expressing:
An emotion; anger, happiness, etc.
A dream scene
A paradox

Then paint it with watercolor.

Figure 157

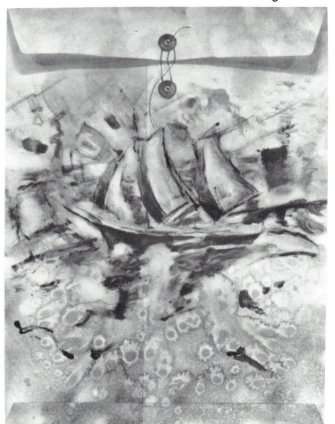

MARIN AT CAPE SPLIT, 23" X 17", comments on John Marin's individualism... puts him in his own bag, especially at his Maine retreat.

DOIN'A NUMBER, 23" X 17", parodies Charles Demuth's famous painting on the premise that the top shape of the number "5" is similar to the top flap of my envelopes. Satire or parody discovers alternative truths. Nothing in the world of art is so sacrosanct as not to be able to endure a bit of good natured fun.

Figure 158

Enhancing the ability to form mental pictures is to exercise the mind's eye - visualize:

An automobile made of marshmallows
A flower made of electrical fixtures
A human figure made from shoe strings
A bed made of spoked wheels
An ocean made of wrist watches

Accomplish the exercise as a purely image function - don't write it down - tape record it - take the written word out of the process. **Develop the mental capacity to image, it's more fleeting, more direct.**

NEG. TO POS., —TO +, PARODY

Somerset Maugham, the famous writer said, "Imagination grows by exercise. Contrary to popular belief, it is *more powerful* in the mature than the young."

Inspiration rarely comes magically out of the blue, instead, this leap of imagination results from thinking processes. *Transforming negatives - eyesores, apparently useless mistakes, etc. - into productive, beautiful, functioning positives is a highly creative activity.*

Everyone has taken something seemingly useless and changed it into something useful, a very *creative* accomplishment. Jackson Pollock, 1912 - 1956, certainly wasn't the first painter to encounter the casual splash and splatter of paint . . . but he was persistent enough to create a unique form of painting by *transforming a negative into a positive* - the thing we didn't want to look at . . . he made us want to look at.

Seek out negatives, knowing you have two paths . . . making the negative a virtue by repeating it - giving it meaning or structural contribution - or do yourself and the viewer a favor by removing it.

Breathing new life into unwanted objects or images requires transformation.

Can you transform the imagery in *Figure 159* into another subject, another thing? Use tracing paper and change the basic structure/image into something new. Turn the image any way you like. Do the same with other images from magazines, etc.

Parody is the humorous or *satirical theft* - imitation - of a serious work of art, employed to *discover an alternative truth*. Parody or satire is pure **fun** . . . it's like Carol Burnett doing "Gone with the Wind" one more time, poking fun at something so firmly entrenched it could suffer no harm.

Nothing in the world of art is so serious as not to be able to endure a bit of good-natured **fun**. *Figure 157, 158,* exhibit **parodies** of some of my favorite watercolorists. If I didn't like these watercolorists . . . I wouldn't bother to be humored by them. I sincerely hope someone bothers to parody my efforts!

Parody turns apparently spent material into a new turn of the wheel, it extends the life of the original, turning a negative into a positive.

Two negatives do not make a positive. But, capitalizing on mistakes and extending the value of anything by adding life to it transforms negatives into highly creative positives.

Thomas Edison transformed unwanted background noise from a telegraph recorder into astonishingly accurate reproductions of sound.

Figure 159

Graphic materials like magazine ads present compositional ideas which may transform ordinary subjects into creative painting results. The little red schoolhouse that is the center-piece of Kennedy Park in Hessville, Indiana, is very ordinary subject matter. But when I imposed the magazine ad its shapes became sidewalks viewed from above. A "gameboard plan" emerged. Turn the page all four ways and discover: houses; gas station; basketball court; swimming pool; diving platform; sliding board; swings; baseball field; entrance to parking; parking spaces; main street; schoolhouse; and apple for the teacher.

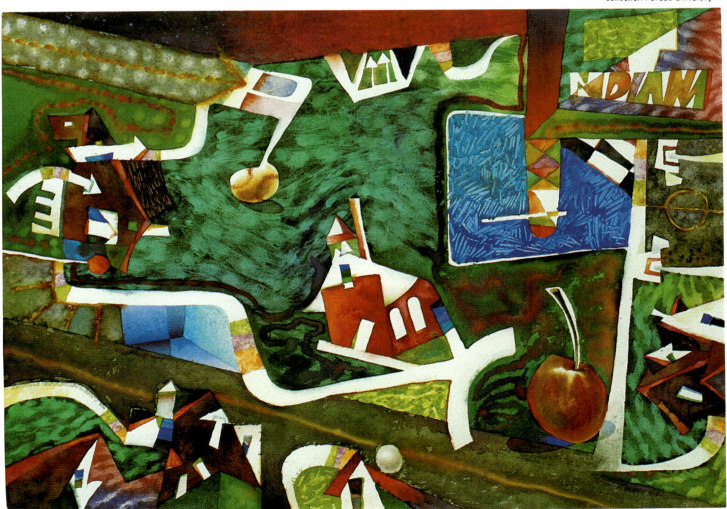

Figure 160 KENNEDY PARK, Hessville, IN, 21" X 29" transparent watercolor,

Figure 161

CHANGING YOUR FRAME . . . OF REFERENCE

Thinking processes that are diffused, humorous, playful, generalized, intuitive and capable of dealing with contradiction become the foundation for a changing frame of reference. **Essentially, creativity will never become a science, it will remain a mystery.** The frame of reference that brings anything into focus may also collapse and tend to support alternate understandings. Is *Figure 161* an obese person's view of their shoes . . . a rear view of a cat with round ears . . . a round room with round mouse holes . . . or a pre-pubescent Mickey Mouse? Is *Figure 162* a man wearing a striped necktie, or a mountain railroad track?

"Understanding" on more than one level serves to reinforce flexibility. Possessing the power to see/perceive various meanings from a single stimulus is imperative to the act of shifting emphasis - **changing your frame of reference.**

Arresting and gathering similarities and opposites will become useless activity if the ability to *change your frame of reference* is lacking. If you cannot accept *Figure 152 and Plate 19,* as being pictures of oceans, you will never gain an appreciation of their essential *ideas.*

FLEXIBILITY

The nature of **duality is flexibility.** Preconceived ideas - *"closed thinking",see page 97,* block the flow of subconscious ideas. Tennis pros claim that the advanced player is often unable to return the easiest of volley shots because his attention is diverted from what is actually happening to what he *thinks* will happen after the tennis ball has bounced. **Learn to trust your sensibilities, flexibility is necessary.** Examine all the facts carefully . . . only then act on those facts.

Simple self tests such as building a watercolor upon the idle placement at three, four, or five positions on the paper, of any one of the design elements are not only fun, but also keep the mind sharp. **Design play dissects creative thinking.** By testing the flow of ideas, flexibility and originality, the capacity to analyze and redefine with the subconscious is developed.

Relaxed alertness is the keystone to successful visual game playing. Fresh ideas from the subconscious will result if you;

Place seventeen randomly placed dots on a 9"x12" piece of paper - close your eyes if you like - "discover" something by selectively connecting the dots. Use only straight lines to connect on one set, only curved on another, alternate the next set. Make up arbitrary rules for accomplishing. Invite a friend to play the visual game with you. Paint the good ones.

Have four or five painting friends each place a shape or mark on your clean white paper . . . invent a painting from those marks/shapes. *Figures 164, 165 and Plate 17* were developed from playing musical chairs with watercolor.

"Shut Up and Deal," is a watercolor game sure to stimulate your mind. Play as solitaire or with a group. On fifty-two index cards, write the following words or phrases - make substitutes if you like, see *"Ideas",page 110.*

White Shapes	Perspective
Colorful	Space
Gray	Balance
Surface Division	Horizontal
Split Complementaries	Oblique
Only Yellow-Red-Blue	Lines
Break-up/Reassemble	Values

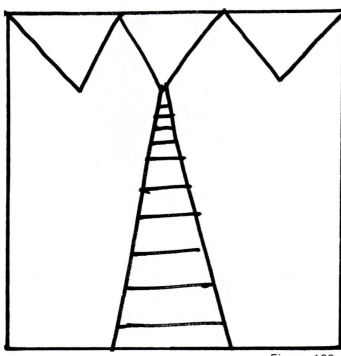

Figure 162

Triangular	Calm
Circular	Overlapping Shapes
Rectangular	Single Shape
Color Intensities	Crystalline
Dark Shapes	Dripping
Fragmentation	Splashy
Happy	Transparent
Melancholy	Drybrush
Intense Color	Wash Shapes
Vertical	Empty
Hard Edges	Full
Soft Edges	Orange-Green-Violet Only
Imbalance	Textures
Movement	Sequential
Exploded View	Bizarre
Complementary Colors	Contrast
Geometric	Harmony
Organic	Repetition
Frenetic	Alternation

Shuffle the cards and offer a blind drawing of a card to participants, all painting the same subject, or *"Shut Up and Deal."*

John Marin, 1870 - 1953, in a long life and a painting career that extended over fifty years, produced only three thousand works. Analyze this fact. If you are familiar with Marin's paintings, one conclusion may be reached, the works deceive us with their simplicity. The apparent freedom was a product of *interacting knowledge, imagination and evaluation.* Marin often spoke of the **"blessed equilibrium."**

Old habits, lack of self-acceptance, timidity, painting the fastest and easiest way, and lack of flexibility hinder the creative watercolor.

Traveling, hobbies, reading and game playing aid the creative process. **Your imagination is your most important possession.** Even the negative forms of imagination - worry, anxiety, discontent and rejection - may be redirected into positive areas to promote creative activity. Airplanes would not fly if the air didn't resist. *Transform your negatives to positives with flexibility.*

At first it may seem impossible . . . but **the impossible is just something no one has done yet!** Test your solutions . . . you'll discover you have plenty of creative ideas.

Some watercolor painters sit on their fat camping stools looking for an idea - having an idea will depend on what thoughts are available to that watercolorist, and will be directly related to that painter's experience as a thinker. There are many good thinkers who sit on their fat camping stools looking for good ideas - but if you don't get up off your fat camping stool and fill that idea with action....someone else may have the idea first!

Figure 163

NOYO, 29"x21", transparent watercolor
Even though I painted this during a creative workshop at the ocean in South Carolina, I was transported to California by the casual paint marks generated by members of the class.

Figure 164

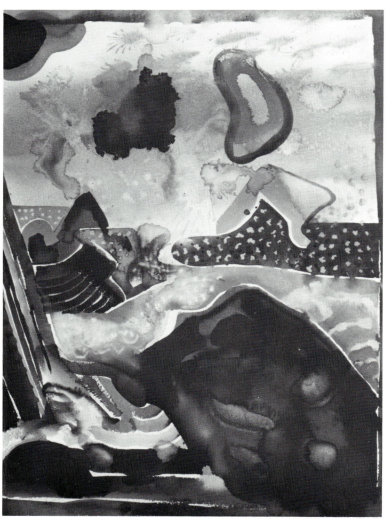

Figure 165

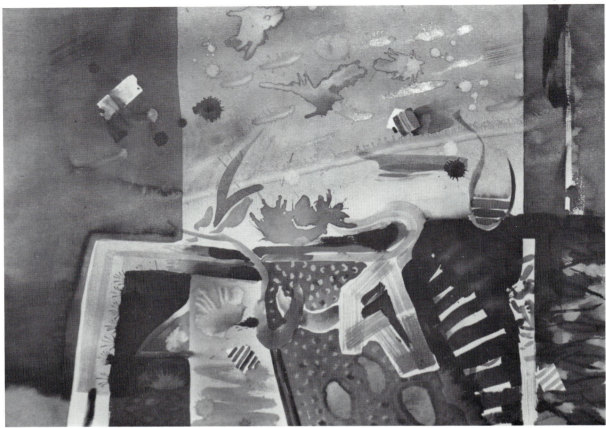

SEAGRONOMY, 21"x29" transparent watercolor

CHARLESTON STARS, 29"x21" transparent watercolor

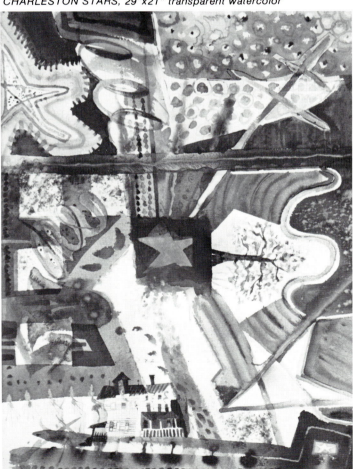

Figure 166

SEAGRONOMY, figure 165, was accomplished on a cold snowy day as a demonstration in creativity for a workshop in Connecticut. Figure 166 illustrates the serendipitous paint marks supplied by class participants. A taut geometric grid was employed to the "discovered" sea vegetation.

CHARLESTON STARS, figure 167, began with seventeen dots and an odd lot of stars, a spring tree, a cross and curly cues left by a particularly creative group of workshop participants. Painting with flexibility as your goal offers many opportunities to exercise the imagination through discovery and invention.

Figure 167

PUTTING THE PROCESS TO WORK WITH WATERCOLOR

SIX STEPS ★ THE PROBLEM IS THE PROBLEM ★ GATHERING INFORMATION ★ IMAGINING ANSWERS ★ RELAX & WAIT ★ LET'S PAINT ★ JUDGEMENT DAY

PUTTING THE PROCESS TO WORK WITH WATERCOLOR

Have you ever struggled with a problem you knew you had the answer to, but no answer came to mind? Often it's as simple as the name of a particular person, place or thing. It's right there on the tip of your tongue . . . but the harder you try, the more distant the answer becomes. Eventually, you give up the struggle and allow your mind to relax and think of other things. Shortly, "out of the blue" the answer pops into your mind.

Answers stored in the subconscious mind are often blocked by the rapid brainwaves of the conscious mind. The harder you try to recall, the faster the rapid impulses become, blocking the flow of the subconscious, and with it, the answer. This common experience has a painting parallel.

Studying and practicing the creative process on a daily basis for years, I have genuine difficulty recalling exactly what happens, what thought procedures take place during the painting process. The most satisfying paintings seem the most difficult to explain. It was as if I had been somewhere else . . . *not in a normal state of awareness!*

Paintings that fail seem painfully clear. Years after their destruction, I'm still able to recall each square inch of a failed watercolor. Possibly, this common occurrence explains one reason why **we learn more from our failures than our successes.**

Psychologists tell us that the creative process functions best in the **subconscious mind.** Consider this explanatory analogy:

Pretend that brainwaves are the images in a motion picture projected before us on a screen in a darkened room. The brainwave/images are being projected on the screen at the rate of twenty-four frames per second. The images are moving normally. **Beta** brainwave rhythms of the human brain parallel this normal set of conditions. When the projectionist slows the frames passing between the light and the lens to sixteen frames per second, we become aware of a flicker effect. Slowed to twelve frames per second, we see what we know as "slow motion" - half as fast as the normal twenty-four frames per second. Now, slowing the frames to eight per second, we observe a choppy movement of images, much like an old-time movie. We are now at the level of frames per second that corresponds with the **alpha** brainwave rhythm. *"Eureka," the subconscious,* the *level of the creative process.*

To understand the full range of brainwaves; slowed to five frames per second, which corresponds with the **theta** brainwave rhythms, we begin to see the separate images that produce motion pictures - like "still" photos. Slowing the images to two frames per second, we are presented with the visual paradox of moving stillness. Classify this level as the **delta** rhythm, produced by the brain customarily during dreamless sleep. This completes the range of *beta, alpha, theta* and *delta* brainwave rhythms.

If we had never seen a movie before, and did not understand how motion pictures were made, this experience would make the process very clear.

Increasing the frames to twenty-four per second, we are again observing normal image movement corresponding to the waking state of beta brainwave rhythm. It is now difficult to remember the slower levels of brainwave/image awareness because we are caught up in the images presently projected on the screen.

The point of the analogy is that the conscious mind and the subconscious mind are distinctly different. The subconscious brainwave alpha rhythm, relaxed but alert, is much more perceptive. We can "look between the frames." This phenomena works equally well for any endeavor that requires relaxed concentration. *See Concentration , page 106.* Baseball players allowing the *subconscious alpha rhythms* to function claim they are able to actually see the laces on the baseball when delivered by the pitcher for hitting. They describe a sensation of slowing the pictures in order to make better contact with the bat. An actor becomes convincing in a performance only when so forgetful of self that he draws upon *subconscious associations* to the character he is portraying.

Putting the alpha waves to work is at times illusive, requiring primarily the ability to relax and concentrate. Some of the best hitters in baseball have slumps and the best of actors can turn in mediocre performances.
Most of us may never paint a masterpiece, but we can all be more creative by allowing the subconscious to work.

The subconscious is a vast storehouse of thoughts, ideas, information, emotions, and best of all, solutions.

SIX STEPS

Slice it, dice it or atomize it . . . creative watercolor paintings don't just happen! I haven't seen a lucky painting yet. **Luck is nothing more than preparation meeting opportunity!** Many painters may deny the existence of any set regimen that produces creative paintings, however, upon closer examination, creative watercolor results - *see Creative, Page 92.* - are generated by conscious or unconscious involvement with satisfying the demands of *six definite steps.* Each painter may place the steps in a different order, and emphasis may vary but the six steps are unavoidable!

Problem = The problem is the problem
Preparation = Gathering information
Visualization = Imagining answers
Incubation = Relax and wait
Performance = Let's paint
Appraisal = Judgement day

THE PROBLEM IS THE PROBLEM!

Creative watercolor paintings result from correctly defining the problem. Many supposedly creative painters are completely ignorant of, or choose not to consider the **problem of the problem.** Producing the same answer over and over using a formula approach eliminates any hope of a creative result.

The watercolor painting,"Fisherman's Wharf, Monterey, CA", *Plate 9* was a class demonstration that began with a definite problem; How can I show this cliché piece of subject matter in a unique way? With the setting of the problem, I *rejected* all the solutions I've seen before! No lazy little fishing boats anchored in the bay at misty sunrise or brilliant sunset; no rickety old piers swaying in the tide with cute little signs, ladders, ropes, arm in arm couples, etc. - I have no hostility towards those things or those painters who paint them, just *those solutions* for creative paintings that are tired, worn out and lacking in any substantive creative power.

Accepting the obligation to present the subject *uniquely,* I've *invented* symbols that identify familiar things in a different way. A bird's eye view spatially, brand new symbols for water, concrete walkways, cannery, boats leaving and arriving, antique cupolas, directional signals, fishboat, Harbor House Restaurant, use of rabatment in a fresh way, etc. All become part of the creative solution. Along with setting the problem, I set the wheels turning toward a creative solution.*Understanding that the problem was the problem, automatically* eliminated the easy solution.

Analyze *Plates 1, 3, 15 and 16.* Can you see that the problem was the problem from the start?

Creative watercolors avoid the ordinary! See Definition, *Creativity - Creative, page 92.*

Choosing not to consider that the problem is the problem - you do have an alternative - *choosing to be less creative.* Setting and solving a less creative problem is easier, finds a larger audience and may even be more rewarding immediately. The answers to less creative problems are included in each of the zillion watercolor books that adorn bookstore shelves.

Your creative problems and your creative solutions lie within you.

GATHERING INFORMATION

Gathering information before you paint - **preparation** - is wide ranging. Some painters must experience for hours or longer, new environments, objects or persons, some require only brief periods of experience with the same persons, places or things.

Painters tend to divide along the line between being *perceptual* or *conceptual,* a thorny if not impossible distinction to draw conclusively, due to obvious overlapping. Both approaches rely upon perception at some point and both also utilize conceptualization. The division occurs through emphasis.

Perceptual painters are more naturalistic, attempting to reproduce a likeness of what is seen before them, externally.

Conceptual painters rely upon internalized images, trusting internal visualization processes and imagination. *See Imagination Is Silly, Page 105.*

Creative results are attainable with both methods. Avoiding the "ordinary" is the only creative qualification. Gathering information should be accomplished employing **all** the senses. The sounds, smells, tastes and tactile experiences of the subject are vitally important - it's the sensory information that you collect with your computer/brain that produces *feelings, intuitions, and ideas.* Picasso claimed if he walked in a forest he painted green paintings as a result.

Ready and waiting for you, right now, stored in the subconscious is a wealth of raw material for creative thinking. Depending upon how much experience you've had with the medium of watercolor, and visual expression in general, there will be some of that kind of information stored there also. **Keep storing everything!** Become completely involved. This kind of preparation is never ending, you do it every day of your life.

Preparation encompasses all random information. Time should be spent gathering information that is free of organization - *Gestalt free,* not knowing where or if you'll ever use it - and information that may associate to feelings, ideas and organization.

"Golf N'Stuff,Phoenix,AZ", is a painting that began as a demonstration for a creative class. An amusement complex that included a miniature golf course became very different subject matter. The drawings, *Figures 169, 170, 171, and 172* were gathered on the spot. Back in the classroom, I began to compose, *Figure 173.* For completed painting, *see Plate 3.* I enlarged upon the sensory data, textures, smells, sights, sounds, lines, values, colors, sizes, and shapes gathered on the spot, plus all the memory image/sensory information stored in the subconscious.

Preparation - gathering information - may involve experiencing subject matter, design elements or strategies, something non-objective provoked by paint and material, or merely mood and random thought.

Planning often produces ideas. Overhauling a problem and breaking it down into related smaller problems within the larger problem can be an effective procedure. Left brain thinking - logical, closed thinking - may be applied as a forceful tool for creating ideas. The peril lies in expecting logical thinking exclusively, to render imaginative ideas.

Figure 168

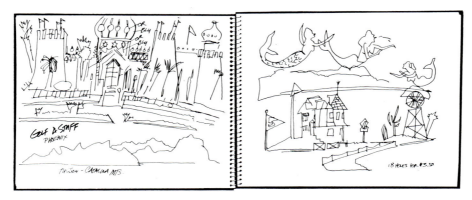

Figure 169

Figure 170

Preparation means becoming completely involved. Preparation encompases all random information - gather information that is free of organization.

Figure 171

Figure 172

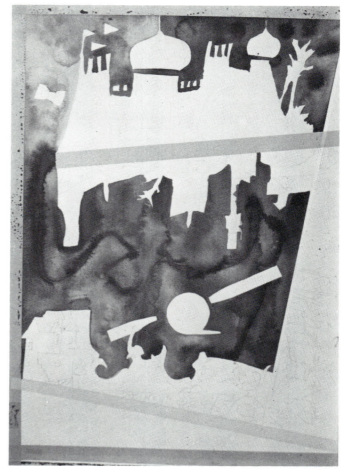

GOLF N' STUFF, PHOENIX, AZ, 29'' X 21'', began as a demonstration for a creative class. A local video game center and miniature golf complex provided an unusual piece of subject matter for exercising my imagination. The drawings were gathered on the spot. Back in the classroom I began to compose, figure 173. Enlarging upon the sensory data gained on the spot, I added all the memory image/sensory information stored in the subconcious.

Figure 173

IMAGINING ANSWERS

After setting a creative problem and gathering information that may or may not solve that creative problem, the imagination enters, center stage. *See Imagination Is Silly, page 105.* **The imagination is a pivot** - a go-between - an interlocutor - between what is; the problem and the preparation, and what might be; a creative watercolor painting.

Right here, free association becomes paramount. **Free association** is the uncensored expression of ideas, passing through the mind to facilitate access to the subconscious.

Because artists *free associate* better with **images** than with words, a Rorschach-like exercise would be optimum, but if you practice with words it will get you started.

Leafing randomly through a magazine, allow your eye to roam and pick out anything it chooses. Write the word/symbol for whatever you've chosen in two columns, like:

Pink	Fur
Hard	Black
Flower	Ornate
Denim	13
Red	Boots
Turkey	Armpit
Glasses	Lavender
Lace	Pointed
Lens	Sky
Circle	Formal
Cuffs	Velvet
Hat	Epaulets
Cycle	Stack
Water	Skin
Blue	Balloon
Tapes	High
Perfume	Silhouette
Mustard	Cigarette
White	5
Cork	Yellow
Rough	Eagle
Ribbon	Royal
7	Earring
Drops	Dots
Gray	Moustache
Medal	Flat black

Casually, without thought or reason, draw lines from one word to another to *freely associate* different words. Some combinations will make sense, some almost make sense, and some, no sense at all. Combinations that make sense have no new associations. The almost combinations are more inviting to contemplate, offering some fresh mental images. The no sense combinations offer creative challenges.

Similar procedures with *mentally visualized images,* will prove to be a *hotbed of creative solutions* for any creative problem. Playing this game with information gathered on the spot, subconsciously stored information, and some bizarre unrelated images, can bring surprisingly creative solutions.

Record your solutions in a "think book" 5"x8" paperback sketch, write strategies that might work on the opposite page. Don't evaluate the solutions - imagine and record them. Literally record them with a tape recorder. And then.....

RELAX AND WAIT

Relax . . . wait . . . you'll be amazed how many more ideas come to mind while you're cleaning the studio, watering the garden, or relaxing in an easy chair. *Keep your "think book" handy . . . you're going to receive some more solutions you didn't count on.* You may consciously think you've stopped imagining, but your subconscious doesn't give up that easily, it keeps working even though you're relaxing. This procedure produces marvelous answers if you're a person with a strong pattern for beginning and completing life's tasks - if you have a good *life "Gestalt."*

This **incubation period** gives your subconscious time to exhaust the imagining possibilities - although another idea may flash to mind weeks from now - and time to evaluate some of the ideas you've imagined.

LET'S PAINT

After relaxing - the time period is always different, through necessity or available time - your subconscious already has done a preliminary evaluation. Examine the recorded ideas, choose one - the others will wait - and *let's paint.*

The performance need not be examined here, you'll do enough of that by yourself on the paper. Begin with the basic recorded strategy from the "think book" and keep alert for possible new directions the painting may take . . . your subconscious may still be providing you with ideas.

As you paint, reward yourself with verbal "pats on the back." Find areas and elements you like, choosing the most positive things. Developing a genuine like for something is much more important at this point than finding fault or things to reject.

The difficulty of performing and criticizing at the same time, on a scale of one to ten, is an *eleven.* Each is a separate act. Fine tuning a picture that is not yet in view requires a certain kind of genius.

Painting is the fun part of this whole six step procedure - **love it** - it's all there is. *See Answers for the Thinking Watercolorist, page-8.*

JUDGEMENT DAY

Temptations to make analytical judgements should be resisted until there is something substantial to appraise. *Breakdown in concentration during the painting process generally signals the loss of subconscious impulses providing a perfect time to stop.* You now either have a start, a painting in progress or, on a rare occasion, a completed effort.

Advising a reader what to evaluate is like *picnicking in a mine field.* So called design laws and rules are subject to countless exceptions and are rendered useless to the creative process. Since this is my book, it is appropriate that I make some constructive suggestions that you can apply without sacrificing creative intent. Try a question and answer session with yourself - ask:

Am I solving the creative problem I've set for myself? *See Problem, Page 121.*

Are content and form supporting each other? *See Content and Form, Page 14.*

What opposites am I creatively combining? *See Contrasting, Page 22.*

Does the painting's sub-structure reinforce the painting's intent? *See Sub-structure, Page 73.*

Is there a dominant M.O.? *See Choosing An M.O., Page 66.*

For fine tuning, ask:

Are my painting and idea unified? *See Unity, Four Ways, Page 28.*

Have I utilized harmony and contrast? *See Harmony and Contrast, Page 26.*

The bottom line question is:

Have I satisfied the demands of creativity? *See Creativity - Creative, Page 92.*

Depending upon whether you're working **directly** - without definite plan - or **indirectly** - with definite plan, will be a contributing factor to fully answering these questions. This process of questions and answers will separate things you like from things you don't like - that's a start. Locating some positives is always encouraging. The negatives must be removed, obliterated, or transformed into virtues. *See Negative to Positive, Page 114.*

Creative painters rely mostly on internal standards for evaluation; if you're creative, you'll eventually establish your own system. Until you do, the critical views of well-meaning friends and relatives are best avoided. They have no expertise and simply won't know what you're trying to do!

Constructive criticism from *knowledgeable persons* can be very valuable. Working out your painting problems through accepting criticism/suggestions and then using those that you deem helpful is a creative way to move in fresh directions - **creative feedback.**

There are no constituted authorities - there are many self- appointed ones. In the final analysis you are creator, painter, judge, jury and appreciative audience of your paintings. No one viewing your paintings could hope to have the sheer enjoyment you've had creating them. Viewers and collectors may share some of the fun, but it's your private world. If your painting symbolizes something for you, that's all that is necessary. See Quality, Page 14.

Anything that's new in the arts - especially watercolor - encounters resistance. **Pioneers always have arrows in their backs.**

Figure 174

ISLAND LIVING, 22"x28", is a visual metaphor, connecting multiple spheres of meaning; islands are isolated, being surrounded by water; a piece of string may surround real or unreal objects; a real piece of string may also isolate painted shapes; etc. See page, 112.

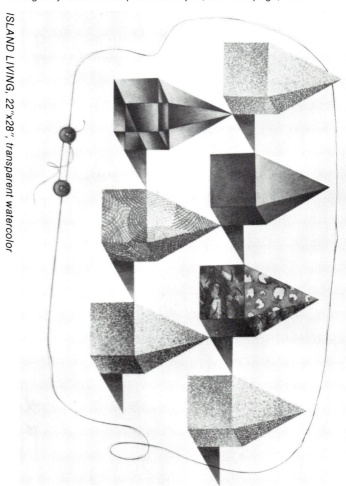

ISLAND LIVING, 22"x28", transparent watercolor

COMPETITIONS

Competitive watercolor exhibitions are curious for all participants. If every painter pursued the same goal, it would be easier to understand and judge, **but they don't.** If every juror was an expert we could support their choices, **but none of them are.** Jurors are briefly given the privilege of emphasizing **their opinion** of success or failure.

We have the right to paint how and what we choose - one of the few areas where such freedom is possible - *why would any thinking watercolorist want to be ordinary?* All creative watercolor painting is subjective. Any other type you may think of is academic. **Laws and rules do not exist.** Individual interpretation **is** the vitality of all art forms.

Most important for me is the search for creative form - the mental activity involved with each idea - *concept.* A watercolor painting that develops from a strong idea or definite purpose automatically conveys oneness. **Discovery and invention is idea and purpose.**

On the flip-side of competitive exhibitions is, they bring out the best in all who participate . . . paintings are put on display! Our lives are enhanced and expansion occurs each time we share experiences with other watercolorists. *Creative understanding and appreciation belong to the flexibile participant, ready for challenging the past one more time.*

CREATIVE CONTEMPORARY
WATERCOLOR AND MEANING

CREATIVE CONTEMPORARY
WATERCOLOR AND MEANING

Through neurological pathways - the cerebral cortex where images are stored, to the autonomic nervous system, to the pituitary and adrenal cortex - *an image fixed in the mind may literally affect every cell in the body.* Why, as painter or viewer, we can be affected to such an extent, remains enmeshed within the *mysteries* of empathetic relationship, point of departure and individualism.

Meaningful watercolor paintings will not result from merely reading a book or learning doctrine. Meaningful paintings errupt or ease from the inside - they **must** be painted - motivated by *inner necessities.*

Watercolor painting like all art forms is necessary to mankind . . . having the power to investigate the unanswerable questions of life. Children and creative individuals ask all the big, unanswerable questions - Who am I? What is God? Where am I going? What is the meaning of life? As an adult, "education" has taught the child to ask the smaller questions that science and academics can answer.

Creative individuals explore questions as yet unanswered. Where else could discovery and invention survive?

If your watercolor carries profound meaning for you, a primary requisite of meaningfulness has been satisifed.

Best of all, watercolor paintings result from acts of hope and faith. One good reason for wetting a watercolor brush is knowing *there will be a tomorrow.*

CREATIVE CONTEMPORARY
WATERCOLOR PAINTINGS

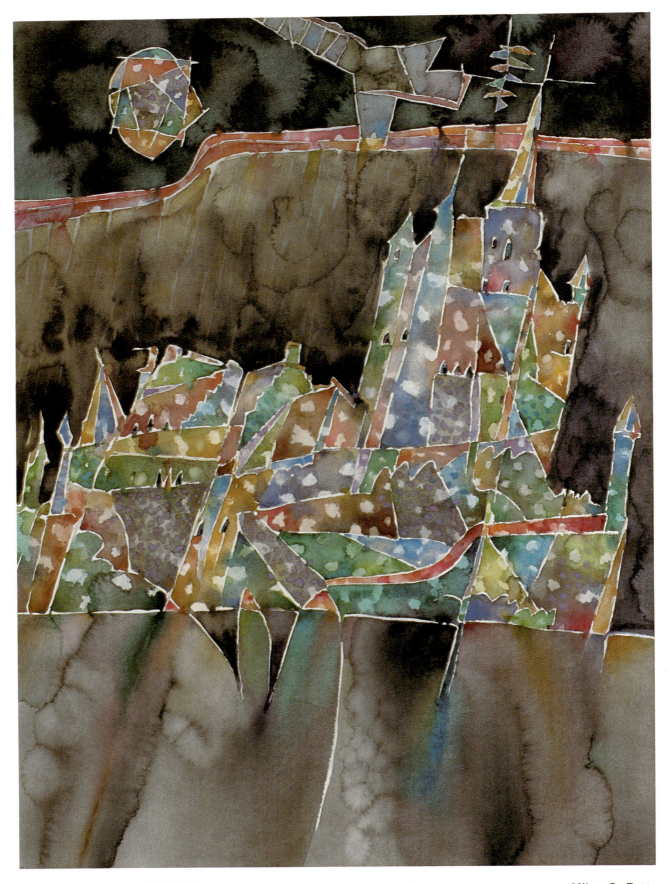

CASTLE IN SPAIN, SEGOVIA *29'' X 21'' transparent watercolor* **Miles G. Batt**

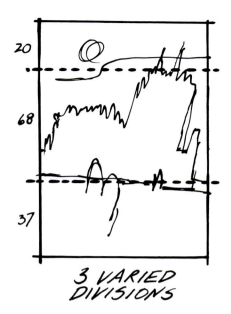

20
68
37

3 VARIED DIVISIONS

ONE VARIED REPETITION

ALCAZAR SEGOVIA, SPAIN

PLATE 1

Traveling in a foreign country and painting creatively with watercolor is challenging. Segovia Spain is home for one of Europe's most exciting castles. Walt Disney borrowed from this castle to produce the prototype used in the Disney parks.

We were allowed only a short time to paint on the spot (not my choice). Most of the other painters in the group attempted a post card view painting. I decided that a charming, tourist folder interpretation was impossible for the allotted time, and less than I was creatively capable of painting. The castle's **shape** was imposing what more did I need? Using the ideas in the positive and negative shape exercise, *pages 89-90,* I drew the castle on a three shape surface division, *page 56,* which created five or six large but various sized shapes. Lines that were painted around became a principle element, *plates 4 and 23.* Subdividing the castle shape with more lines provided additional shapes to place warm vs. cool colors, and tissue blotted textures that were fun to create.

The common dilemma for the less creative painter is what to focus on, if not the post card view of such subjects. I focused on what the castle could be rather than what it appeared to be. Specifically, I concentrated on reducing the panorama to a few large shapes and the *"passage"*, page 76, from

one to another; *colorful vs. colorless; warm vs. cool; rough vs. smooth;* and *repetition.*

The gray shape in the lower section is animated by opposing colors mingled in the wet into wet handling. Looping oval lines are the remnants of what was a tree studded foreground. Turn the page upside down and find that the steps and a small tree originally at the base of the castle now enhance the upper shape. *"Open Thinking"*, page 97, allowed me to move subject matter, and play with *"closure"*, page 70, creating extra interest. The celestial body is rendered to harmonize with the castle. Isn't this painting more stimulating than a postcard view?

Techniques used:

Flat shapes chosen for their variety and intrinsic interest; severely reduced subject matter; painterly, watery, paint manipulations balanced upon a loose geometric sub-structure.

Fresh water introduced into nearly set washes produced the wet into wet water textures. Additional colors were glazed into areas when dry. All the white lines are white paper painted around, allowing for some bleeding to produce passage across shapes, avoiding a coloring book result.

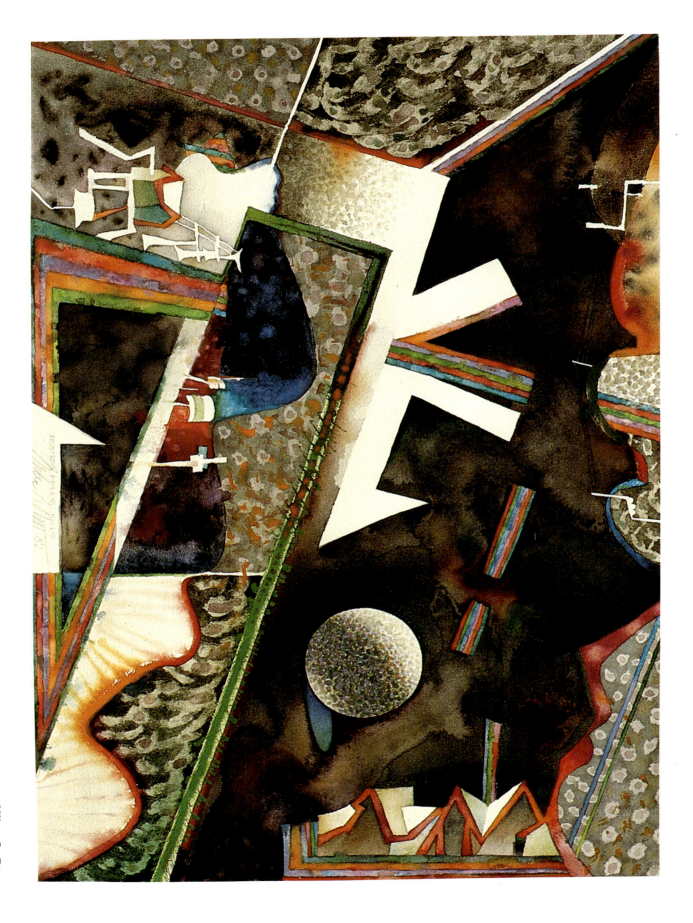

21" X 29" transparent watercolor

Miles G. Batt

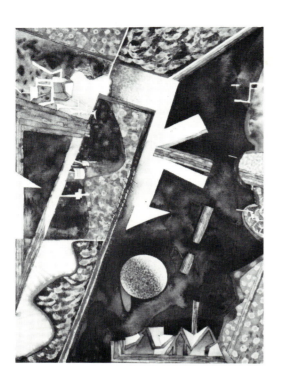

Refer to figures 149 and 150 on page 108 for composition and information sketches.

PLATE 2

Boston Mills, Ohio, is a winter ski resort. During the recent summer, off seasons, the complex was transformed into a beehive of watercolor activities for students and their painting instructors. Motivating others to paint creatively has forced me to search within myself for fresh concepts, new ways to release myself from conditioned responses when expressing feelings.

Without an idea and having promised to demonstrate creatively on the final day of the workshop, my subconcious presented the sketch/idea above, in the middle of the night.

The award winning painting "Boston Mills, Hills", is the result of the imagination and *"internal thinking"*, *page 105*, the overlapping of involuntary image making when memory, dreams, and even hallucinations contribute to the creative act.

I have never been on a pair of skis on a snow covered slope, but I do have an active, fertile imagination.

The imagination is a pivot between what is and what could be.

Using a visual vocabulary, perhaps only decipherable to me, this watercolor becomes a narrative of what it must feel like to ski down the man-made hills at Boston Mills. Beginning with the white arrow on the bottom edge and continuing on the colored stripes up the slope with the attendant ski lift, following to the white arrow with the striped plumage that races down the hill - oblique direction above the undulating hills - toward the right.

Gravity loses its normal pull upon the images that cling to the top and right side. These images, the partially revealed architecture of the lodge, on the right and the additional hills with ski lifts, wires, etc. on the top seem to obey only the central axis around which all two dimensional shapes play. See *"Balance"*, *page 27*.

The large dominant dark shape is a throw-away, negative shape, but it's an interesting shape enlivened by liquid textures, warm and cool color nuances, and relieved of its flatness by the saddle stitched ribbon and the volumetric moon, quasi snow ball. Can you identify the *repetition* functioning within this painting? Check the balanced repetition of similar colors, textures, stripes, and white shapes.

Techniques used:

Wet into wet was used directly to perform the large dark shape. When dry the more subtle animating warm and cool colors were applied using a *glazing technique*, *page 18*, various tissue blottings texturized allocated areas, which were then energized by assorted color markings. Pointillist-like dots invigorate two flat areas and serve to produce a volumetric looking sphere, which also effects a triangular configuration of these dotted repeats. See *"Other Composing Devices"*, *pages 74 - 77*. The green furry line/shape running from center to down right was the result of an airbrush operated close to the surface.

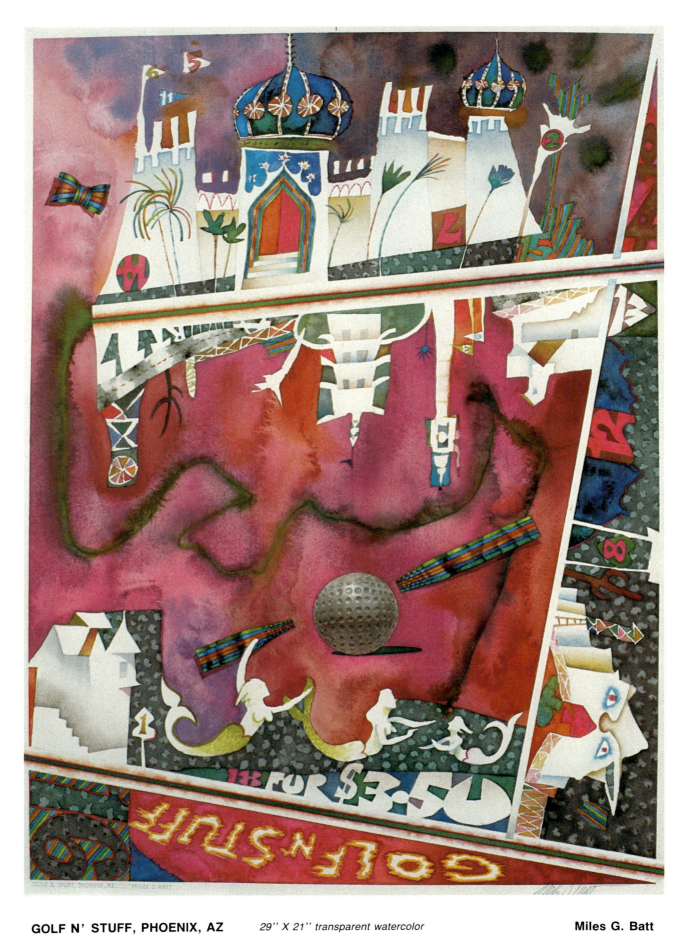

GOLF N' STUFF, PHOENIX, AZ *29'' X 21'' transparent watercolor* **Miles G. Batt**

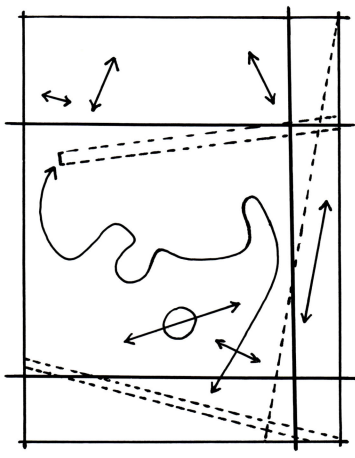

SHIFTED 3 DIVISIONS
OBLIQUE STRAIGHT LINES
BALANCED BY CURVALINEAR

PLATE 3

Selecting unusual subject matter can result in an unusually creative painting. A video game center and miniature golf complex becomes the unusual subject matter for this exercise of my imagination, *page 105.* "Golf N' Stuff, Phoenix, AZ" received three national awards before purchase.

Evolving from information collected on the scene during a class dealing with creativity, *page 122,* unity among contrasting elements was fulfilled largely through an orderly weaving or connecting of the parts.

Repetition of color, texture, pattern, shape and style are easily recognizable. The gray tissue blotted shapes are repeated in a balanced scheme. "Realistically" painted ribbons and golf ball find a repeat in the bow at top left. Blue colored domes find repeated color in the mountain at the right hand border and the arbitrary blue shape at the bottom left edge. Coloristically this watercolor is a dominantly red painting - the largest area is an unusual variety of reds - ranging from orange red orange, through red red violet. *See "Repeti-*

tion, page 30, 74. **Displacement,** putting some of this into that and some of that into this, *page, 74,* is at work with the shifting of some red into areas other than the dominantly red shape, and vice versa. Oblique - dynamic - directions are dominant **balanced** by jerky curvalinear directions.

To help reduce the overwhelming number of visual objects on the scene I conciously selected and simplified shapes. Choosing to represent only a few of the eighteen miniature golf holes with its "around the world" theme.

This fully realized creative statement makes the exotic familiar and the familiar exotic. **Eureka!**
Techniques used:

A variety of low tack tapes were used on main division line/shapes. An airbrush was used to furrow the fuzzy green line/shape through the large red shape while it was wet. Wet into wet was used to animate the largest shapes balanced by the indirect wash techniques of surrounding areas.

Refer to figures 169 through 173, page 122 for working sketches and first washes.

21" X 29" transparent watercolor

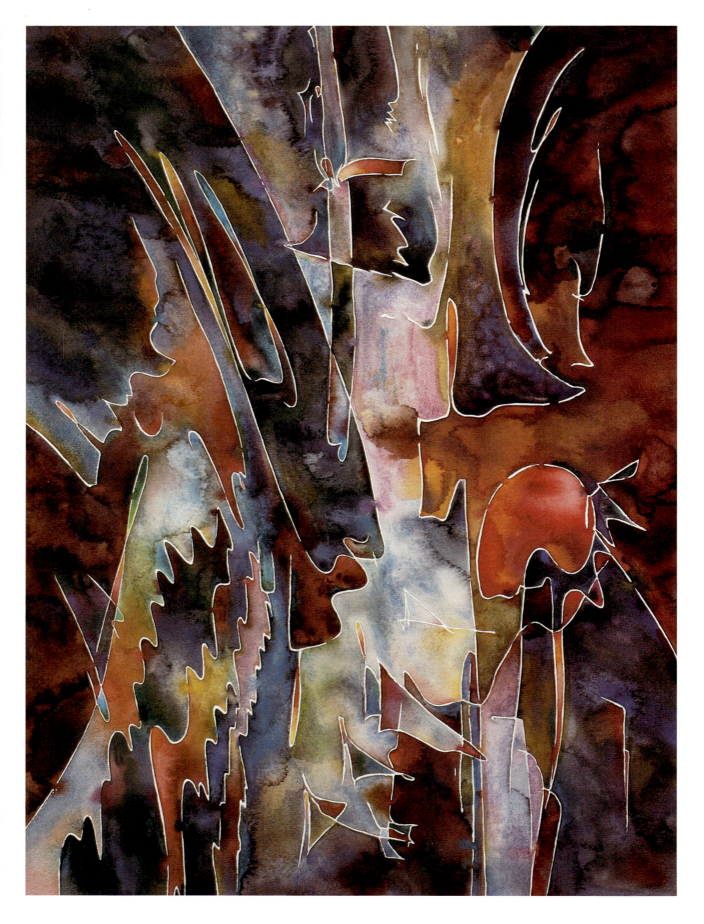

Miles G. Batt

The value plan above indicates how "Magic Sunrise, Jetty" might appear if the Port Everglades inlet jetty at Fort Lauderdale, Florida, was painted in a traditional - retinal image -*representational M.O., page 66.* While this result may appeal to the larger audience because it's easily and rapidly understood, it's ordinary. *If you're intent upon being creative, never allow anything to become ordinary!*

Before you stand up and applaud let's analyze the ordinary approach and decide what may be retained and what may be rejected.

Comparing the more unique result (below) to the representational M.O. plan (above) there are similarities - both approaches utilize a value plan for darks, lights and midtones - and there are objects depicted in each painting. Creatively, the focus is changed from imitating to symbolizing. Concentrating on qualities that could only happen with paint on a piece of paper - *orchestration becomes more important than imitation.*

The element of line was chosen to carry the melody, with a small sketchbook, rapid linear impressions were produced on the spot. From twenty or so scribbles one was chosen for its *"Gestalt"* - its simple completeness, *page 69.*

All the other elements in this orchestration augment the white line that is painted around. The value plan consists of a dark shape surrounding a lighter shape. Some checker boarding or *alternation* of dark and light occurs as the eye moves from

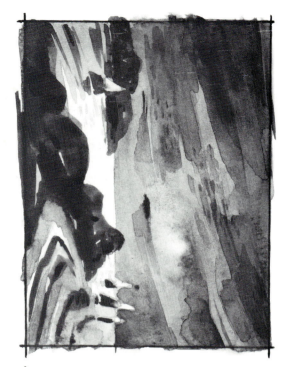

VALUE PLAN

PLATE 4

dark to light and back again, *pages 24, 31.* Warm colors are dominant, *page 29.* The contrast of *intensity, page 47,* is the formative color contrast. Placing intense reds next to dull, grayed reds,was my first color impulse. From this first incentive the subordinate color contrasts, *simultaneous contrast -near complements - page 48,* and warm vs cool contrast -*temperature - page 47,* seemed to be natural by-products.

Knowledge is wasted without inspiration! The important ingredient to remember about this painting is that I was moved so strongly by the sunrise on this spot that I was motivated to paint in a unique way, not satisfied with an ordinary result. Creativity *requires* motivation - get excited about something! *See "Color Construction", page 51.*

Techniques used:

The linear sketch was carefully enlarged to the full sheet (22" X 30") to preserve the fluidity of the original. I didn't use stop out or resist to produce the white paper line. Care was exercised when broaching this line. Colors have been intentionally encouraged to run into adjacent areas with the anticipation of interesting accidental color minglings. These minglings take on an intrinsic life of their own when allowed to dry with little or no agitation. Practically the entire surface of this painting was treated as wet into wet, with occasional glazing, *page 18.*

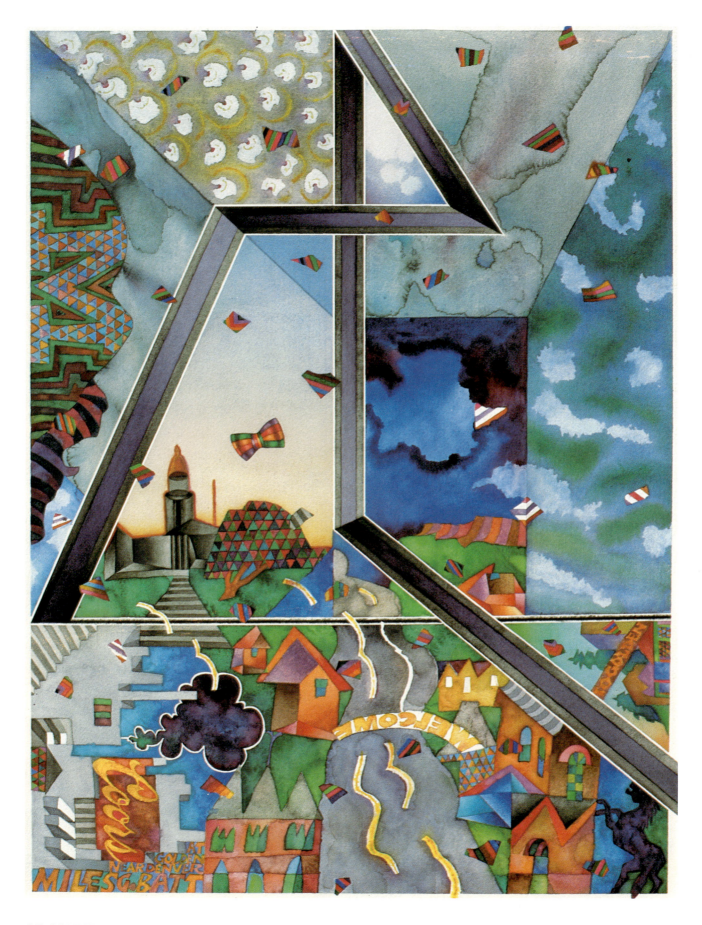

AT GOLDEN, NEAR DENVER *29'' X 21'' transparent watercolor* **Miles G. Batt**

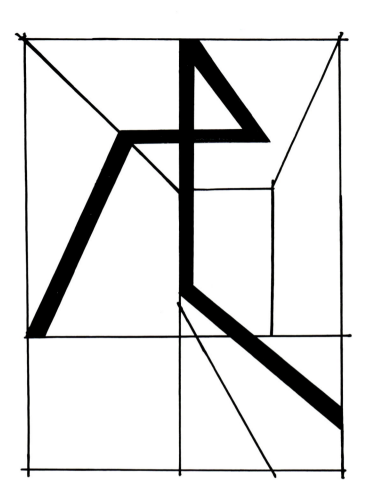

PLATE 5

Golden, Colorado is home for the Foothills Art Center, sponsor of the annual Rocky Mountain National Watermedia Exhibition. It was a privilege to serve as co-juror and conduct a workshop in conjunction with the 1983 competition. New places stimulate my imagination. When visiting in a new environment *"discovery"* is an enjoyable objective. The senses are aroused, everything seems fresh. It's fun to *invent,* to *play, page 101.*

The problem I set for "At Golden, Near Denver", was to invent a fresh way to experience the contrasts of this small nineteenth century mining town.

The upper square of the painting, see *"Rabatment", page 51,* is constructed so the viewer is inside a box. The central dark blue rectangle is the distant closing end of the box. Each perspective plane of box exhibits a different kind of sky treatment. People in Golden will tell you, "If you don't like the weather, stick around for half an hour and it'll change."

This antique western setting also contains a sprawling twentieth century brewery. The smell of hops cooking, - much like string beans - fills the air. Hang gliding is a favorite sport. Can you see the hops and gliders in the air? *See "Similarities" pages 110 - 112.* The mining school is conspicuous in Golden, displaying a giant "M" on the side of a mountain. Turn the book so the left edge becomes the bottom and the mountain with the "M", the "Devils Thumb" and Coor's Brewery become more evident. It's distracting to have easily readable "words" in paintings, like signs, boat transoms with names, etc., they take over. I've had fun with the "words" in this painting, using them as *repeats* - even working the title and my signature into the scheme - however, none of them leap to the eye. My antique houses are visual puzzles, the State Capital in Denver is symbolized at the left center, the perpetual steam release from the brewery echoes the cloud hole on the back sky wall, and the Foothills Art Center is at the left center, bottom. The rearing horse in the right bottom corner was actually a revolving white plastic store advertisement.

The succession of hills on Golden's main street make the broken yellow line play visual games. I used the idea to induce a stepping stone *movement* for the eye, *page 32,* beginning at the bottom center. The ribbon that traverses the width of the painting is simply another spatial inducement.

Creative gain is always at the risk of something. Picasso said, "The first act of creation is destruction." "At Golden, Near Denver", requires the viewer to abolish many ordinary approaches to painting, to appreciate the creative play, the *discovery and invention.* Risk something! *See it differently!*

Techniques used:

A wide range of paint handling was utilized. Each sky shape exhibits either a tissue blotted, wet into wet run-back, glazed, or patterned surface. Colors were chosen in terms of local color, simultaneous contrasts, and a balance of warm vs. cool, *pages 47 - 48.* Can you locate the many flat wash shapes, and the graded shapes?

21" X 27" transparent watercolor, graphite, ballpoint pen

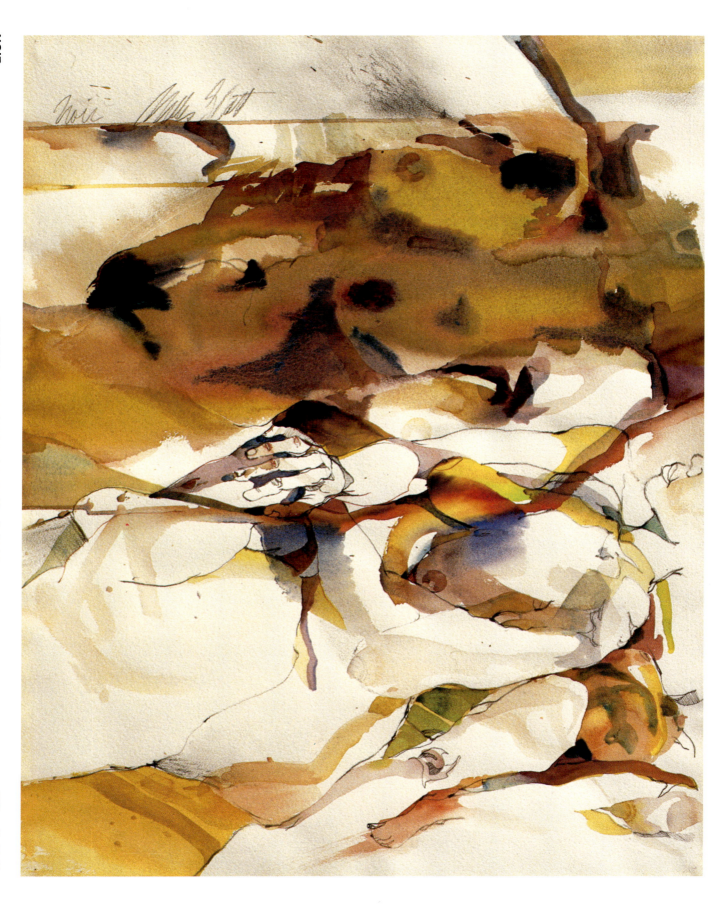

Miles G. Batt

The nude human form as subject matter is constant, it never goes out of style. Occasionally it may retreat from popularity but as long as there are human beings painting, they will be painting other humans unfettered by wearing apparel. Historically the nude has mirrored the cultural attitudes and mores of time.

Vulnerable, audacious, languid, heroic, narrative, erotic, primitive, subtle, exotic, cute, sexy, allegorical, academic are descriptive words that might be applied to the M.O. for painting the nude figure. Various nudie magazines amply satisfy the larger hunger for the slick, cute, saccharine, photographic nude.

The essence of the human form is *movement*. Renditions of the nude figure freeze-framed in a predictable environment disappoint me.

For years I attended regular life classes. I stumbled through Bridgeman, Nicolaides, etc., as if in a tunnel devoid of light at either end. The stack of single figure paintings/drawings indicated the promise, but fell short of the delivery. Determined to encourage creative results I decided to take one piece of stretched watercolor paper to each session and begin to compose - selectively I chose poses and extended the mediums utilized to effect a vitally animated concept of the human form.

HOOK/CURVE REPEATS

PLATE 6

RABATMENT

Movement is symbolized by change - with "Noir" I have employed fragmentation. Portions of perhaps eight or nine different poses are **connected** - systematically **unified** - joined - to present an active surface. Gestural watercolor brush handlings are balanced by studied carefully observed linear elements - contour drawing. Large fragments are juxtaposed with smaller sections, creating size variation. See *"**Dominance**" page 29*. One figure melts fluidly into the next, with little notification the eye is persuaded to move along basic organic repeats (diagram above).

"Noir", black in French, suggests the complexion of the model - the color scheme that resulted reinforces the fact. Contrasts of brown violet and yellow green prompted the auxiliary contrasts of red, blue, and blue violet.

This national award painting is resolved as an organic, *kinetic surface* that is coincidentally representative of the nude human form.

Techniques used:

Hake brushes loaded with pigments translated the larger torso on the left, various pencils and ballpoint pens contributed the contour lines, and several pointed sable brushes completed the controlled washes.

BLUE COLLAR RIP-OFF *14 5/8'' X 9 1/4'' transparent watercolor* **Miles G. Batt**

VESTAL TRIP

SUNRISE FILE

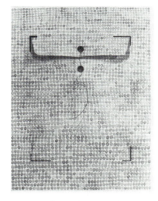

AUTOMATIC BEHAVIOR

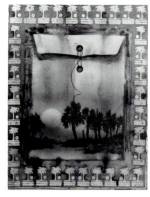

FLORIDA SUNSET FILE

SEA FILE

ANONYMOUS REQUEST

MAGICIAN'S INTRO

DOUBLE-BAGGER

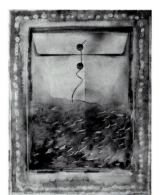

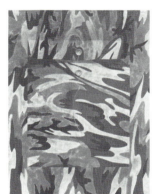

PAINTING IN A SERIES FORM FACILITATES UNCOVERING VARIATIONS ON A THEME. MANY EXCELLENT IDEAS MAY BE LOST WITH ONLY ONE VERSION.

PLATE 7

The M.O. used for "Blue Collar Rip-Off" is definitely representational - descriptive to a fault. However, these objects generate a strange paradoxal scenario, *page 113.* Visual/psychological tensions are created through **contrast,** *see "A Handle on Ideas", "Similarities", "Opposites", "Changing Your Frame of Reference", pages 110 - 116.* The tie string usually used as the closure on an envelope, perhaps enclosing a legal document, is now the tie for a workingman's shirt collar. The tie is where a tie should be, but it's not the correct kind, producing visual heresy and the deeper implication that crime is a burden shared by all classes in society.

This award winning painting is by-symmetrically oriented. The tie string is the only asymmetrical element and clearly the main player in the scenario. Although it's a quiet surface, it seethes with intense meaning. The sharp **simultaneous color contrast,** *page 48,* red orange vs. blue adds spice to the message. Rendered with a staring kind of reality, the viewer is challenged to accept what cannot be.

Techniques used:

The red buttons and the tie string were masked from the blue washes. The borders of the hot press sheet were masked with low tack tape. Unhappy with the result of first washes of blue, I re-wet and cross-hatched the entire area with a coarse house painting brush which yielded a wonderful denim-like texture. Buttons, tie string, stitching and shadow shapes were meticulously achieved through a magnifying glass.

DANCE OF NEGOTIATION

40" X 60" acrylic

Miles G. Batt

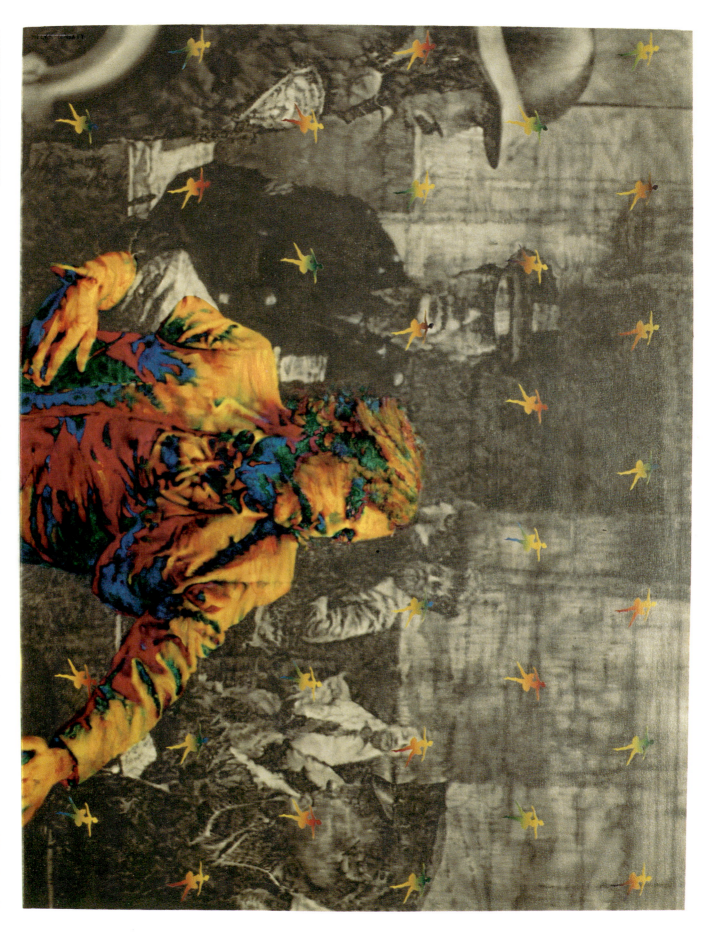

PLATE 8

If this painting *annoys* you I've succeeded! Being creative means you have access to ideas that may *annoy* someone. Being creative guarantees that you'll *annoy* someone. Creative paintings require the viewer to re-think, re-negotiate the status quo! Many people find it *annoying* to have to **think.**

Countless historically significant paintings were initially labeled ugly....beauty is always in the eye of the beholder.

"Dance of Negotiation" projects an intensely felt attitude. One of the barometers used to evaluate contemporary art is its intensity....synonymous with, *strong, powerful, potent, passionate,* even *excessive, extreme, or feverish.*

The opposites in this painting are creatively combined. What could be more contrasting than a human situation errupting in violence vs. ballet dancers? Colorless (gray) vs. colorful? Stillness vs. motion? Vertical and horizontal vs. oblique directions? Organic vs. geometric construction? Yellow vs. red vs. blue vs. black vs. white? *See "**Contrasting....Points of View**", pages 22 - 24, and "**What to Contast? It's Elemental Watson**", pages 34 - 55.*

Balancing polar opposites creates harmony! *See "**Harmony**", page 26.* The mathematical alternation of right face/left face, and warm upper/cool lower ballet dancers, presents a geometric grid configuration that overlaps and combines with organic gray shapes. *See "**Alternation**", page 31.*

Psychological tension, as well as tension between elements is present, *see "**Tension**", page 78.* Beauty of color is sacrificed in favor of the expressive result. *See "**Simultaneous Opposition**", page 48.*

Generated by a black and white newspaper photo, the main figure is caught, frozen in a pose that suggests a dance pose. This **similarity,** *see page 110,* dictated the ballet dancers and ultimately the title.

Techniques used:

Acrylics applied with an airbrush.

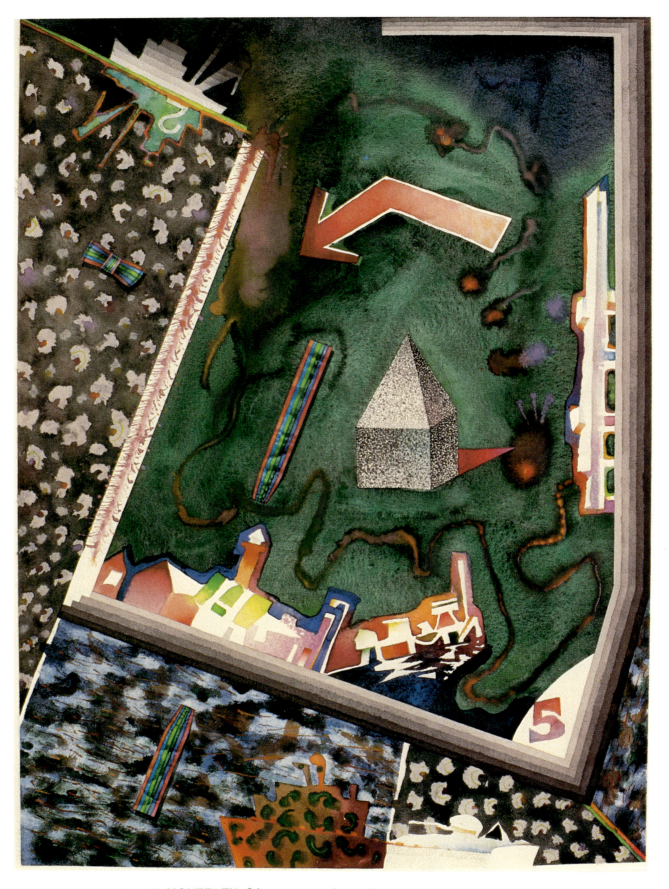

FISHERMAN'S WHARF, MONTEREY, CA *29'' X 21'' transparent watercolor* **Miles G. Batt**

FLEXIBLE RABATMENT

REPEATED DIRECTIONS OVAL MOVEMENT

PLATE 9

Why rejuvenate tired subject matter? Why do it differently? *See "Why Creatively","The Same Old Thing is Always Changing"* and *"Things Go Better With Fun", page 103.*

Thousands of watercolors are produced each year that treat boats, docks, canneries, piers, etc., in the traditional, representational M.O. The creative impulse yields to the academic. Such paintings are easily understood by a wide cross-section of the viewing audience, but rarely do such paintings have the strength to sustain interest beyond the first encounter.

"Fisherman's Wharf, Monterey, CA", was conceived on the scene as a workshop demonstration. Through **empathetic projection** I imagined I was a sea gull flying over the scene, *page 112,* producing the larger break-up of the full sheet watercolor. Positioning this division, *"Rabatment", page 53,* was employed. The clockwise shift of the share that rabatment produced, retains the proportions of the division and offers a fresh idea for its implementation. Inventing the textures that symbolize water,combines tissue blotting and wet into wet painting, patterning and airbrush markings.

Various low tack tapes were used to mask certain areas during large first washes. Turning the corner with the airbrush out of the tape shape at the top left center, the cup full of paint tipped and spilled on the wet green wash. Undaunted, I refilled the cup and proceeded. My audience was sure I had ruined the sheet, yet at completion this spill is one of the more

interesting areas. No need to paint five hundred sailboats if one with a five on it will do. The Harbor House Restaurant and accompanying shapes of lighthouse, fish shacks, light poles, diving bell, ropes, steps, water reflections, etc., are the source objects for the colorful configuration resting on top of the gray value stepped geometric shape that becomes a border and symbolizes concrete docks. The white shape on the right is a cannery. The stippled pyramidal shape symbolizes the ship's carpenters cupolas and bric-a-brac architecture I have chosen not to include. The arrow is directional navigation. At the top left are reversed images of boats arriving and departing.

The factually reported colored ribbon bow and penetrating ribbon pose volumetric contrasts to the otherwise flat rendition.

"Readability-Closure", page 70, is at work on the bottom edge. **Eureka!** It's a boat! Isn't this painting more alive, more fun than another ordinary painting of pretty boats bobbing next to a ho hum pier?

Oblique directions, the color green, flatness, imagination, and fluid textures are some of the dominant elements easy to identify. These elements are contrasted or balanced by curvalinear movements, a variety of smaller red colors, volumetric rendering, realism, and flat dry textures.

For further information on this painting *see, "The Problem is the Problem!", page 121.*

21 1/2" X 28 3/4" transparent watercolor

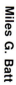

Miles G. Batt

The lure of the sea and fishing boats has long fascinated the imaginations of artists. Almost every watercolor painter finds the sea and boats irresistible, I did when I began painting. In spite of this obvious charm I concluded that the creative possibilities for the subject matter were small. . . . I avoided painting fishing boats. Time has proven to me that painters don't necessarily choose subjects. . . . *perhaps subject matter chooses the painter.*

Noyo is a small seaside village just north of Mendocino, California. Commercial fishing is the prime industry. While relaxing on a headland overlooking the Pacific Ocean, local fishing boats were visible below, maneuvering into position for a morning of fishing. I watched for a long time as they moved. This visual experience generated a few very simple sketches similar to one above which explored **shapes** and **movement.** I didn't rush to paper and paint - I conciously rejected the idea of fishing boats. Days, weeks later the experience and the sketches were still popping from my sub-concious to my concious mind, a small visual treasure that someday I could do something with. Slowly, sub-conciously I understood that what I lacked was a problem! *What was I trying to show? How could I present the idea creatively?* It required more "cooking" time in my sub-concious. Eventually **movements,** changes in the fleet became the motivating idea. Parts of the painting emerged from my sub-concious and began to fall into place even before I had wet a brush. Tiles in a shower suggested the gray, abalone shell tesselated sea, which also serves as the key to alternating color and non-

color areas. The wave lines easily became "ribbons" of sea. Bordering the left edge are six different views of similar boats also suggesting movement. Interrupting the rhythm of this movement by interposing a rectangle of "sunset" accomplishes a fundamental *"tension", pages 76 - 78,* and provides **repetition.** Notice that the missing rectangle appears in the lower right corner of the painting. The trademark envelope button and the string are symbols that are intriguing whether they have meaning for the viewer or not. **Gradation** implies movement, *page 32,* notice the many uses of gradation.

The important color contrasts are, colorful vs. colorless, and as the central boat and border boats display, warm vs. cool, with contrasts of hue, *See plate 25.*

Concealed behind everything is a "realistic" sunset. The "realistically" executed button, the strings, and ribbon alternate with the geometric painterly areas, presenting contrasts of rest and motion.

This painting is creatively realized - it's not like any other painting I've seen. . . . it's an invention that is both mentally and visually satisfying.

Techniques used:

The realistic sunset was rendered with an airbrush in a glazing (layering) procedure, *page 18.* Many shapes are handled as graded washes. The abalone sea squares are simple wet into wet handlings, all the white lines and white shapes have been painted around.

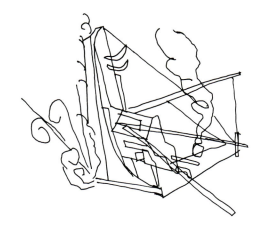

PLATE 10

9 RECTANGLES PROPORTIONAL REPEATS OF PARENT RECTANGLE

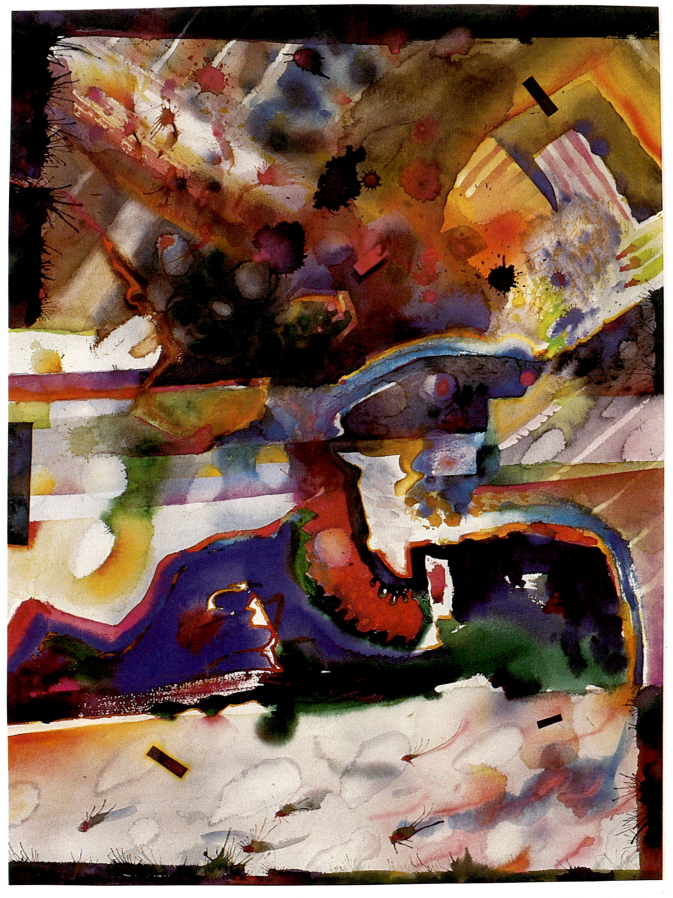

TWIN LAKES *29'' X 21'' transparent watercolor* **Miles G. Batt**

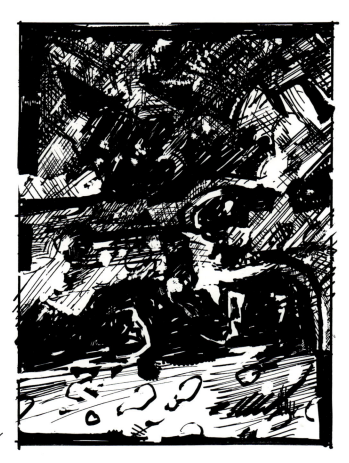

SHAPE/VALUE PLAN

PLATE 11

If there is something that separates the creative from the ordinary watercolor painter perhaps it's the flexibility to change ideas in the middle of a wash. "Twin Lakes" began as an experiment in search of a body of water shape, a lake. My first endeavors had the paper in the reverse of its present top and bottom presentation. Seen in the reverse, the dark violet-blue-green shape becomes a lake/body of water shape with sky above and many symbolic landscape shapes offered as the foreground. Turned right side up once again the final interpretation displays the dark shape as a mountain shape with a lake in the foreground and a large sky area above the mountain. The title, "Twin Lakes", derives from the unriddling of the presence of two lakes.

"Twin Lakes" is a very corporeal, animated, expressive surface. Shapes were retained strictly on their energy factor. An unswerving love affair with paint and paper is evident.

Employing **harmony** and **contrast** as structuring tools, *page 26* , lines, values, textures, colors, sizes, shapes and directions were set in a **balanced** vibration.

Splashes, drips, airbrush spatters, dry brush marks, finger painting, wet paint into wet paint, hair spray into wet washes, sponge scrub lifts, and glaze build-up manipulations all contribute to the success of this award winning watercolor.

The content of the painting is conveyed through its compositional structure and selected symbolization. Subject matter is purposefully simple. Far from a photographic image - it can only become visible through paint. It's an **imagined** place! An **invented** painting!

A combination of accident and improvisation allows the paint to exert an influence upon the developement of the composition.

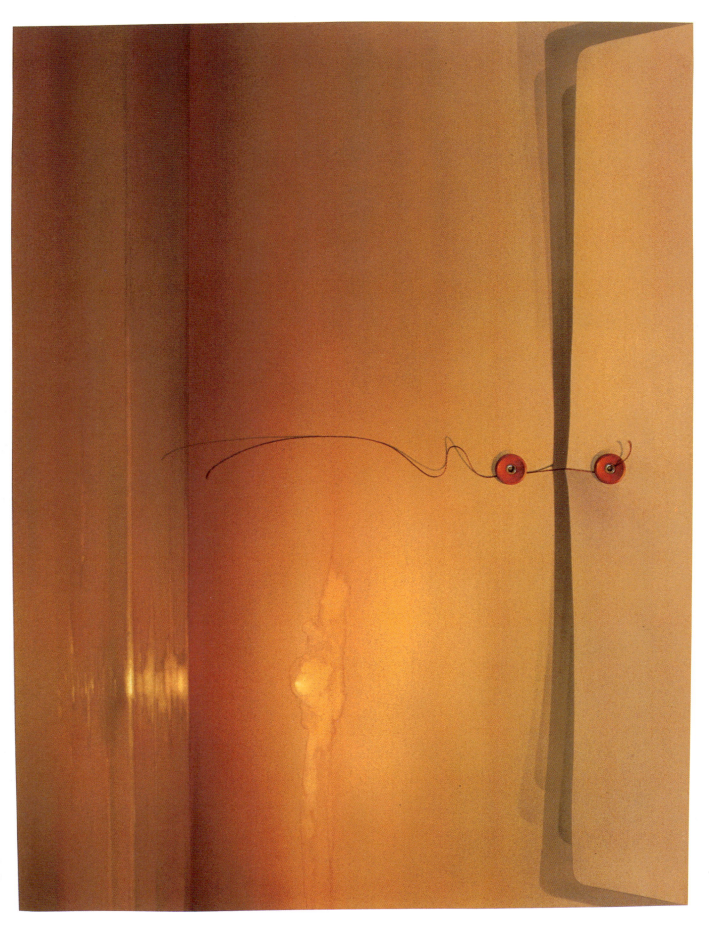

20 1/4" X 26 1/4" transparent watercolor

Miles G. Batt

The questions the viewer inherits from "Grand Larceny" are more engrossing than any answer.

Everyone has experienced the confusion of dream and reality after sleeping. A similar predicament is presented when two equally compelling images - objects - ideas are combined. Because **"closure"**, page 70, is impossible, but seems so probable, the painting constantly provokes thought. **Passive unity** is effected through an equality of forces, and is produced by psychological disorientation - contrasting subject matter is synthesized. See, **"Dominance"**, page 29, **"What is Creative"**, page 92, **"Similarities"**, page 110, and **"Tension"** page 78, "Grand Larceny" is an interesting title and seems to fit this medal winning painting. To detract from a sunrise or sunset may be related to a criminal act. See,

"That's Not My Thing", page 100, and figures 145, 146, 147, 148.

Techniques used:

The buttons were masked before large washes of color were applied with an oriental hake - "Hockey" - brush. Followed by countless airbrushed glazes which blended the surfaces with subtle color nuances. Using a commercially prepared frisket paper for masking, the shadow under the envelope's flap was airbrushed. Clean water worked into the multiple layers of airbrushed glazes along with judicious razor scrapes created the sun concealing cloud and the reflections on the ocean. Finally the buttons and the string were carefully rendered with a brush. The process spanned four days.

ENVELOPE

SEASCAPE

VERTICAL RABATMENT AND DIAGONAL TO LOCATE HORIZONTAL PRODUCES 4 REPEATED, BUT VARIED RECTANGLES.

STATIC SUBJECT MATTER

PLATE 12

VARIATIONS

LEFT HANDED COMPLEMENT

MISTAKEN IDENTITY

EXPECTING PREFERENCE

ROCK MUSIC AND SHRIMPERS, SHEM CREEK, SC　*29" X 21" transparent watercolor*　**Miles G. Batt**

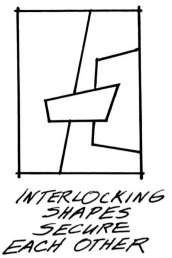

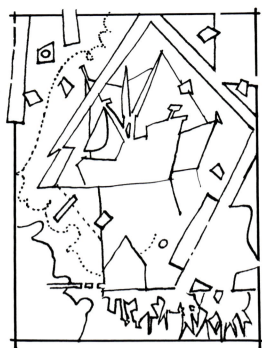

INTERLOCKING
SHAPES
SECURE
EACH OTHER

PLATE 13

Easy access to Atlantic shrimping waters makes Shem Creek, SC, a perfect haven for a shrimp fleet. A clear spring day, boats arriving and departing, nets, floats, masts, outriggers, crews making repairs, and *rock music playing on a radio,* the key to a creative idea.

Involving the sense of hearing gave birth to the music staff and notation symbols, D *f* (Double Fortissimo), *f* (Fortissimo), *m* (Moderato) etc., the pyramidal cupola is utilized for reasons described in the text for *plate 9.*

Featured in the large shape division is an off-set, open sided diamond. The central shrimp boat is a telling silhouette that withholds **"closure",** *page 70,* and adds to the left to right movement. Left to right movements are more adventurous than right to left. This boat is departing.

Viewing this painting from all four sides reveals additional boats - familiar shapes when seen upside down or turned one quarter to right or left assume an air of mystery - a fresh new life.

"Rock Music and Shrimpers, Shem Creek, SC., has received five national awards to date. *Would anyone have noticed this painting if it were an ordinary painting of shrimp boats?*

Each problem requires an individual answer. Solutions are sometimes arrived at sub-conciously, sometimes con-ciously - conditioned by the factors at work. While painting, the medium, method, measures, strategies, etc., are important, but when a painting is finished, forgetting the technical concern and all the effort required is a welcomed relief. *The pleasure is becoming one of the audience, interested only in what the painting expresses.*

Techniques used:

Blue moving towards green and violet is the dominant color, balanced by smaller but vibrant varieties of red and orange. A three value chord displays a large mid value shape with smaller light shapes, enclosed by a dark shape. The smaller white shapes are thin lines painted around, tape shapes, and various other white shapes, placed to effect *"balance",* page 27. The many boats seem juxtaposed in a random, fragmented manner - notice however, the numerous devices employed to connect diverse sections of the painting - repetition - interlocking shapes - overlapping shapes - visual stepping stones - and paths for the eye. *Parts have been adapted to one another.* See *"Harmony"* page 26, *"Unity",* page 28, *"Repetition",* page 30, *"Movement",* page 32, and *"Composing A Meaningful Substructure",* pages 73 - 74.

FIGURE # 7915

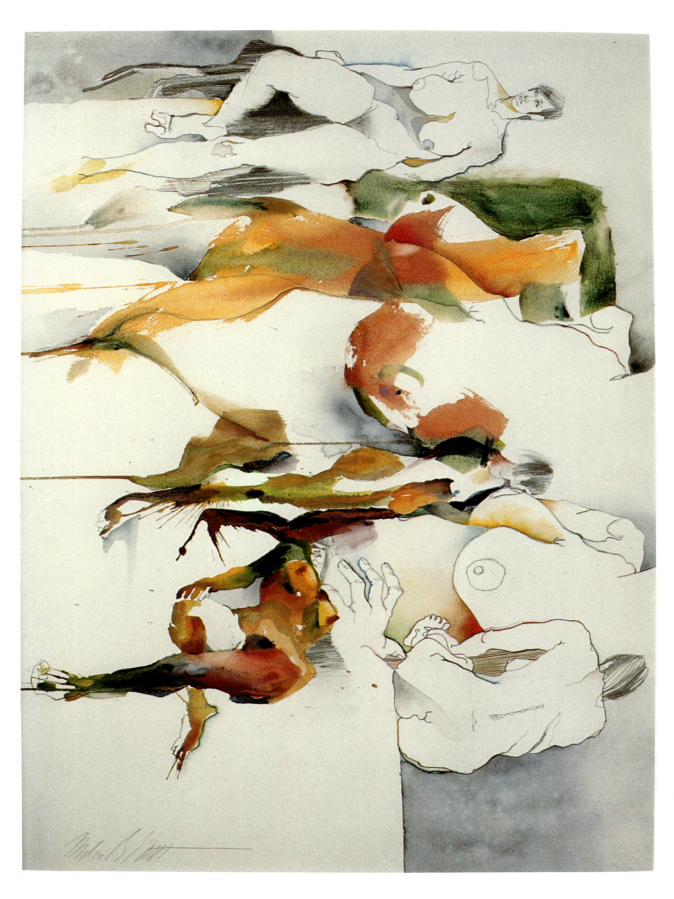

21" X 29" transparent watercolor, graphite, ballpoint pen

Miles G. Batt

Composing multiple poses to create a *dynamically active surface* solves the larger problem of indicating the human form creatively.

Contour drawing is accomplished by synchronizing the movement of eye and drawing tool while "visually touching" the contours of the model. Looking at the paper while the tool is moving is prohibited. Kimon Nicolaides' 1941 book, "The Natural Way To Draw", systematized this historically practiced method of drawing. Rigid academic results are shunned in favor of natural distortion. Seeing *through* the eyes rather than *with* the eyes, the artist becomes a conduit for honest observation rather than photographic rendering.

Two poses are combined (three breasted large figure) to imply *movement*. Alternating sizes, warm and cool colors, and white paper checkerboarding suggest

additional time/motion sequences. See "**Alternation**", page 31, and "**When Hell Freezes Over**", page 47. Contrasting colors are played against silver gray repeats, see "**Repetition**", pages 30 and 77.

Organic anatomical fragments are stabilized by a rectangular geometric sub-structure. See "**Composing A Meaningful Sub-Structure**", page 73.

Step down repetitions occur as diagrammed above. A watchful eye takes advantage of these structural potentials when they present themselves or actively pursues structural additions as an organizational tool.

Passage from one anatomical configuration to another is fulfilled by various devices. Notably common lines, repetition, positive/negative shapes and junction with extension to next junction.

SUB-STRUCTURE

STEP DOWN REPEATS

MAP-LIKE JUNCTION AND EXTENSION TO NEXT JUNCTION

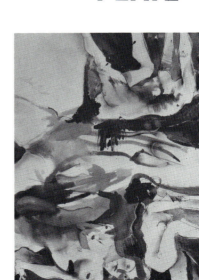

PLATE 14

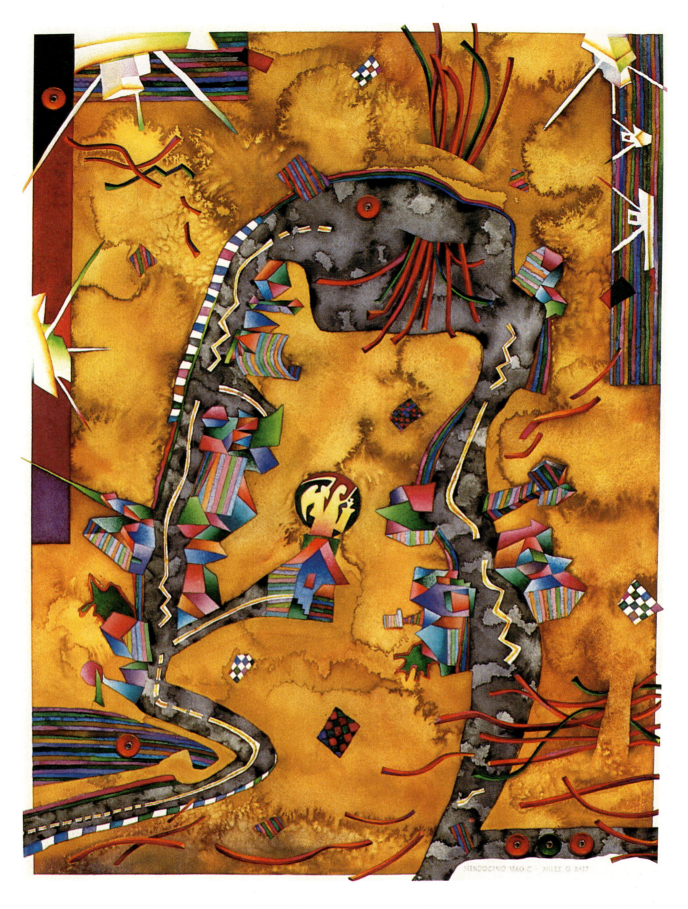

MENDOCINO MAGIC *29'' X 21'' transparent watercolor* **Miles G. Batt**

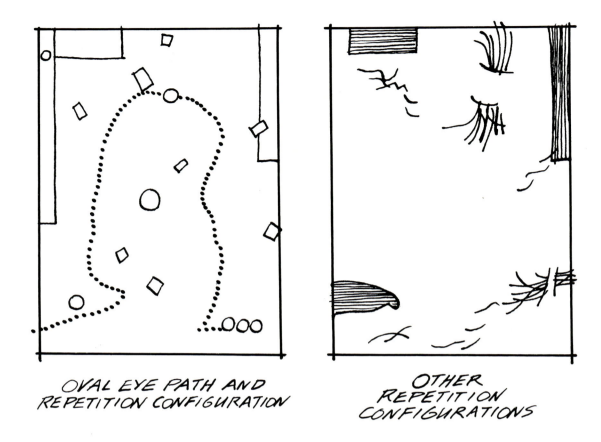

OVAL EYE PATH AND
REPETITION CONFIGURATION

OTHER
REPETITION
CONFIGURATIONS

PLATE 15

Positive forces may be understood as balanced by the negative. As a painter the concepts you reject are as important as the concepts you pursue.

Mendocino, on the northern coast of California, is a town seemingly frozen in the nineteenth century. The old buildings, weathered clapboards, whale towers, rickety fences, etc., are charming anachronisms. I hesitate to admit being vulnerable to Mendocino's particular fascinations, but its geographic location - headlands with cliffs which drop off to the Pacific lend a natural scale to the spectacle that's difficult to resist. *Magic is where you find it*..surrounded by breathtaking urban architecture or perhaps captivated by the special attractions of a place like Mendocino. Being stimulated and motivated to paint by these wonders is a way to commune with and become part of the magic.

Creating symbols, page 67, involves inventing surrogate images, stand-ins for the actuality. Capturing the essence of a thing requires processing - reducing - distilling - extracting - concentrating - and then re-forming. I try to find the energy - vitality - stamina - intensity - potency - guts - power in everything I want to symbolize.

Conceptually I viewed the whole town in a map-like configuration. The whale towers, church, clapboard buildings, indigenous architecture like the central town building with the masonic sculpture mounted on its roof, golden native grasses, fishing boats off-shore, main road, yellow traffic markings, water etc. are active participants in this painting. These symbols are the receptacles for the **line measures - value weights** - and **color qualities** that create a tenuous equilibrium through the central fulcrum. *See "Balance", page 74.*

Schematically the small balanced areas of intense colors are **contrasted** against the large areas of warm grays - dirty yellows - and cool grays - neutral tint and lamp black.

The buttons, penetrating spaghetti-like shapes, and the colorful confetti are symbols of the magic. Each sequence contributes its own configuration, *page 77.* Suspended in mid-air is a set of paths for the eye to follow, *page 32.* These volumetric shapes also force the viewer to read the painting alternately as flat and in relief. The magic that is Mendocino is an incantation on my paper.

Techniques used:

The large grayed yellow shapes were rendered wet into wet and so were the cool gray shapes, they are also liberally sprinkled with salt, fresh water run-backs, and blurbs. Flat and graded washes occupy the smaller color areas. The volumetric relief was carefully painted. The effect is deceptive. This award winning painting consumed more time, energy and loving care than is indicated.

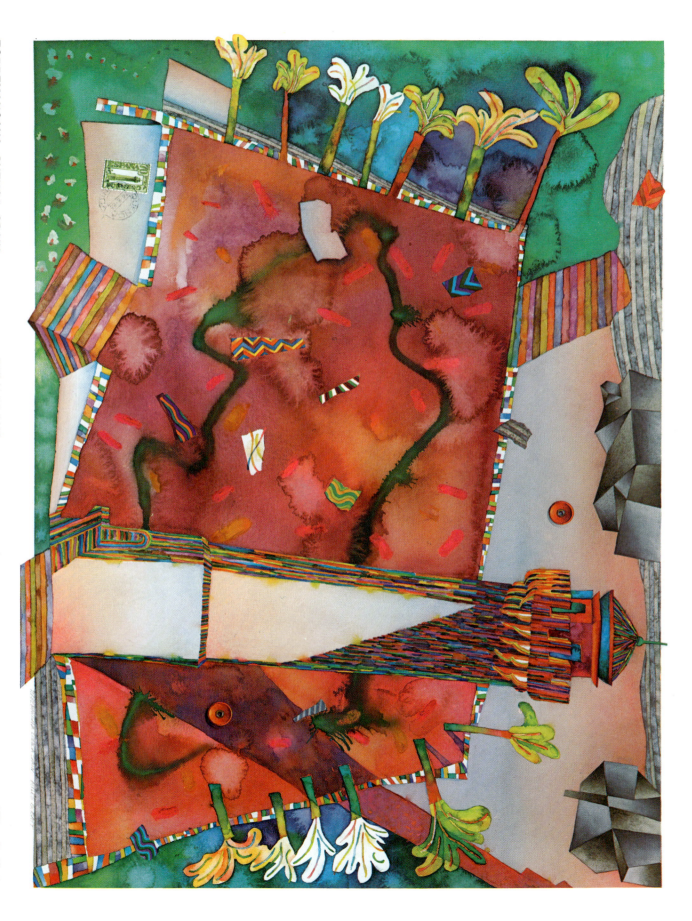

21'' X 28 3/4'' transparent watercolor

Miles G. Batt

Cuenca, Spain, is an enchanting Spanish hilltown where some of the houses literally hang on the side of a steep slope. Located on its own tree lined plaza, the tower of Mangana is a remnant of the twelfth century moorish occupation of this unique city.

Subject matter on the spot, the tower, steps, fenced plaza, trees, mountain, spacious overlook, adjacent architecture, and ringing tower bell are combined with various design elements, personal symbols, and a fabricated postage stamp that repeats the "Torremangana." Color is vibrant. A large piece of various reds is **balanced** by smaller simultaneously contrasting green shapes.

The creative process counts both simplicity and complexity among its resources. Trompe L'oeil (Trom-ploy) painting - rendering extremely fine detail to emphasize the illusion of the tactile and spatial qualities is employed on the red tie string buttons and the postage stamp. An essentially flattened surface has been **punctuated** by volumetric rendering.

Careful observation proves that the invented commemorative postage stamp

is painted on the sheet rather than simply glued fast. The cancellation mark is also painted on the sheet.

Eliot O'Hara called them "oozles". They've been described as "puddles", "run backs", "slops" etc., I call them "blurbs", and academic painters call them "mistakes." They are not a new phenomenon. These naturally exciting, stains, unique to watercolor, are easily produced by introducing additional water into almost dry washes under a warm Florida sun. In the studio or under humid conditions, overnight drying may be necessary. Working on a hard surface paper - hot pressed - or through pre-conditioning any paper with a coat of diluted acrylic medium, will also facilitate these animated marks.

Manipulations alone may quickly become insincere, stale, empty gossip. Relating paint manipulations to design functions and or meaning, insures a relevant contribution to the painting as a whole.

"Torremangana, Cuenca, Spain" received a national award in its first exhibition.

PLATE 16

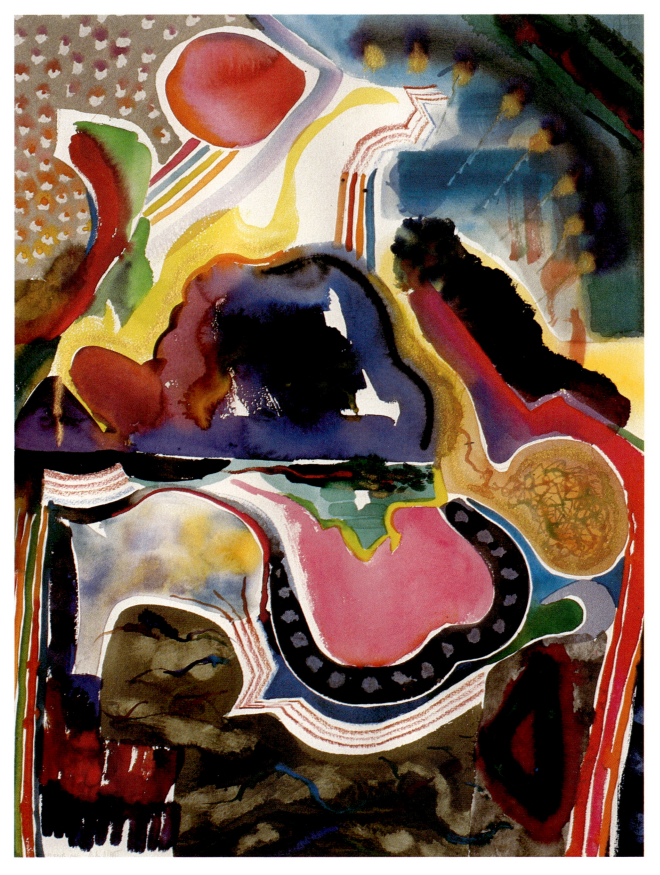

MIRROR LAKE *29'' X 21'' transparent watercolor* **Miles G. Batt**

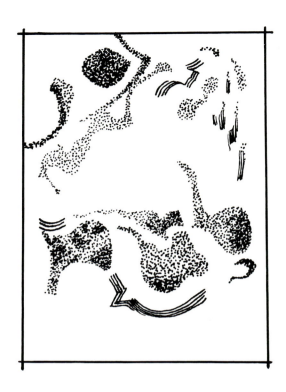

PLATE 17

Playful but challenging watercolor activities, games, puzzles, community painting, etc. have been the theme of my creative workshops for years. The random placement of colors and or shapes, marks, etc. by workshop participants for me to paint creatively is a test of my *"flexibility", page 93*. Once the paper has haphazard, un-organized elements painted on it the emphasis shifts from the cost of paper to transforming *negatives into positives, page 114*. Countless opportunities are presented to graphically demonstrate the virtues of strong idea, repetition, color relationships, balance, etc.

Recently at a creative workshop, the participants left me with the careless group of shapes/marks diagramed above. Many of the marks are visible in the result. The purity and innocence of shapes gathered by this method is a wonder to me. Suggesting that painting like this regularly produces a winner would be untrue, however, I'm amazed with every result. Some are more stimulating than others, and some become humbling experiences. . . .especially with an audience.

I wish I had a miracle formula to offer. . . .I don't. Frankly I do not know, nor do I question how or why certain of these demonstrations are successfully resolved. It must be related to *"facility, flexibility,* and *elaboration,"* page 93. Trusting intuition, see *"Answers for the Thinking Watercolorist"*, *page 8,* requires allowing the sub-concious to provide answers,see *"Putting the Process to Work with Watercolor"*, *page 120*.

Falling into the sub-concious in front of an audience (forgetfullness of self) becomes easier if I am prepared to accept the results as being the best results I could accomplish under the conditions at hand.

I begin by identifying the painted *"elements"*, *page 34*, that were given to me. Mentally I label and categorize them, hoping to later exercise *repetition, pages 28, 30, 77*. Turning the sheet four ways occasionally may reveal hidden subject matter. Lacking a subject I'll resolve a few large shapes, and look for opportunities to employ the theory of *contrast and harmony,* - Sharpening and Leveling - *page 26*. In the early stages I'm also alert to a generalized scheme for color usage, *plate 25,.*

Comparing the shapes given to me (above) with the finished painting displays a variety of methods utilized to *unify,* or connect the parts of the painting, *page 28*.

A lake shape that mirrors the shape of a mountain became the discovered subject in this watercolor. All the forces of nature are present in "Mirror Lake", which received the first award at a National Watercolor Oklahoma Exhibition.

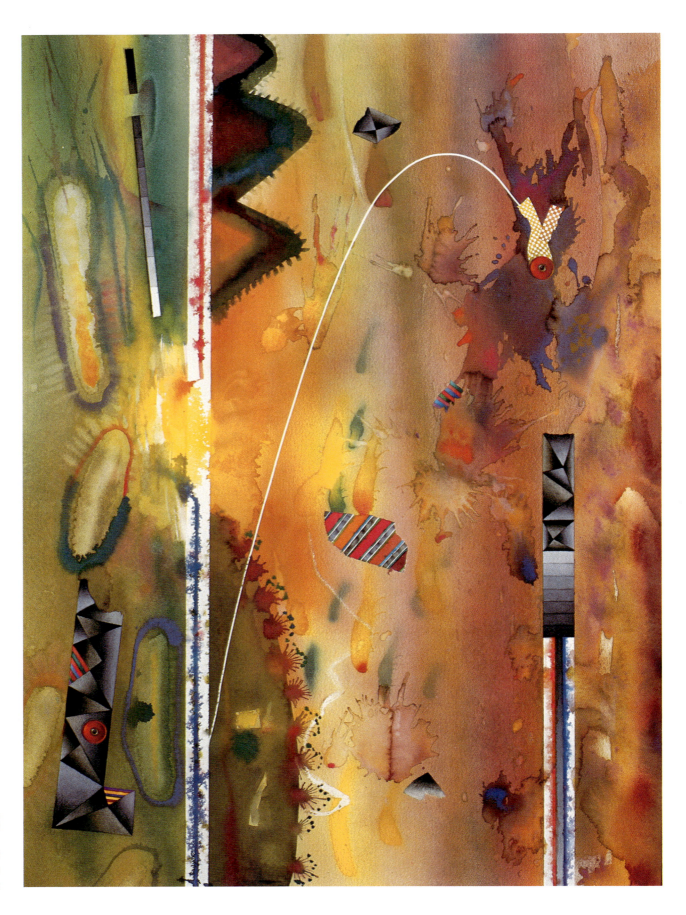

21" X 29" transparent watercolor

Miles G. Batt

PLATE 18

"Morning Flight of a Yellow Bird" transforms an experience and associated sensory information into a meaningful visual form.

The parador at Ribadeo, on the north coast of Spain, was one of our stops during a recent workshop. It's a very quiet place, off the beaten path. One morning I was jolted out of bed by the sound of a roaring engine. It was frightful enough to send me leaping to a window to investigate. A single prop yellow seaplane - it looked official - was practicing touch and go landings on the enormous tide water bay adjacent to the hotel. These moments of fright/exhilaration, the sunrise, and the long looping take-offs became the stimulus for creative play with **paint application** - the materials, page 93.

Applying paint in a manner that enlarges the idea of what constitutes a watercolor painting is invigorating, and demands resourcefulness. Uncovering new working methods isn't easy.much of what you can think of has already been done and paintings that exhibit primarily inventive paint manipulation often suffer the acusation of lacking sound two dimensional structure.

If your interests are occupied with creative watercolor manipulation, build a vocabulary through trial and error, identify and record your discoveries then by **"Changing Your Frame of Reference"**, page 116, search out **"Similarities"**, page 110, and **"Opposites"**, page 113.

I've been playing with airbrushes since high school, and though it's perhaps just a sophisticated way to fling watercolor at a piece of paper, it has amazing auxiliary possibilities. Whisking color into uninteresting dry areas is a way to "glaze" with little danger of disturbing previous applications. The airbrush also makes its own indigenous marks, splats, furry lines, and clean water furrows.

Carefully masking areas to be saved, the airbrush loaded with clean water can literally pressure clean paint from paper in tender fashion. When dry the paper acts and looks like untouched white paper.

"Morning Flight of a Yellow Bird" started with positioning off the roll and torn shapes of various low tack tapes, one or two brush fulls of masking agent randomly placed, and colors sprayed over selectively assigned wet areas. Tear drop airbrush marks are evident through the central width of the painting. In the lower portion a "Hake" brush was used to cover a large area rapidly, into which I sprayed alcohol and hair spray. Lifting the long horizontal tape pieces, paint was encouraged to run under its boundaries. A simple warm line on left, cool on right were sprayed lightly with clean water immediately. Selective whisking/glazing completed the initial stage. Finishing the painting meant **inventing symbols**, page 67, **balancing the many contrasts**, page 22, **and synthesizing reality with fantasy**.

Erasers were used to carefully lighten areas. Commercially prepared size, homemade mixtures of water and gelatin or water and acrylic medium are handy remedies for scuffed, sandpapered or abused paper. Clean the paper of loose fibers, burnish the area with the flat surface of a finger nail, apply size, then paint as usual when dry.

A catalog of commonplace manipulations of paint, chronicled in many other books, is diametric to my desire to encourage a personal investigation with paint and paper.

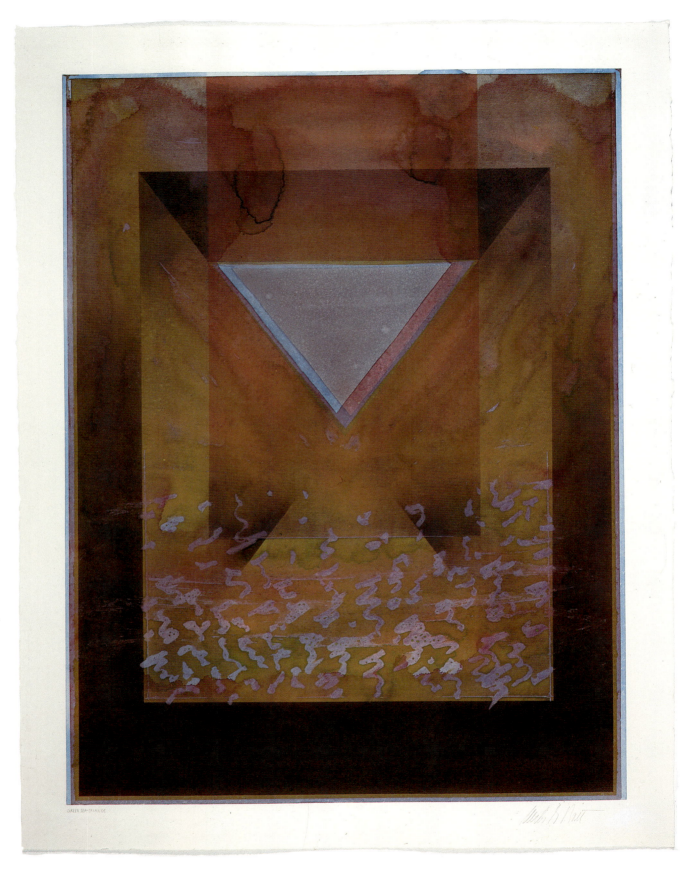

GREEN SEA TRIANGLE *26 1/4'' X 20 1/4'' transparent watercolor* **Miles G. Batt**

VALUE CONTRAST PLAN

SEE PG. 25

CORNER TO CORNER ARMATURE AND RABATMENT CREATE THE MAJOR SHAPES.

PLATE 19

PROBLEM; Using an earthly phenomenon, like the ocean, discover or invent a new symbol that virtually fills the rectangle.

GATHERING OCEAN INFORMATION; Visit. . . . morning, afternoon, twilight; walk in the tide; swim; sit and look at and into; stare across its surface plane, mentally and photographically note lines, values, textures, colors, sizes, shapes, directions and movements; respond to natural forces . . . wind, tide, sun; what's mysterious about it?; Read a book on sea life; how does the ocean function?; Investigate and ponder other painters solutions to similar problems. A sustaining interest in anything from which you hope to extract essences is vitally necessary. Weak, unconvincing paintings may correlate directly to less fervent interests and poor preparation.

IMAGINING SOLUTIONS; Analyze the gathered information for essences or truths that strike relative chords with emotional involvement and the possibilities inherent in the painting materials; see *"Similarities", page 110*; visualize finished paintings; visualize beginning a painting; record all ideas in an idea book; use diagrams, value and shape plans; empty your mind of every idea.

RELAX AND WAIT; Record involuntary ideas; keep idea book handy; if you're not ready to paint. . . . start over!

LET'S PAINT; Choose an idea, a starting place or a finished idea and paint; be alert for changes in plans.

JUDGEMENT DAY; Review entire process *Pages 120 - 125;* Especially "Judgement Day", *page 124.*

*"**Green Sea Triangle**", extracts the essence of constant movement indigenous to sky and ocean, with limitless space, transparency, sharp divisions of horizon, and reflected light as content. The formal elements . . . geometric shapes opacity, containment, alternation of light/dark values, warm/cool colors, dirty/clean colors, rough/smooth textures, large/small sizes, and shallow two dimensional space presents contrasts that firmly lock content to form. **Gestalt** is accomplished, page 69.*

Techinques used:

Corner to corner armature. We look into as well as on the surface. Gray neutral tint triangle was painted first. Full sheet glazes were applied in the order recorded on the right and left edges of the paper, this becomes a framing device. A wax resist was used between the last two glazes. Masking and an airbrush completed the geometric divisions.

Discovery and invention is the gauge for creativity.

This award winning watercolor painting combines the organic feeling of sea and sky with a simple but severely formal geometry.

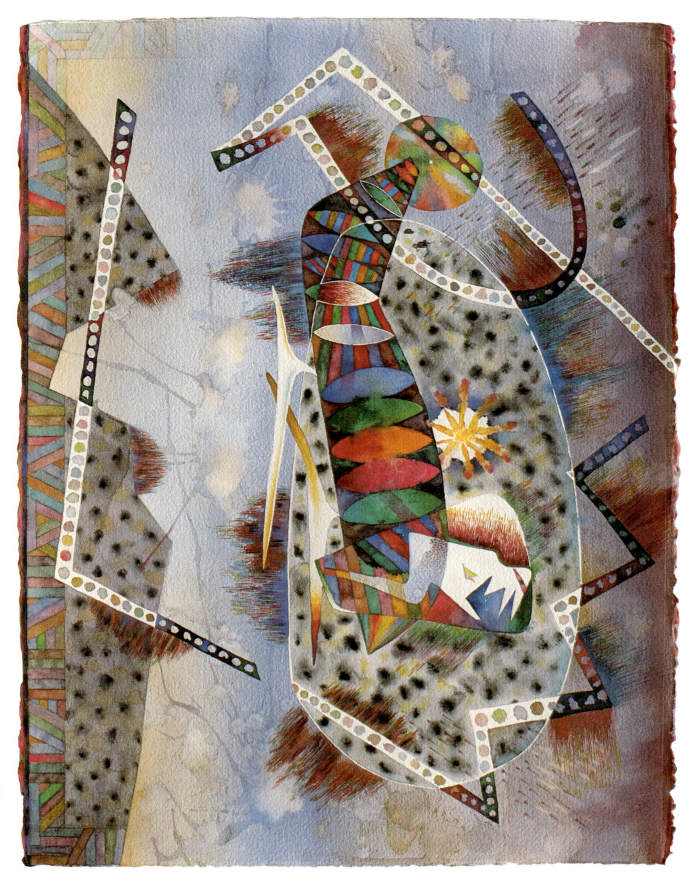

23" X 30,1/2", transparent watercolor

Miles G. Batt

PLATE 20

Freedom, as it's applied to painting with watercolor, is often mistaken for facility - paint placed on paper impulsively - unrestrained. **Technique and facility play no part in the true idea of freedom.** It's easy to become a prisoner in the arms of any method. Freedom is found through believing in an attitude. Only **within** a belief and its restraints is there enough freedom and definition to permit the inner self to function - to discover one's own way.

Personally I adhere strongly to the belief that to be creative with watercolor, being different - perhaps even **outrageous** - is **required.** Paintings that are easily confused with someone elses or "anonymous" contribute little. If you were a scientist . . . would you spend any time inventing penicillin? No! We already have penicillin!

Drawing everyday, using puzzles, games, free association, etc., *pages 110 - 123,* sharpens wits, and allows assertion of the inner self. Time set aside to **play** encourages *"open thinking", page 97, "flexibility", page 116,* and builds a repertoire of lines, shapes, textures, values etc. The right brain, *page 9,* thinks in images as naturally as the lungs breathe. Just as lungs may be developed for greater capacity and efficiency, this portion of the brain that images, develops with regular exercise.

"Over the Ampersands" employs one of these drawings.

Be outrageous . . . paint anything that flies, walks, runs, pops, jumps, falls, floats, hurts, laughs, etc.!

20 1/4'' X 26 1/4'' transparent watercolor

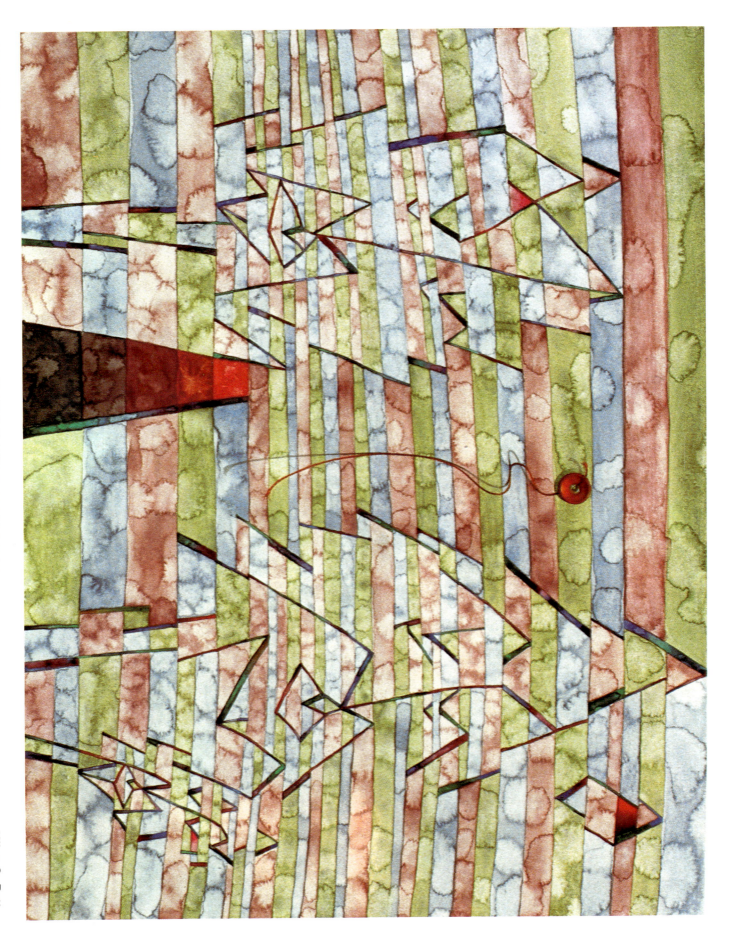

Miles G. Batt

Horizontal stripes present a formal structure and lend a time layer idea to the painting "Autumn in the Tree". Cool relationships within a family tree are symbolized by three faces - male, female, child - a road of life, a celestial body and the realistically detailed envelope button and tie string.

Cool detached expressions occupy each face. The road of life is a gradation from warm black to intense red orange, and like the tie string, which is emblematic of the mysterious coolness between close family members, is located between the male and female members. The road is loosely attached to the male breadwinner, and the child in the lower right corner is maternally attached. The sun/moon far to the right is a seasonal/time symbol. This painting is a *metaphor*, *see page 112.*

Hot pressed paper was employed as the painting support, and is directly responsible for the "blurbs" within the various horizontal stripes which play games with the linear/shape elements - also of varying widths. The surface is held in a tenuous balance. *Color tension* is established because the yellow component of this primary triad is yellow green - an interrupted rhythm, *see page 74. Emotional feel-* *ings have been intellectualized.*

PLATE 21

HORIZONTAL DOMINANT GRID

21" X 29" transparent watercolor

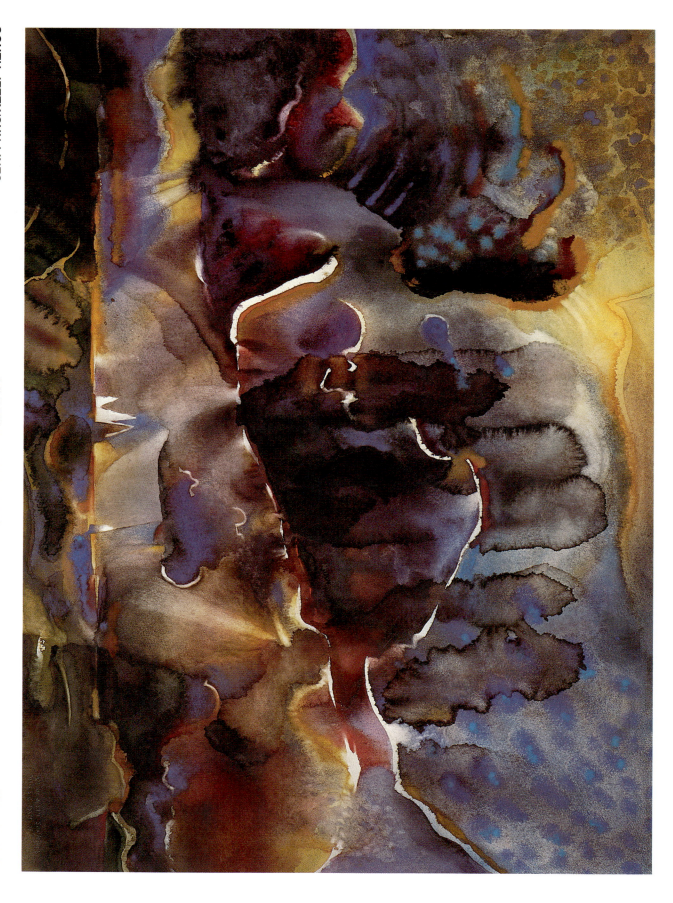

Miles G. Batt

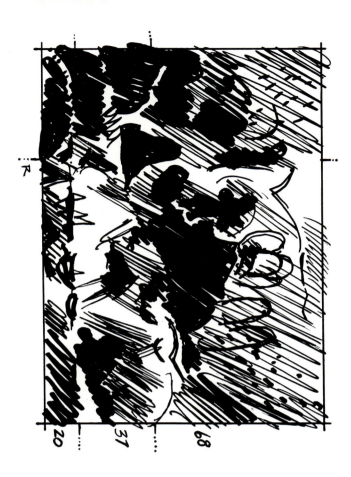

PLATE 22

Remembering the day.... I was standing waist deep in a gently shifting tide when suddenly the sun was obscured by an enormous cloud. There was a moment of fear followed by wonder that remained in my mind's eye long after the experience.

Sky is very mysterious. Few humans have been deeper into its infinite vastness than the altitudes of modern jet aircraft. Sky.... with clouds pushed and shoved by prevailing winds.... big, white fluffy formations.... dark, threatening masses.... to a painter, **vehicles for mood, movement and drama** in a painting. Rim lighted clouds have been around for a long time, but they continue to stimulate the visual imagination. A rich potential for exploring the naturally fluid properties of watercolor and the abstract qualities common to the most realistic of skies, is irresistible.

Large areas of this award winner were painted in a frenzy - hosed off, painted once again, then left to dry in a hot Florida sun. Intermittent painting over the next few days "connected the parts." **"Unity"**, page 28.

Transparency and opaqueness - light and dark - large and small - warm and cool - colorful and colorless - organic and geometric elements contrast in an expressive rhythmic **"Alternation"**, page 31.

Excitement is focused within a segment of this seascape - the sky. The sea occupies a small strip at the bottom. (In a reverse manner the sea could be the exciting segment, and the sky a small strip at the top.)

A spirited grouping of richly saturated washes creates a painterly experience.... not a "real" sky. On the horizon sailboats which **"harmonize"**, page 26, with the rim lighted clouds, lend a clue to the scale and spaciousness of the "center of interest"....the entire sky.

Techniques used:

Wet paint was brushed onto saturated paper and manipulated as it dried. When completely dry a bristle brush, sponge, eraser and tissue were used to remove color.

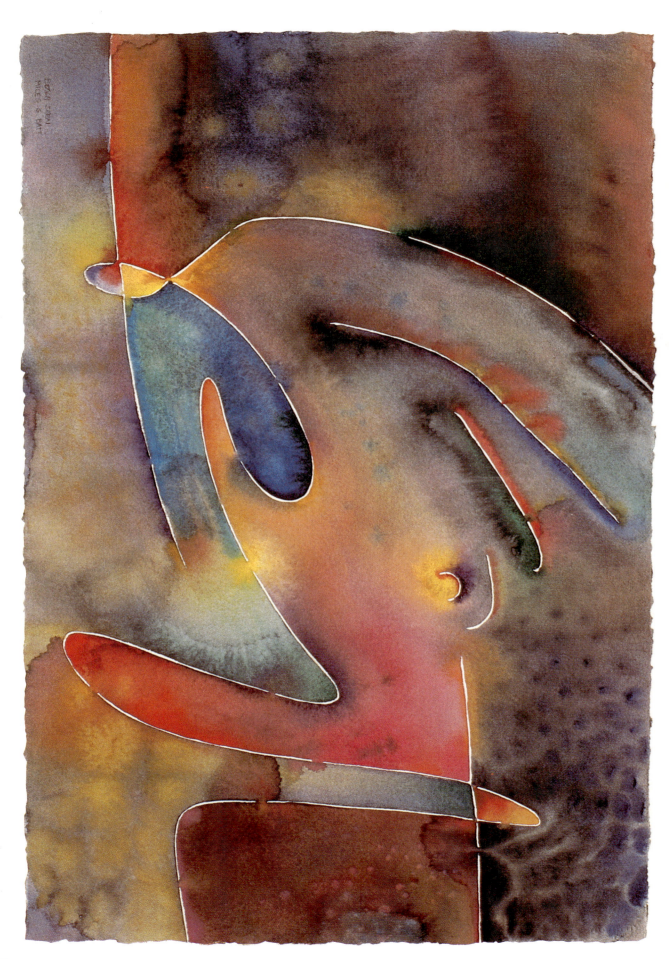

BEACH SEEN

14" X 21" transparent watercolor

Miles G. Batt

All painting is abstract. The illusion of reality does not alter that fact. The realities on a two dimensional surface are line, value, texture, color, size, shape, direction and the physical properties of paint on a support. Paintings which exhibit no recognizable objects - non objective - concentrate heavily upon these two dimensional realities.

*Orchestration of the elements chosen may produce an intense intellectual or emotional response. Lacking illusions of reality the viewer requires a more evolved sensitivity for comprehension . . . **the joys of music are withheld from the tone deaf ear.***

Watercolor painters, and by no means the least well known of them, are suspicious of the term abstract/non-objective and of the art produced under its influence. Non-objective painting is not anti-nature, it does not eliminate nature. There is too much nature in the painter to do anything but **express nature in a different way.**

Intense visual sensations automatically present symbols which are then nourished by the sub-concious, and are compelled to blossom in all forms of art. The impressionist sets up his easel in front of his subject - but the abstract/non-objective painter installs himself looking inward. The mind of man is the greatest of unexplored territories - it is there that the discoveries are to be made, and these discoveries bear the indelible marks of the painter's experience of material nature.

A painting is worth exactly as much as the spectator is able to put into it.

Techniques used:
The white line is saved white paper.

SKYWRITING

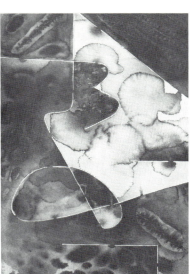

TIDAL

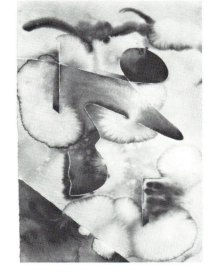

OVER/UNDER

FOOT FALL

PLATE 23

POP-TOP, BLUE FLAG, REFLECTION PAK *28'' X 22'' transparent watercolor* **Miles G. Batt**

SQUARE-OVAL REPEATS

EMBOSSED
CORPORATE SEAL

PLATE 24

What do cardboard boxes, iris flowers, aluminum foil, a rear view motorcycle mirror, a landscape, a road, a yellow centerline, and an embossed corporate stamp have in common?

Carl Sandburg claimed that poetry was the result of combining hyacinths and bisquits.

Poetry is the language of the imagination, the emotions expressed rhythmically.

Painting may be the *visual* counterpart of the imagination.

The diverse elements in, "Pop-Top, Blue Flag Reflection Pak", enlist the road as the common thread - perhaps poetically the "road of life." Merchandising requires packaging all manner of items, which relate the pull-tab and the flattened cardboard box....the pull-tab, aluminum foil, and the rear view mirror are of similar metalic substance.... the foil and the mirror are both reflective.... iris, (blue flags) pop-top and mirror exhibit similar oval shapes.... the center line of the road doubles as another leaf in the flower grouping ... the iris also symbolizes human sight through word association. The embossed corporate stamp, which discloses a road worker, was discovered in an antique shop years before its use in this painting. The idea that I was the only person who could make that mark on a piece of paper appealed to me.

Overlapping shapes create space and the "real" objects confound a spatial reading.

Opposing elements of color, shape, texture and "real" substance illusions are related in rhythmic visual repetition. *See pages 30 and 73.* **Opposites are creatively combined. Invention is accomplished.**

Techniques used:

Detailed rendering of illusionistic "real" objects; regular tissue blot pattern; full color areas giving way to salt textured, gray areas.

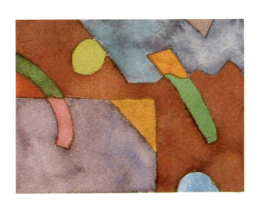

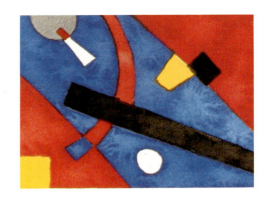

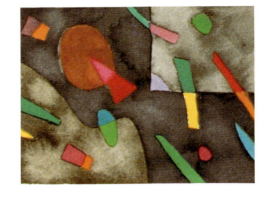

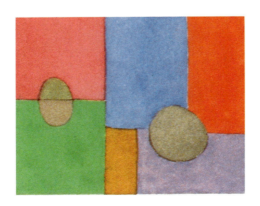

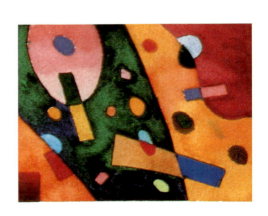

COLOR CHART (SCHEMES) The seven color contrasts used as color strategies.

TOP ROW (LEFT TO RIGHT)
1. Contrast of hue
2. Contrast of intensity
3. Contrast of value
4. Contrast of warm and cool temperature

BOTTOM ROW
1. Harmony of intensity
2. Complementary contrast
3. Simultaneous contrast
4. Contrast of amounts

Each contrast may be utilized as the dominant color system for a painting, or broadly intermixed.

PLATE 25

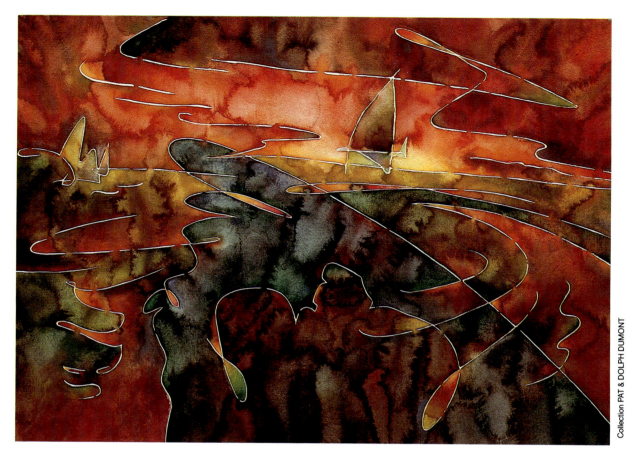

RED LINE JETTY *21″x 29″ transparent watercolor* **Miles G. Batt**

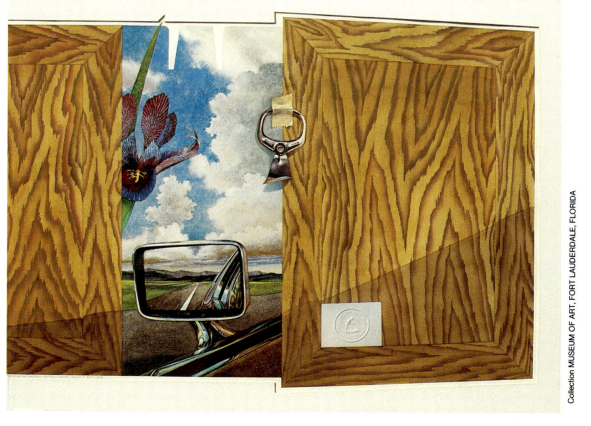

PANTRY OF THE PERVERSE VENTRILOQUIST *22″x 28″ transparent watercolor* **Miles G. Batt**

AMARYLLIS QUILT *30''X 22'' transparent watercolor* **Irene Charles Batt**

Warm, cool, light, dark, clean, dirty; the essence of my watercolors does not flow freely from my fingertips. Ideas are easy, painting is not! Translating all the colors and shapes familiar to me onto a flat sheet of paper is brain-work, right and left. Weaving, sewing, clay, all the three-dimensional work of my adult life is compressed onto a sheet of 30" X 22" white paper.

Vertical is excitement, it is growth! My flowers want to explode from the paper and are held fast with rigid, woven, contrasting ruler drawn shapes. These grayed, warm and cool shapes unite to march across a counterpane of brilliant, fluid, sensuous flowers and bind them to the surface. The flowers re-bloom in the quilt like borders, hybrids of my mind.

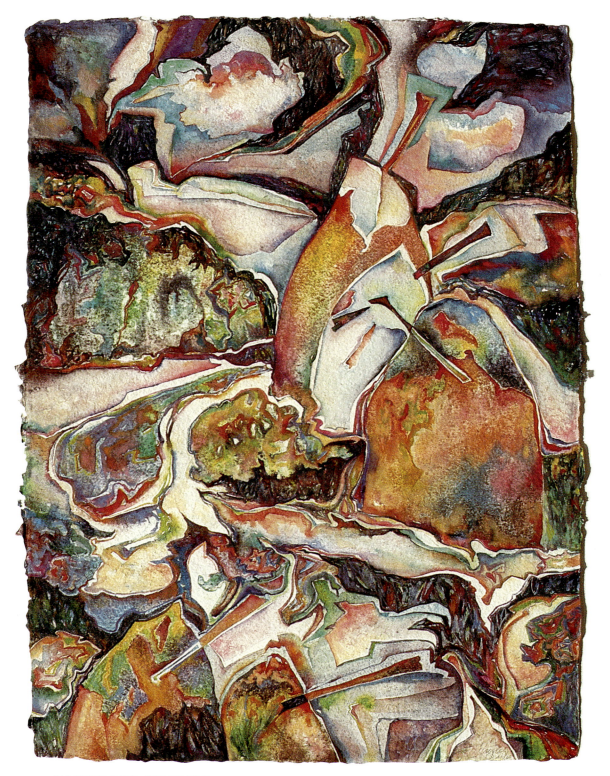

HAYSTACKS, MOTRICO *29'' X 21'' watercolor* **Irene Charles Batt**

A haystack is a haystack, except in Northern Spain, where they become giant triangles that run up and down the hillsides like oversized toys. The needle-like shapes that project from the stretched coverlets caught my eye with their aggressive upward thrusts into the sky and at the same time downward into the soft hearts of the stacked masses, a fascinating connection between the sky and the farmland.

This visual excitement was overwhelming and I had to paint haystacks, one, two, three or maybe even a hundred of these shapes that overlap and intertwine.

The paper is handmade by an artist in Cuenca, Spain, and lends itself to the subject matter.

MASKETTE

13" X 20" transparent watercolor, mixed

Miles G. Batt, Jr.

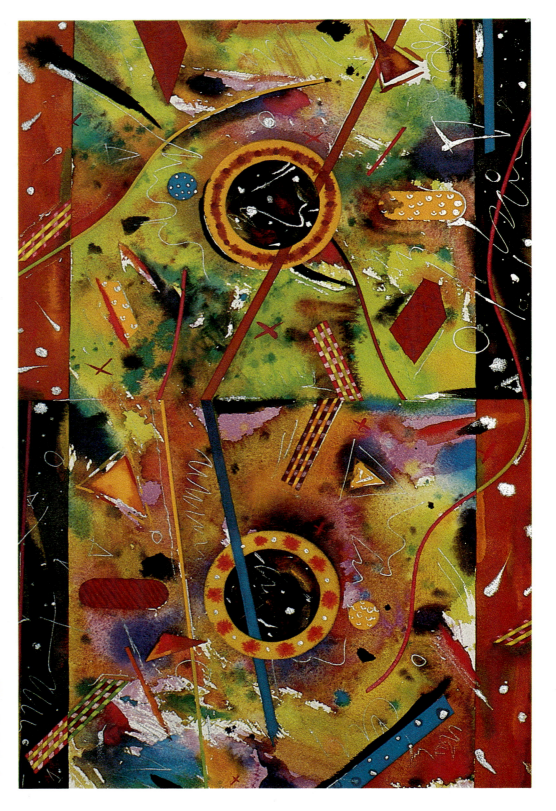

Why do I paint?

For self expression; an emotional need to communicate with others.

To create; Humans are created, hopefully in love, hence the love to create. How often have you seen a child who lacks imagination or doesn't find joy in creating his own little world? A tremendous percentage of this creativity is diminished or snuffed out by adulthood. Fortunately mine wasn't. I get great pleasure seeing, feeling, or hearing something new, be it my creation or someone elses.

To grow; Practice provides growth. Each painting is growth, sometimes I strike out, or maybe hit a single, but if I stick with it I'm going to hit some home runs! It's the quantum leaps that excite me most, the painting that is

so easy to paint, the one that makes me glad I paint.

Where do I get my ideas? Dreams and personal experiences provide ideas. Books can teach creative dreaming. Take a trip to your favorite bookstore or the public library.

Personal experiences (being there) always surprises me with creative ideas. Painting on location doesn't always give me the best ideas, but things stick in my subconcious and emerge later in a fresh more exciting way.

Experiencing other artists work is often inspiring.

What is my painting philosophy? I try to use my present knowledge, and continue to read and study. Maybe some day this will all develop into a philosophy. At present, I'm just trying to grow.

STONE SERIES　　*60'' X 40'' Acrylic watercolor*　　**Louise Cadillac**

Inspiration for my work in the stone series was drawn from early Greek and Russian Ikons. My purpose is to rival the reverence and the high surfaces of these religious symbols. This is accomplished by layering or glazing and otherwise manipulating acrylic watercolors. I strive to produce surfaces visually rich, symbolic of the layers of time, space, oxidation and corrosion; also of human grief, adulation, offerings, juraments, and prayers.

The visual excitement of this high surface is created by the illusion of depth contrasted against contemporary elements. The effect is often jarring, creating tension that draws the viewer into further contemplation.

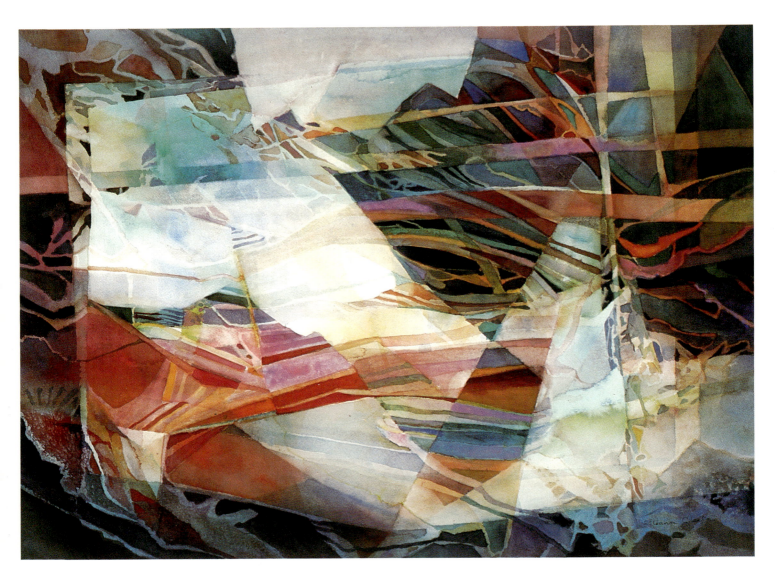

ZARAGOSA *22'' X 30'' transparent watercolor* **Eleanor Clarke**

When I was in Zaragosa, Spain, several years ago, I was struck by its rugged, sculptural landscape. This particular painting began to evolve much later, having moiled about in my head, along with impressions of folk art, shopping centers, classical music, leaves and sunlight, poetry, Scottish moors, fabric designs, and TV.

Rather than reacting to my environment realistically, I play with tangles of images and impressions much like I would solve a puzzle, developing the painting abstractly, in multiple stages, bit by bit, piece by piece. Sometimes I let the watercolor have its own way. When these "puzzle pieces" refuse to fit, I move on to another painting. Rather than being appalled by a mess of paintings in various stages of completion, I look upon it as a valuable and stimulating inventory. Something within me wants to impose order on each waiting painting and bring it to life.

Ultimately every work is completed. Some of my most unruly paintings end up being the most successful. The tussle of creating them is what makes painting so exciting. That and the joy of expressing my wonder at this puzzling and dazzling world.

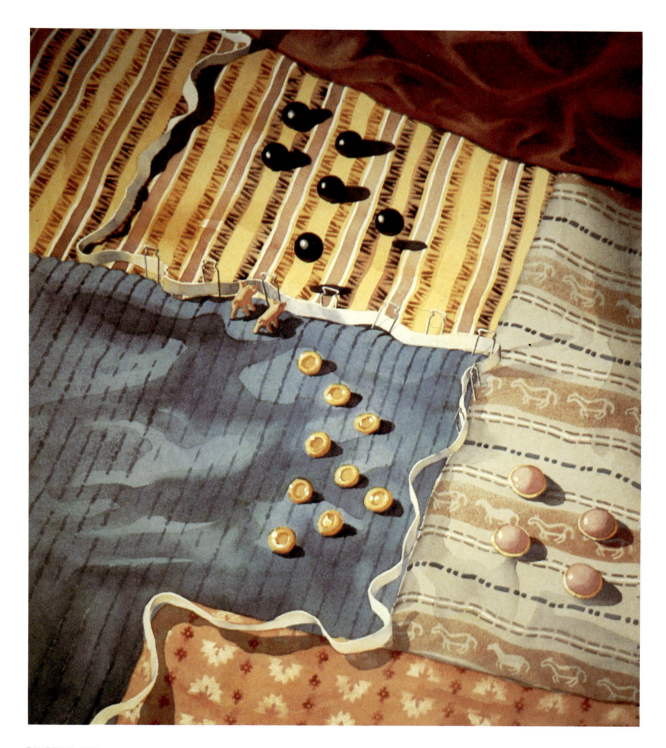

CROP'S UP *25"X 22" transparent watercolor* **Ellen Fountain**

I want to, need to, have to paint! It's the way I communicate ideas best. The altered state one goes into during the creative process is very pleasurable, like meditation, zen, runner's high, and eating chocolate.

An artist builds a vocabulary by learning to draw, studying color and design. Virtuosity is no substitute for content. . . . find something to say. Look within as well as without. Discover yourself, your uniqueness is the only "new" thing you can contribute. Don't accept or impose limitations. There is no "right way".

My ideas involve things I know and experiences I've had. My most successful paintings combine emotional and intellectual in-gredients to create a visual statement. Searching for the truth as I see it and the process of re-creating my environment in two-dimensions keeps me growing as a person and as a painter.

"Crop's Up", is an example of using common place subject matter. The landscape is painted from various fabrics (I have been sewing since childhood); fence of ribbon, posts of upholstery pins; and a "crop" of ball buttons. Center stage are the plastic pig "dice" from a game called "Pigmania", that are observing the visual pun that provided the painting with its name. The "crop" is figuratively and literally "up".

PIDGEON KEY, SUNRISE *15″ X 22″ transparent watercolor* **Don Gabbert**

Watercolor painting relates to and duplicates the experience of running a business, that is; getting started, learning the principles, careful planning, and handling success and failure with almost equal satisfaction.

Elusive, evasive and unpredictable, watercolor demands planning and thinking. When I observe the mingling of colors on wet paper, luminosity, transparency, creative — it's the best show in town.

NETWORKING *22'' X 30'' watercolor* **Winnie Hawkins**

When someone looks at one of my paintings and says, ''Oh, that looks like a'', or ''I see a'', I have accomplished what I set out to do. My goal in painting is to pique the viewer's curiosity and interest in such a way that allows him to read the painting through his own frame of reference rather than through mine.

Ideas for paintings are everywhere. Some are from reality. Many begin with a word or phrase; some spring from sounds or passages of music, but most of them are pure imagination.

Work begins with a drawing and an abstract underpainting, and then moves to glazes to define the images. Through color and line, often on a grid structure, I develop recognizable shapes and shapes that are ambigous enough to be interpreted in many ways.

In art, as in nature, the whole is the sum of its parts. It is of little consequence to me how it is put together, or by whom. I hope my viewers will be as entertained interpreting the finished work as I was painting it.

ITALIAN LANDSCAPE *30" X 22" watercolor mixed* **Simonne Hulett**

I can't imagine going a week without painting; painting is an obsession; I grow flowers, collect toys, dolls, etc;
animals intrigue me; always carry a drawing pad; traveling and painting is fun; we have a ranch....I sketch;
my sister lives in New Jersey....salt marshes and ocean;
Vermont is where my aunt lives....I paint there too;
"Haptic" that's me - "Lay hold of" - touch; expression....not distance or perspective;
ideas? - Feminine symbols....flowers....trees....mother earth.....cats;
draw, choose colors, mix them, line, shape Value or texture - paint right sided;
full sheets....4" X 4" petit can be monumental; save everything for a year...evaluate;
never evaluate while painting; if you love something and just do it you must improve;
if someone else appreciates your efforts....Good! If not....Tough!
The world is so exciting to draw....I just do it!
Love....Lines....Color and curved lines; *Random thoughts on painting*

SAIL STRIPES *22'' X 30'' transparent watercolor* **Steven Jordan**

My paintings are usually the result of visual encounters with interesting subjects or ideas. In the last few years this inspiration has come from the exposure to brightly colored patterns. After the ideas are transferred to paper, I enjoy taking liberties with color and composition.

Very fluid passages of color are manipulated on a slick surface by tilting the paper to yield smooth, untouched color areas! The imperfect fluid characteristics inherent in watecolor show through most attempts to achieve dead flat washes. I don't object to painterly techniques that display brush strokes, but feel that they would detract from the simplicity of the bold colorful shapes in a painting like, "Sail Stripes".

When I hear comments about my use of bright primary colors, I reply, "Even as a child, with a box of crayons, I always selected the brightly colored ones".

OFFERING *22" X 30" transparent watercolor,mixed* **Fran Larsen**

I paint what I see around me, the world of pueblos, Spanish villages, and the Anglos who have ventured into this place. My watercolors are about a multi-culture in which I am immersed. Each painting is as lovingly embellished as the folk art of these people. Filled with color played against non-color. The images are as allegorical and enigmatic as tales of the dances and doings of ancient and honorable people who have come together to make what we know as the Southwest.

The need to paint is one of the basic urges I was born with. I can't remember not "making things", drawing, painting. A part of most days must be spent in this way or I feel that I haven't accomplished much. This drive makes it easy to practice the old "seat of the pants to the seat of the chair" philosophy of creativity. Do it! And keep on doing it! The more the better! New ideas accompany each new painting.

I often photograph the pueblos and villages around Santa Fe. These photographs become my idea file, and from them grow non-photographic images within my head. One photo may spark many paintings as I move the images around in my mind's eye. None of what I paint exists as I portray it, but is an extension of me and my imagination.

STRATA ABOVE *44" X 34" mixed water media* **Hal Larsen**

My passion is for the grandeur of the land. The limitless space of the Southwest. Each time I look around me I discover more color, form, space. Inherent in the naked earth of these desert lands is a gem-like quality, unpolished and rough, as discovered, when held to the light and examined

Not portraits of a place, my paintings are everywhere - and nowhere . . . my land, my colors, my dreams. I travel the Southwest constantly, photographing and absorbing. What emerges from the paintings is me.

It would be impossible for me not to paint, having so strong an emotional response to the visual stimuli of the desert. When I first came to Santa Fe and drove through the aorthern Rio Grande valley, the view of myself as an artist and my place in the world changed immediately with an omnipresent flood of desert light.

In "Strata Above", I am recording my emotional and visual response to a misrocosm of rocky land. The stratification of earth from the ancient sea bed reveals rock surfaces that are cracked, stained, upheaved, and covered with lichen. They are "painterly" surfaces, aching to be transformed by abstract thinking into an introspective, personal statement of simple existance.

Technically, I used a Cresent watercolor board, hot pressed surface, transparent watercolor, watercolor pigment in pencil and stick form, gouache and acrylics. Over this surface I attached a transparent scrim of hand-stained papers in a collage technique.

SEASONS OF THE COW *37" X 37" watercolor mixed* **Annell Livingston**

"Seasons of the Cow" grew out of the realization that time is experienced differently by animals and humans, but that animals and human beings share larger pieces of time "Seasons".

Images of cows and clockworks were chosen to symbolize peace, love, nurturing, time and change. The many repeated moons and stars are synonymous with daily life and major life transformations from birth to death.

Arbitrary color choices and techniques encouraged the discovery of "new" color relationships. Formal balance, often utilized in early Christian art was chosen to convey a sense of importance and power. Although "Seasons of the Cow" was designed with a formal structure, (not often used in contemporary art) it was rendered in a contrasting informal manner.

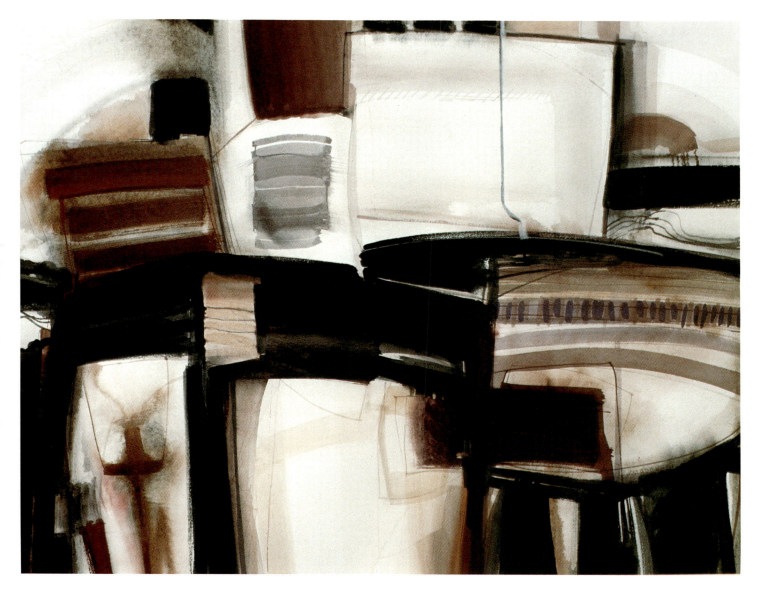

SPACEUM　　　　　　　*26"x 33" watercolor/etching*　　　　　　　**Sandra Marchetti**

All art is an abstraction not the "real" but the visual essence of thought. The key lies in ones ability to glean not only from the present recognizable subject sources, but also from the wealth of forms provided by one's imagination.

Intellect directs us to utilize the myriad of possible oppositions presented in the elements of art, design, and beyond.

The result can be an adventure into the reaches of unexplored abstract space.

My paintings and etchings originate from abstracted organic images. As I work the forms generate a spontaneous play against refined surfaces and lines weave themselves sinuously through space.

Only through abstraction can I create, my world and give the vision to you.

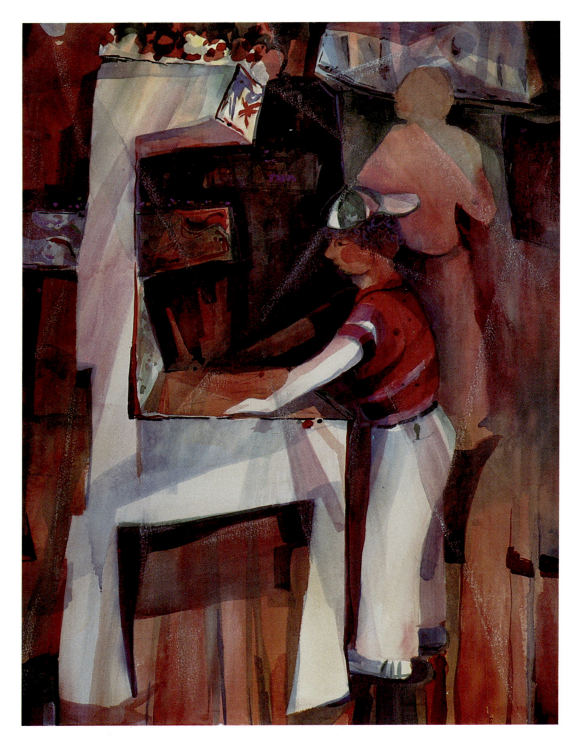

VIDEO-IDIO *30″ X 22″ transparent watercolor mixed* **Barbara Meeker**

Drawing and painting have always been a primary function in my life. Applying color to paper is a special outlet for my emotions and a way to record particular events in my own experiences, as well as the world around me.

Retrospectively my works display inconsistency - as if they are the product of more than one mind - the positive aspect of this revelation is that each painting has been resolved within its own context. My mood swings and general lifestyle dictate different results from painting to painting.

"Video-Idio", received a jury award in the Hoosier Salon Exhibition.

Manipulating watermedia, collage and mixed media into fresh subject matter satisfies my need to create a different image.

1001 MOONS OVER IMPERIAL PALACE *28'' X 38'' watercolor mixed* **Billie Murphy**

Following three separate trips to China and with a great admiration for the oriental culture, I inevitably painted the Imperial Palace. Gathering enough basic information required numerous photos, guide books, travel folders and a book full of sketches. It took seven years to visualize and build the courage to attempt to paint such a huge, detailed complex.

Six or seven design plans were executed. Choosing the layout that said Imperial Palace most completely, I determined not to strive for an oriental style painting, but rather a contemporary handling of oriental subject matter. The Chinese are absolute Masters of decorative patterns on architecture. Extreme simplification was the only way I could avoid chaos - reduce reality to painted equivalents that were manageable with paint.

"1001 Moons Over Imperial Palace" evolved as a "pattern painting". Repeated configurations, alternating rhythms, and the tension of asymmetric subject matter performed in a symmetrical format.

Creating a unique painting using sound design is of primary importance to me. Many artists get bogged down in painting a certain style and never seem to move past that style. I care more about the uniqueness of individual paintings, rather than developing "a style". However, I reserve the right to change my mind at any time.

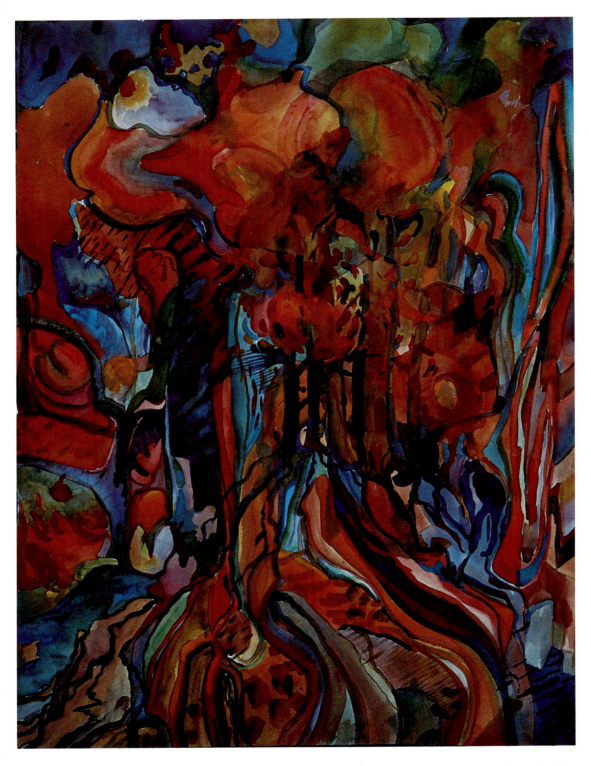

CAPTIVE REVERIE-RED *30" X 22" transparent watercolor* **Jane Paden**

My finished paintings always surprise me! How did I do it? Where did it come from?
Explaining that colors, shapes and lines are the most important elements for me when expressing my ideas
- or that I'm aware of ways and means - the choices to be made in the name of organization, seem too academic.
Painting the quintessence of a moment, an emotion, a feeling, or a personal vision is what I strive for, not
the incident, but rather the essence.
Ever since I gave myself permission to paint ideas I began to paint watercolors with substance. It's O.K. to
paint ideas! Eureka! I'm still surprised when I'm finished!

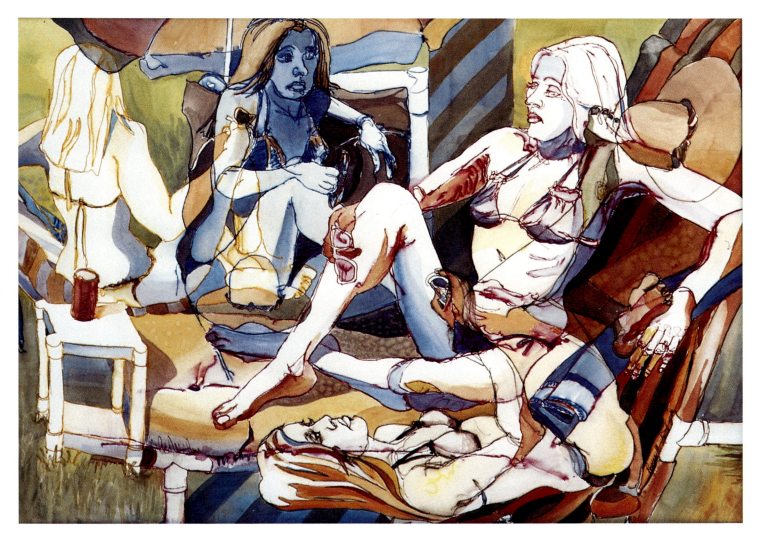

PIPE-FINE BEAUTIES *22'' X 30'' watercolor and ball point pens* **Rowena M. Smith**

Life's experiences structure what I create. Searching for the essence of what I know and feel, then responding in an individually expressive manner fills each day with watercolor activity.

Creating a piece of art is intense, hard work, occasionally even depressing....but when an idea works and a painting assumes a harmonic or dissonant life of its own, terrier-like I pursue the idea as far as it will take me. Spontaneously I shift values and shapes....creating tension and movement until I'm satisfied with the result. Using varied techniques, this creative process produces a series of works on a similar theme.

"Pipe-Fine Beauties" is the first of such a series of paintings. Working on 140 lb. D'Arches hot pressed paper, I used water soluble ball point pens for the many blind contour drawings of a single model viewed from numerous vantage points. I like to move around the model. Drawing from life allows me to exaggerate the subtle imperfections that seldom appear in photographs. With this beginning I completed the painting in my studio using fresh tube colors.

Strong value contrasts and vivid colors excite me....mirroring my moods; anxiety, anger, joy, and pleasure. Continuous experimentation with color combinations assists me in avoiding a mundane result. My easel is always up, palette ready, with several works in progress.

PARROT'S PLEASURE *22' X 30' watercolor mixed* **Mary Anne Staples**

Finding words that add anything to my paintings is difficult for me. Expressing myself with shapes and color relationships is much easier and certainly more fun.

Drawing is where my paintings begin. . . . draw, then redraw. . . . perhaps many times until the shapes feel as though they are completely mine. Then I choose colors that like to be near to each other and paint them.

"Parrot's Pleasure" means something very special to me. I painted an impulsive shape or two with acrylic gesso over an ordinary drawing of onions drying on a fence. Then I decided to paint the onions and ignore the gesso shape. While playing with the color relationships the parrots just happened!

Flexibility is an asset. Often I'm told that my paintings are whimsical. . . . I'm not sure what you'd call them, but I am sure I want a little of me on each sheet of paper.

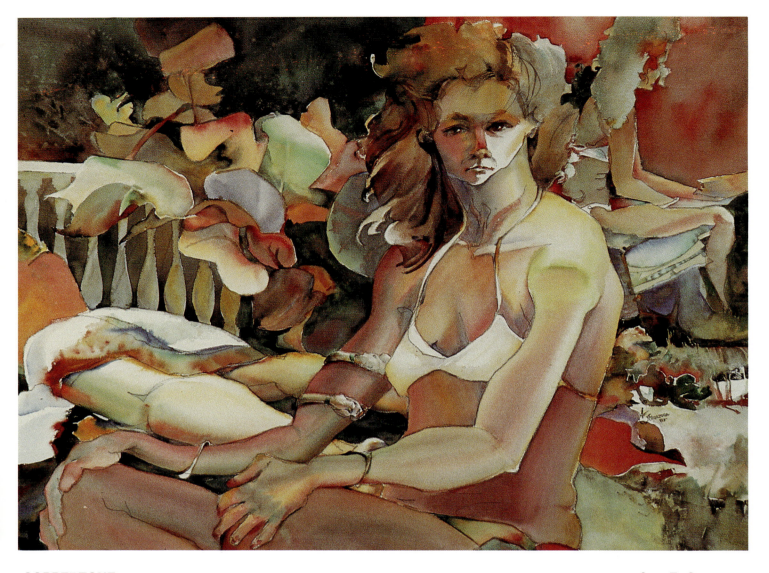

COPPERTONE *22'' X 30'' transparent watercolor* **Ann F. Stewman**

My paintings are both representational and expressive. I intentionally walk a tight-rope between the two. Bending one way or the other may be proper, prudent, and artistically acceptable. My intent is to be me, to see the shifting ''real'' world around me in a different light that will persuade others to risk another point of view. That is my approach to creativity.

SUMMER ON SULLIVAN'S *30" X 22' watercolor, water crayon, mixed* **Patsy Tidwell**

Experimenting with new materials and new techniques. . . . new relationships with the many moods of nature. . . . that's exciting! I enjoy active surfaces. . . . for me that's what painting is all about.
If you really look, all around you there are images, textures, colors, shapes, etc. that have strong similarities to accidental and planned painted surfaces.
Designing and planning for everything can make a good painting, but just playing with the paint. . . . spraying, blotting, scraping, scribbling, splashing - using hard smooth paper. . . . then soft absorbent stock - and just watching the paint do its thing is fascinating.
Sullivan's Island is a short trip from Charleston, S. C., where I live. "Summer on Sullivan's", happened as a result of playing with the materials until something fit. What was happening on the paper reminded me of walks on the gray sand beach, the blue gray sky with flashes of sunlight, wet foot prints, seashells, the horizon where sky meets water and sand dunes. . . . it's all in the painting.

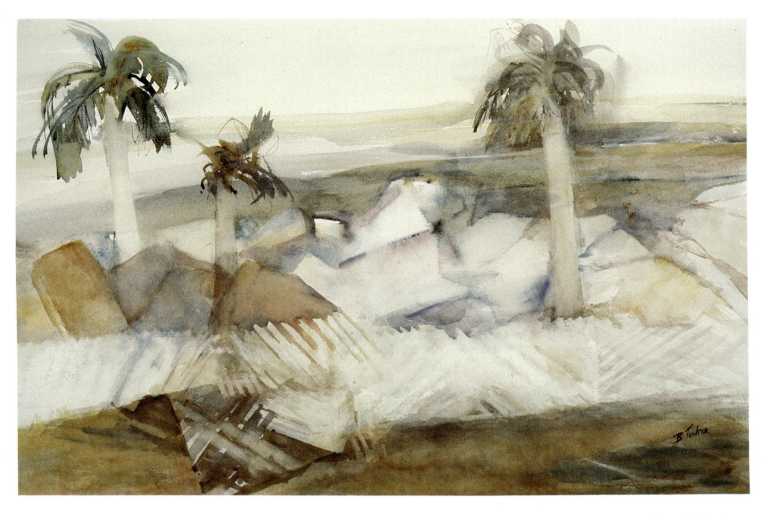

BALLAST ROCK *22'' X 30'' transparent watercolor* **Bea Q. Tucker**

Often I've said, "I want my watercolor paintings to look as if they were poured from a cream pitcher."

My feelings about the things I see dictate how I paint. . . . I like to be natural. . . . spontaneous. Although I've successfully ventured into oil painting and graphics, watercolor remains an inspiration.

Ideas are marvelous indescribable somethings - at times right there in front of you often however, a simple color experience or relationship rooted in the mind's eye from another time.

Color and design are important to me but never more important than my emotional involvement.

"Ballast Rock" was the result of a strong impression I had while looking through a motel window in Florida. Large slabs of concrete had been planted on the beach to protect the near-by highway from a rising tide man against the elements.

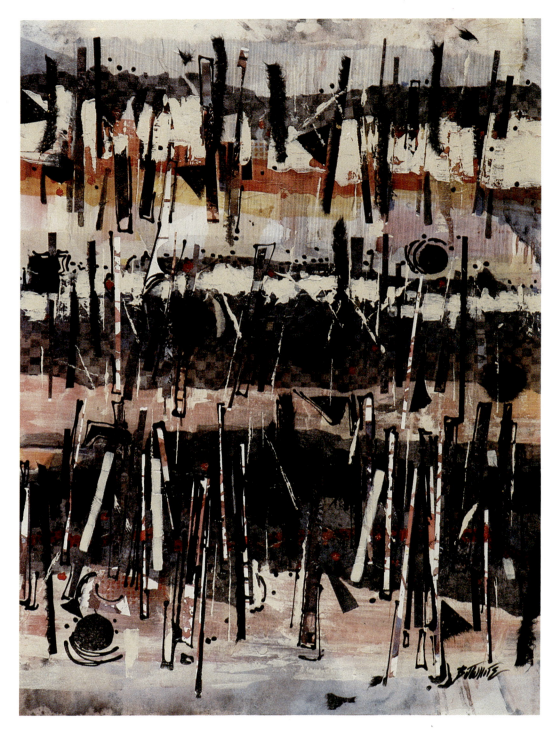

MIXED MARRIAGE *30"x 22" watercolor mixed* **B.J. White**

To write about my painting is difficult because I'm becoming more introverted verbally and more extroverted visually; however, the whole process of painting is stimulating to me. I work on several pieces at a time, layering color, experimenting with textures, rub off, repaint, scrape, collage, continually modifying the painting surface until it satisfies me.

Some paintings are influenced by political or social absurdities, environmental or health issues and some are painted out of rebellion, in order to break a so-called rule. Many paintings begin with no idea in mind—just playing with paint. Then the problem solving process of making the painting work begins, taking from a few hours to a few years. I would like my paintings to intrigue the viewer, to hold his attention from a variety of distances. A reaction from the viewer is important—even if it is shaking his head as he walks away.

GAELIC ENCOUNTER *22"x 30" acrylic watercolor* **Betty Usdan Zwickler**

Painting is joy and agony....often lose sleep over work in progress....exhilaration is creative process itself....challenge ceases with completion....feel let down....cycle starts again - fear of blank paper, excitement of discovery, the anguish, insomnia, the gratification....use representational overtones to explain abstract statements....strong color sensibilities....concerned with patterns, textures, sculptural masses....need to express is all pervasive....obsession to work....may not succeed, but compelled to make art.

printed by GRAPHIC DYNAMICS, INC., Pompano Beach, FL

designed, produced and edited by MILES and IRENE BATT

INDEX

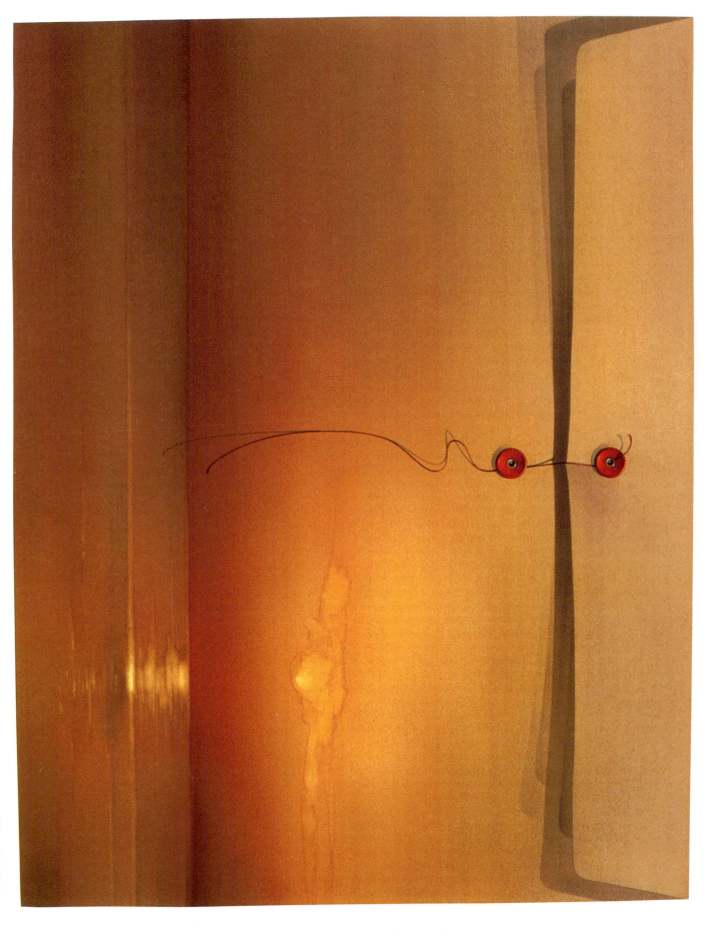

20 1/4" X 26 1/4" transparent watercolor

Miles G. Batt

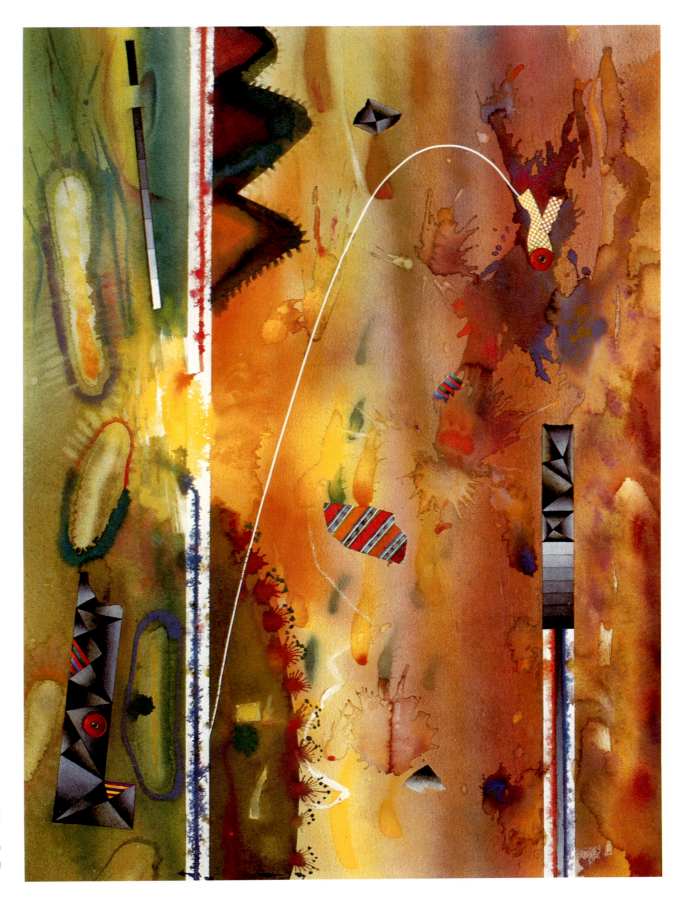

21" X 29" transparent watercolor

Miles G. Batt